PHILIPPE HALSMAN : A RETROSPECTIVE

PHILIPPE HALSMAN

A RETROSPECTIVE

Photographs from the Halsman Family Collection

Edited by Jane Halsman Bello and Steve Bello

Introduction by Mary Panzer

A Bulfinch Press Book

Little, Brown and Company BOSTON NEW YORK TORONTO LONDON

First Edition

Library of Congress Cataloging-in-Publication Data

Philippe Halsman : a retrospective : photographs
 from the Halsman Family collection / edited by
 Jane Halsman Bello and Steve Bello ; introduction
 by Mary Panzer. – 1st ed.
 p. cm.
 Published in conjunction with a traveling exhibition.
 "A Bulfinch Press book."
 ISBN 0-8212-2373-9 (hardcover)
 1. Celebrities–Portraits–Exhibitions. 2. Portrait
photography–Exhibitions. 3. Halsman, Philippe–
Exhibitions. I. Halsman, Philippe. II. Bello, Jane
Halsman. III. Bello, Steve.
TR681.F3P58 1998
779'.2' 092–dc21 98–15245

Designed by J. Abbott Miller, Paul Carlos, Ric Aqua:
Design/Writing/Research
Digital photography and duotone separations by
Martin Senn, Philomont, Virginia
Printed by Meridian Printing,
East Greenwich, Rhode Island
Bound by ACME Bookbinding, Charlestown,
Massachusetts

Bulfinch Press is an imprint and trademark of
Little, Brown and Company (Inc.)
Published simultaneously in Canada by
Little, Brown & Company (Canada) Limited

Printed in the United States of America

Contents

Texts accompanying photographs are from Halsman's journals.

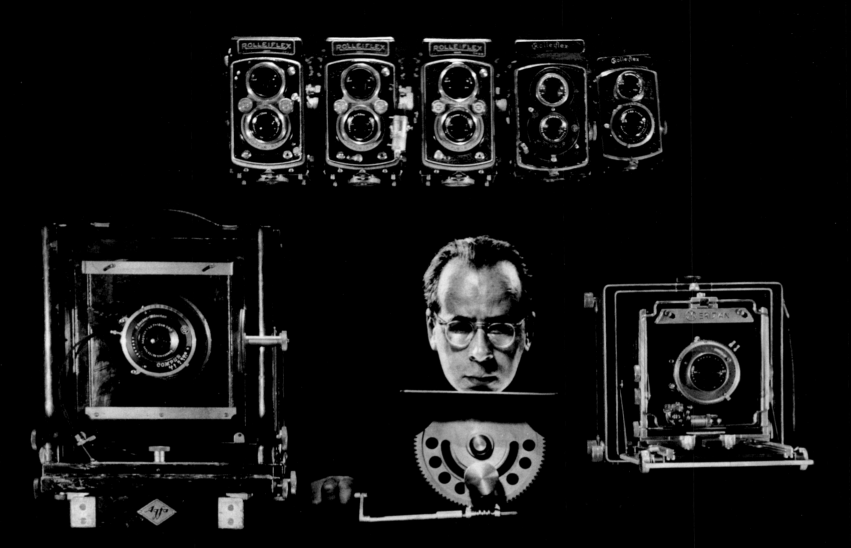
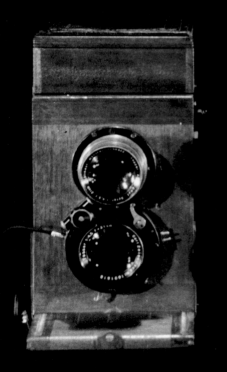
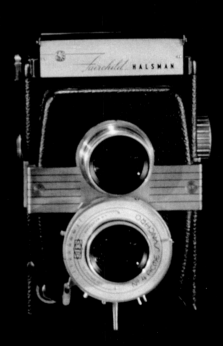

Philippe Halsman,
1950

Introduction

by Mary Panzer

"Great Success in the U.S.A."

From the 1940s through the 1970s, Philippe Halsman's portraits of beautiful women, powerful men, celebrities, stars, intellectuals, and politicians appeared on the covers and pages of America's big picture magazines, *LOOK, Good Housekeeping, Ladies' Home Journal, Esquire,* and especially *LIFE.* In Europe, he worked for *Picture Post, Paris Match,* French *Vogue,* and *Stern.* Readers could also see his stunning portraits in advertisements for Old Gold cigarettes, Pond's cold cream, and Elizabeth Arden cosmetics, and in publicity for NBC, Simon & Schuster, Ford, and countless other corporate clients. Halsman set the standard for celebrity portraiture. Amateur and professional photographers gave him high praise, and the photographic press published many stories about his work.[1]

In 1958, *Popular Photography* conducted a poll of its readers, who named Halsman one of the "World's Ten Greatest Photographers," along with Irving Penn, Richard Avedon, Ansel Adams, Henri Cartier-Bresson, Alfred Eisenstaedt, Ernst Haas, Yousuf Karsh, Gjon Mili, and Eugene Smith.[2] Each one produced images that glowed on the page. Today's list would be established by a museum, not a magazine, to reward photography that fits firmly within the larger history of art, but many of the names would be the same. By the 1960s, Adams's majestic landscapes and Cartier-Bresson's surrealist-inspired "decisive moment" had secured them wide recognition as artists who worked with a camera. By the 1970s, the rising status of photography and photographers brought museum exhibitions for Penn and Avedon and enhanced the reputations of journalists like Eisenstaedt and Smith. Karsh entered the popular marketplace and succeeded largely by defying the world; his shiny, monumental portraits seem impervious to change. Historians now assign a less exalted place to Mili's creative experiments with light and to Haas, who mastered color printing.

Of all the Greatest Photographers of 1958, Halsman belongs most completely to the magazine era—even though his fine prints and secure reputation meet every standard set by the world of art. For *LIFE* he covered prominent personalities, the Broadway stage, and American fashion. His commercial assignments document our more ephemeral celebrities. The faces he recorded for NBC belong to the story of the rise of television, and one could even trace the growth of big business through his corporate reports. Together, his subjects create a vivid picture of prosperous American society in the middle years of this century.

Philippe Halsman's photographic career began in Paris in the 1930s, where he made portraits and contributed to fashion magazines, including *Vogue, Voilà,* and *Pour Vous.* He arrived in New York early in November 1940 with little more than his camera. Within three months he had a contract with the Black Star agency, and before two years had passed, his work appeared on the cover of *LIFE* magazine. One hundred more covers followed before his death in 1979. Halsman's ability to combine glamour, sex, and wholesome energy in one portrait made him *LIFE*'s favorite photographer for sensual stars like Marilyn Monroe and Sophia Loren. Halsman's essential understanding of the studio as a place of artifice and fantasy led him to collaborate with Salvador Dali on a long series of playful tableaux that had all the disturbing irrationality of a dream—or a painting by Dali.

Halsman's style owes much to the aesthetic innovations of the surrealists. In Paris in the 1930s, the work of surrealist artists and photographers appeared in galleries as well as in publications like *VU,* where the work of Kertész, Man Ray, and Brassai illustrated stories on fashion, celebrity, and Parisian nightlife. As Peter Galassi has described, the surrealists were the first to understand that "ordinary photographs, especially when

1. For biographical information on Philippe Halsman, see Bruce Downes, "Modern Portraiture Number Two—Philippe Halsman," *Popular Photography* (February 1946): 20–31, 158–62; "Philippe Halsman," *Current Biography* (1960): 174–176; Peter Pollack, "Philippe Halsman, Portraits in Character," *Modern Photography* (June 1972): 84–89, 102–104; Ruth Spencer, "Philippe Halsman," *British Journal of Photography* (10 October 1975): 898–901, 919; Owen Edwards, "Halsman: A Tribute," *Portfolio* (October/November 1979): 40–45; and Philippe Halsman, Untitled Introduction, *Halsman Portraits,* edited by Yvonne Halsman (New York: McGraw-Hill, 1983), n.p. I also received generous assistance from Yvonne Halsman, Jane Halsman Bello, and Steve Bello.

2. "World's Ten Greatest Photographers," *Popular Photography* (May 1958): 63–84.

3. Peter Galassi, *Henri Cartier-Bresson: The Early Work* (New York: The Museum of Modern Art, 1987), 33.

4. On Dali in New York, see Julian Levy, *Memoir of an Art Gallery* (New York: G. P. Putnam's Sons, 1977), 208–224; also Meredith Etherington-Smith, *The Persistence of Memory: A Biography of Dali* (New York: Random House, 1993), 223–273. On Halsman's collaboration with Dali, see Ralph Hattersley, "Critic's Choice, Creating Surprise out of Commonplace Events," *Popular Photography* (April 1965), 74–75, 113–115; and Yvonne Halsman, *Halsman at Work* (New York: Harry N. Abrams, 1989), 82–95.

5. "Famous Photographers Course in creative photography for professionals and serious amateurs," *Famous Photographer's School* (Westport, CT: Famous Photographers School, 1963). Jacob Deschin, "New Way to Teach, Famous Photographers Course Starts Soon," *New York Times.*

6. "Philippe Halsman," *Current Biography* (1960), 174.

uprooted from their practical functions, contain a wealth of unintended, unpredictable meanings," and the subsequent "attempt to harness this centrifugal obstreperous force" occupied modern photographers for decades to follow.[3] From the surrealists Halsman learned to surprise his viewers. Through lighting, focus, and close cropping, he turned formal fashion shots into serious investigations of character. By including homely and ultimately disturbing details he gave his subjects memorable drama. Arcing lines radiate from the moon-shaped bifocals on André Gide's spectacles, to the spectacles themselves, to the eyebrows, and even the oval shape of his head like the concentric rings of a target. In Halsman's iconic portrait of Einstein, the scientist's leonine head hovers over shoulders draped in a soft sweatshirt, and the clip of a pen cuts across the collar, a jarring reminder of the ordinary constraints on a less-than-ordinary man. Halsman posed his NBC comedians against bare white paper, eliminating all defining context; their isolation emphasizes physical idiosyncrasies and human frailty while it also inspires laughter.

From the surrealists' early exploration of the erotic unconscious, Halsman also learned the strategies he used to represent sex. The classic curves of Connie Ford's profile against a fragment of an American flag reveal a slender, bare shoulder; both figure and background are incomplete and clear, suggesting the full forms that extend beyond the edge of the picture. In an early assignment for Elizabeth Arden, Halsman portrayed a model whose head was covered with a Medusa-like crown of electric curlers while a technician's shadowy hands enter from the upper right; keeping the composition in creamy high key, Halsman gave his subject charming serenity and considerable allure. Halsman preserved a disarming innocence in his frequent use of hats, hands, cigarettes, and other fetishized objects. He certainly was not a prude, but he never theorized about why his work consistently exerted a strong sensual appeal. Halsman's use of surrealism belongs to the realm of the popular.

Halsman also absorbed the strategies of surrealism through his long collaborative relationship with Salvador Dali. They met in 1941, when Black Star sent Halsman to photograph New York's reigning art celebrity (an assignment that resulted in Halsman's first published picture in *LIFE*). Over the next two decades, they collaborated as equal partners on many projects, producing a book, many portraits, and a series of tableaux; their most notable production was *Dali Atomicus,* a photograph in which the artist, his canvas, furniture, cats, and water all appear suspended in air. Dali also reinforced Halsman's conviction that a successful artist could thrive in the public sphere. Dali arranged display windows for Bonwit Teller, concocted a pavilion for the 1939 World's Fair, and designed dresses, jewelry, and theatrical sets, while his work commanded serious attention, including a retrospective exhibition at the Museum of Modern Art.[4]

Throughout his career, Halsman proudly identified himself as a professional photographer. He was known for his exacting standards: he never missed a deadline, his prints were rich and flawless, he pursued every possibility in search of the right result. Halsman thrived in the competitive magazine marketplace, and his success (and temperament) enabled him to work independently; despite his many assignments (and 101 covers) for *LIFE,* he never joined the staff. In 1945, he helped organize the American Society of Magazine Photographers and served as its first president, providing a professional forum that continues today. In the early 1960s, he served as an adviser to the Famous Photographers School (along with Irving Penn, Richard Avedon,

Alfred Eisenstaedt, and others). Modeled on correspondence schools for writers and artists, the Famous Photographers won the endorsement of "editors, publishers and advertising men" who seemed confident that this staff could turn any serious student into a working photographer.[5] Halsman used these professional credentials to introduce and explain his career to interviewers and readers.

Halsman's great pride in his professional stature is perhaps the most forceful reminder of the historical conditions that governed his practice, along with that of most working photographers who were his contemporaries. The overwhelming popularity of general magazines provided these photographers with a wide popular forum; even art photographs appeared most often on the pages of magazines like *Popular Photography* and *U.S. Camera* (the booming market for 35 mm cameras and home darkrooms made this a very large and affluent niche). The great importance of *LIFE, LOOK,* the *Saturday Evening Post,* and *Popular Photography* can be seen in the many institutions that have come to replace them; today we see photographs in museums, galleries, art schools, on video and the Internet, and in vast numbers of special-interest publications. In 1955, Steichen's popular exhibition "Family of Man" displayed uplifting photographs and inspiring captions on freestanding panels, allowing visitors to the Museum of Modern Art to stroll through an enormous *LIFE* story. By contrast, Philippe Halsman secured his audience in the pages of *LIFE* itself.

From Riga to Paris

Philippe Halsman grew up in Riga, the capital of Latvia, a small nation on the edge of the Baltic Sea. He studied engineering in Dresden. His father, Max Halsman, was a dentist; his mother, Ita, taught school before she raised her family; and his younger sister, Liouba, was lively and intelligent. The Halsmans were a typical assimilated Jewish family; members of an international *haute bourgeoisie,* they were well educated and fluent in several languages, traveled widely, and valued high culture.[6]

Late in the summer of 1928, Halsman, then a twenty-two-year-old university student, reunited with his family in the rustic Tirolian Alps near Innsbruck, Austria, close to the borders of Germany and Italy. By the late 1920s, this popular vacation spot had become a center of the Heimwehr movement, a thinly disguised network for fascist activity. Aside from a few astute reporters, most people doubted that the Heimwehr could ever threaten the official high culture that radiated throughout Europe from Vienna. But that September, Philippe Halsman and his family came into tragic conflict with its growing power.

While father and son were hiking, Max Halsman lingered behind, fell, and died as a result of his injuries. The grieving family arranged for a rapid burial, as required by Jewish law. Their haste aroused suspicion (Tirol funerals were famously long and elaborate). A rash of unsolved crimes in the area and rife anti-Semitism further empowered local officials. Without evidence or motive, they quickly accused, tried, and convicted Philippe Halsman of his father's death. Halsman served two years in prison while his sister and friends drew international attention to his case. Thomas Mann, Albert Einstein, Sigmund Freud, and other important intellectuals endorsed his innocence. Finally, in the fall of 1930, Austrian president Miklas released the "Austrian

Dreyfus" from prison. Halsman joined his mother, sister Liouba, and her husband in Paris, happy to bring an end to his career as a political figure.[7]

In Paris, Halsman left engineering behind, turned his former hobby into a livelihood, and by 1932 had established himself as a professional portrait photographer in Montparnasse, near the bohemian center of the city. Halsman shunned old-fashioned portrait styles, which called for soft focus and a great deal of retouching on the negative, in favor of the dark, sharp images he found in magazines like *Vogue* and *VU*. On the sidewalk in front of his studio, he installed a glass display case; this street-side exhibition space encouraged him to develop a bold, posterlike style. Passersby enjoyed the new pictures that appeared each week, and Halsman's reputation grew.[8]

Halsman turned his talent for portraiture to varied ends. Like countless portrait artists before and since, Halsman sought out well-known figures, including André Gide, André Malraux, Heinrich Mann, and Le Corbusier. He made many head shots for rising stage stars and clearly enjoyed the fanciful creations he recorded for the fashion trade. Halsman's fine technique enabled him to capture a broad range of tones in a single image; his ability to combine dark shadows with shining highlights gave his prints intensity and freshness. His portraits captured unusual, spontaneous expressions, thanks in part to his own technical innovation. Early on, Halsman grew dissatisfied with his conventional view camera; its single lens forced him to secure a pose, focus, then stop, load the film, and hope that nothing had changed. Twin-lens cameras increased speed, but their small negatives did not allow Halsman to produce the large, sharp images he wanted. Working with a local camera manufacturer, Halsman found a way to combine the advantages of both formats; by incorporating a second lens within a large-format camera, he could compose and focus freely while the camera was loaded, allowing spontaneity without sacrificing detail and drama.

By 1938, Halsman had established a thriving business. He married Yvonne Moser, a fellow photographer, and moved his studio to the Rue St. Honoré. Paris had become home. His career continued there until the spring of 1940, when the Nazis threatened France. Halsman's mother, wife, baby daughter, sister and her children (who all had French passports) obtained visas and left for New York. But Halsman's Latvian papers held him back. Just days before Paris fell, he traveled south, along with thousands of other refugees. When he reached Marseilles, Halsman appealed to the Emergency Rescue Committee, an American relief organization that eventually helped many European intellectuals and artists reach free ports in Portugal and Spain, from which they could sail to freedom. But Halsman still needed a visa to enter the United States. He obtained it through the intervention of Albert Einstein. Though not known as a political activist, Einstein responded immediately when Liouba Halsman Golschmann and Yvonne Halsman came to Princeton to ask for his help. Einstein remembered Halsman's case well, and contacted Washington on his behalf. On November 16, 1940, three days after Halsman arrived in New York, he wrote a heartfelt letter of thanks to "the one person to whom I owe the most." Einstein promptly sent warm wishes for "great success in the U.S.A." and congratulated Halsman for having escaped the "bandits" yet again.[9]

New York, and LIFE

When the Halsmans first settled in New York they spoke no English, money was short, and they knew almost no one. Having published work in European magazines, Halsman was able to secure a contract with the Black Star picture agency. After five months of routine assignments, he met Connie Ford, a striking young model with "typically American" looks (and no portfolio), who agreed to pose in exchange for prints. Black Star saw no market for the unusual portraits, but Ford showed her pictures to someone at Elizabeth Arden, who selected Halsman's portrait of Ford against a bold American flag to launch a new lipstick, Victory Red. Halsman continued to work for Arden, secured a long-term contract with Charles of the Ritz, and began working for the *Saturday Evening Post* and *Ladies' Home Journal*. In the fall of 1942, when *LIFE*'s executive editor Wilson Hicks needed a photographer to shoot a story on hats, he chose Halsman for his European training and his experience with fashion. To Halsman's delight, his portrait of a model in a Lily Daché hat landed on the cover.

In 1942, photojournalism was still an experimental field. Most of *LIFE*'s photographers still worked in the careful, composed style dictated by large-format cameras. And while the magazine published stories about current events, overall it endorsed a relentlessly lighthearted and decidedly conservative view of America. Regular accounts of faraway European politics were overshadowed by heartwarming stories of everyday American life, celebrity antics, and national news. The men who developed and launched *LIFE* in 1936 strived for sophistication, modeling the magazine's bold style on the graphics of advertising and European magazines like *VU, Berliner Illustrierte Zeitung,* and *Muenchner Illustrierte*. Using curiosity, drama, history, and humor, the editors sought to promote the illusion that "so much of the world, so judiciously selected, had never been seen before in one place, in one week, as in *LIFE*." [10]

Each week, they needed pictures and stories to sustain that illusion, and as executive editor of *LIFE* from 1938 to 1951, Wilson Hicks hired photographers, assigned stories, and was generally responsible for generating the images from which the magazine was made. A complex, talented man whose arrogance angered many colleagues, Hicks inspired his staff to make extraordinary pictures. Halsman acknowledged Hicks's "great influence," remembering how everyone strived to please him. When Hicks liked a photograph, "He'd laugh; his eyes would light up; his hands would tremble; and he would look like a miser who had discovered a treasure! It was better than anything.…We all tried to produce this excitement in Wilson Hicks." Halsman's work appeared on the cover of *LIFE* more than fifty times during the nine years they both worked at the magazine.[11]

Almost all the ingredients that pleased Hicks and made Halsman's work successful were present from the start. For his first *LIFE* assignment, Halsman used a broad, bold style to photograph Lily Daché's latest inventions, which all flirtatiously concealed one eye with a veil, feather, or frill. (In 1942, hats, unlike most other clothing, could be made without wartime restrictions and so offered a rare chance for frivolity.)[12] Halsman's models play up the irony and redeem the silly hats by turning the story into a welcome respite from the serious outside world. On the cover, Halsman's frontal composition emphasizes the model's smooth, dark shoulders, dark lips, and wide eyes, which

7. "Austrian 'Dreyfus' Freed," *New York Times* (1 October 1930), 2:2. Several scholars have discussed this case, including George E. Berkley, *Vienna and Its Jews: The Tragedy of Success, 1880s–1980s* (Cambridge, MA: Abt Books, 1988), 181–187; Lucian O. Meysels, *In meinem Salon ist Oesterrich: Berta Zuckerkandl and ihre Zeit* (Munchen: Herold Verlag, 1984), 255ff; and Denis Brian, *Einstein, A Life* (New York: John Wiley, 1996), 169ff. The case also appears in memoirs, Berta Szeps Zuckerkandl, *Oesterreich intim: Erinnerungen 1892–1942* (Frankfurt: Propylaen Verlag, 1970), 180–185; and, most interestingly, Martin H. Ross, *Marrano* (Boston: Branden Press, 1976), 16–21, 54, 83–84; neither account mentions Halsman by name. As Ross explains, "No useful purpose would be served by naming him. On the contrary he is entitled to the anonymity he desires" (54). See also Philippe Halsman, *Briefe…*, ed. Karl Blanck (Stuttgart: J. Engelhorn, 1930).

8. On Halsman's European career, see especially Downes, "Modern Portraiture Number Two," 160ff.

9. P. Halsman to A. Einstein (draft), 16 November 1940; A. Einstein to P. Halsman, 3 December 1940 (Halsman Archive). The Halsman and Bello families generously shared their recollections. I am also grateful to Gudrun von Schonebeck for her translations from the German.

10. On the history of *LIFE*, see Loudon Wainwright, *The Great American Magazine: An Inside History of LIFE* (New York: Alfred A. Knopf, 1986). The quotation comes from Wilson Hicks, *Words and Pictures* (New York: Harper & Bros., 1952), 45.

11. Philippe Halsman, "100 Life Covers," in R. Smith Schuneman, ed., *Photographic Communication: Principles, Problems and Challenges of Photojournalism* (London: Focal Press, 1972), 176. *LIFE* marked a landmark in Halsman's career with "51st LIFE Cover," *LIFE* 31 (October 15, 1951): 11–13. On Hicks, see John Durniak, "Focus on Wilson Hicks," *Popular Photography* (April 1965): 59–61, 91–99; also Wainwright, *The Great American Magazine,* 109–110.

12. "Eye Catcher Hats," *LIFE* (October 5, 1942), 77.

contrast sharply with the whimsical shape and texture of the hat. The model turns her eyes away from the camera, her teasing gaze suggesting that we join her outside the frame, where something a lot more interesting is going on. From his street-side display case Halsman had learned to make magazine covers that functioned like posters on the newsstand; more important, from the surrealists Halsman knew how to make images that could stir desire. As he told students near the end of his career, "A cover must…interest, intrigue, attract; it must…be a promise that one will spend an interesting hour with the magazine." [13] Halsman's model became a symbol for the magazine itself; her mysterious smile promised "an interesting hour" to men and women alike.

Psychological Portraiture

Over the course of his career, Halsman enjoyed comparing his work to that of a good psychologist who regards his subjects with special insight and knows how to bring their true character to the surface. [14] With his courtly manners and European accent, Halsman also fit the popular stereotype at a time when Americans regarded psychology with fascinated skepticism. The analogy holds true on many levels. Halsman's studio, like the therapist's office, was kept dim, quiet, and relatively free of distraction. He usually began a session with conversation in order to swing attention away from himself and his camera, and to study the subject's face, both as a problem of form (what is the structure, where is the asymmetry? where is the strength?) and as a reflection of character. Keeping both aspects of the portrait in mind, he imagined the story he wanted his pictures to tell and arranged lights and background accordingly. Halsman also encouraged his sitters to project an imaginary viewer onto his camera's lens. To a writer who needed a portrait for his magazine column, he exclaimed, "This is good…you are looking at your audience!" He often encouraged female subjects to think of the camera as a "symbol for the man she wants to please." [15] Halsman's portraits consistently pleased many audiences— editors, designers, publicists, and the subjects themselves, as well as the public.

John Baird, one of Halsman's early assistants, recalled that a typical session "would start off rather coolly and gradually warm up to the climax when both photographer and subject knew the best pictures were being made." Halsman himself explained the process with subversive wit. "It can't be done by pushing the person into position or arranging his head at a certain angle. It must be accomplished by provoking the victim, amusing him with jokes, lulling him with silence, or asking impertinent questions which his best friend would be afraid to voice." Critics also praise his ability to eliminate obstacles that separate the ultimate (magazine) audience from the subject before his camera. Whether working with experienced film stars or less sophisticated sitters, he was able to "break through the veneer" of self-consciousness. Having obtained a fresh, expressive picture, Halsman managed to render a sharp print full of brilliant highlights. By the time the image reached the magazine reader, it seemed to transcend "the barriers of film and the printed page and let us see [his subjects] as they are." [16]

In the spring of 1952, LIFE sent Halsman, Baird, and a LIFE reporter to visit Marilyn Monroe. As usual, Halsman developed a premise for the story to show that Monroe's natural sex appeal

pervaded her every move—"talking, walking, sitting, eating," reading, listening to music, interviewing for a job. Though the assignment took place in Monroe's Hollywood apartment rather than Halsman's New York studio, the routine was the same— lights prepared, assistant ready, and the backdrop carefully chosen. "I led Marilyn to a corner and put my camera in front of her. Now she looked as if she had been pushed into the corner— cornered—with no way to escape." Then Halsman, his assistant, and the reporter staged a "fiery" competition for her attention, and "the basic situation was provided….Surrounded by three admiring men she smiled, flirted, giggled and wriggled with delight. During the hour I kept her cornered she enjoyed herself royally, and I…took between 40 and 50 pictures." [17]

The resulting portrait, now widely familiar, is full of tension. Monroe stands with her back against two walls, one dark, the other light. Monroe's eyes are half closed and her dark, lipsticked mouth partly open. She wears a white evening gown that slips off her shoulders while it hugs her arms, breast, and torso. A jeweled clip marks her otherwise hidden cleavage. As cropped for the cover, the image eliminates her hands, legs, and most of her hips. Like the woman who is its subject, the cover is both utterly sufficient and incomplete—even the last fraction of the LIFE logo slips behind Monroe's massed blond curls.

When Halsman literally "cornered" Marilyn to elicit an expression that became her trademark, he exploited every possible cliché while deftly avoiding any explicit representation of the true subject of the picture. For a late-twentieth-century audience, well trained to read the signals of misogyny, this armless, legless, open-mouthed woman wrapped in a clinging white shroud seems like a surreal parody of sensuality. Now, Halsman's innocent description of their mutual pleasure in making the picture seems hard to accept. But Halsman's ability to represent sex by inference, allusion, and symbol won him numerous glamour assignments for LIFE (and sustained the magazine's acknowledged fondness for high-toned cheesecake). Using the euphemistic language of the time, Baird explained that Halsman was well-known for his ability to make "suggestive" pictures of beautiful women that were both subtle and "in good taste." He credited this to Halsman's ability to direct the viewer's gaze to his subjects' faces, emphasizing "expression" rather than "physical assets." Baird added, "Halsman is very adept at provoking the expression he wants." [18]

A Dash of Continental Wit

Every visitor to Halsman's studio remembered his wonderful dry humor. Friends still recount their favorite jokes and funny stories, revealing Halsman's pleasure in language, sharp attention to detail, and his theatrical sense of timing. All these qualities clearly informed his portrait style, from his teasing ability to prod a subject out of self-consciousness to the split-second reflexes he used to secure the right expression. Over the course of three decades, Halsman's ability to portray each sitter as a genuine individual, unlike any other, required enormous energy. It also allowed him to depict Woody Allen and Sammy Davis, Jr., with the same sympathy he extended to Vladimir Nabokov and Humphrey Bogart. Halsman simply could not repress his delight in the comedy of the human condition, and never tired of pointing out that such delight was also deeply absurd.

13. Halsman, "100 Covers," 173.

14. For Halsman's own detailed description of his technique, see "Philippe Halsman on Psychological Portraiture," Popular Photography (December 1958): 119–141, 160–164. Yousuf Karsh also claimed this special approach, as discussed in Estelle Jussim, "The Psychological Portrait," in Karsh: The Art of the Portrait (Ottawa: National Gallery of Canada, 1989), 87–111.

15. Bruce Downes, "On Being photographed by Philippe Halsman," Popular Photography (January 1965): 28; Downes, "Modern Portraiture Number Two," 30; Bruce Downes, "Photography Goes to a Halsman Sitting," Popular Photography (March 1954): 66–72, 106, 108, 110.

16. John Baird, "How Halsman Works," U.S. Camera (July 1953): 101; Downes, "Modern Portraiture Number Two," 58; Chester Burger, "Critic's Choice: How Much Their Eyes Tell Us!," Popular Photography (February 1967): 107.

17. Philippe Halsman, "Shooting Marilyn," Popular Photography 32 (June 1953): 66–71.

18. Baird, "How Philippe Halsman Works," 63–66, 100–102.

For many years, the Halsmans printed elaborate jokey Christmas cards—Philippe and Yvonne race down the steps of the Metropolitan with the Mona Lisa under their arms (though the mysterious woman uncannily resembles Philippe); Santa Claus "holds up" the entire family (thus explaining the cards' late arrival); Philippe sails out of a cannon while Yvonne lights the fuse. Homemade cards were common among the artists and photographers they knew, the sign of a world where work and family and friendship combined. Together, jokes and artifacts give us fleeting evidence of an old-fashioned style of sociability that seems distant today. Halsman's wit nearly eludes the historian, as his indirect irony often caught his audience off guard. But once we learn to see it, humor stands as a distinctive aspect of his work, filling every frame with genuine warmth and affection.

Jumpology

In 1950, the art director at NBC asked Halsman to create a bank of all-purpose images of their many popular comedians. The open assignment became an opportunity to collaborate with a now-legendary group of performers, including Milton Berle, Ed Wynn, Sid Caeser, Imogene Coca, Fred Allen, Groucho Marx, and Bob Hope. Halsman began each session by making a traditional large-format portrait, then switched to the small, versatile Rollei camera to record his subject in action. His assistant recalled shooting jumps, headstands, "and anything else we could imagine. He often shot two and three hundred pictures. People like Red Skelton are hard to stop once they start clowning." [19] As Halsman compared these antic images with more traditional ones, he found that each of the comedians had jumped in character.

Desperation (and good humor) finally drove him to ask others to jump for his camera when he tried to make an official photograph of the Ford family to mark the automobile company's fiftieth anniversary. He was having little luck with "9 bubbling adults, and 11 crying children and babies," until he politely asked matriarch Mrs. Edsel Ford, "a grandmother and owner of innumerable millions of dollars, 'May I take a picture of you jumping?'" The astonished Mrs. Ford replied, "You want me to jump with my high heels?" Next, her daughter-in-law Mrs. Henry Ford II requested her turn.[20]

The resulting images had surprising charm, and over the next six years, Halsman asked many clients to jump for him. (Though one magazine hired him to photograph Eleanor Roosevelt with the request that she stay on the ground.) Van Cliburn, Edward R. Murrow, and Herbert Hoover declined Halsman's invitation. A very few others did not release the pictures for publication. But most people realized they had nothing to lose. (Some gained considerably, like the suddenly buoyant and likeable Richard Nixon.)

In 1959, Halsman assembled his many "jump" pictures into a book. Nearly all the subjects were well-known, powerful public figures, politicians, executives, and movie stars whom one would never otherwise see off guard. Halsman claimed the jumps revealed character. "When you ask a person to jump, his attention is mostly directed toward the act of jumping and the mask falls so that the real person appears." [21] His text offered a mock-scientific reading of the positions in which the jumpers held their arms, legs, hands, and feet. In many ways, these images remained both controlled and highly considerate of the subjects.

Halsman pursued this collection to learn about his subjects, and to discover something about himself. "I assure you that often, before approaching the person, my heart would beat, and I would have to fight down all my inhibitions in order to address this request to my subject. At every time when the subject agreed to jump, it was for me like a kind of victory." [22] Today, we wonder how so many could agree to abandon their composure for his camera. Halsman managed to convince each one that the risk was all his own.

Like many who escaped Hitler's Europe, Philippe Halsman rarely discussed the past. He rightly insisted that his most important work took place in America, and in many ways that place of refuge itself became his subject. Even contemporaries noted his patriotic flair. In one typical review, T. J. Maloney, editor of the *U.S. Camera Annual,* praised Halsman's "unsanctimonious and immensely intense portrayal of American bounce." [23] From a historian's perspective it seems clear that Philippe Halsman invented a glowing image of the nation as he saw it, using light, persuasion, nerve, imagination, psychology, and experience. This place and these faces are his creation.

At the end of his career Halsman explained, "This fascination with the human face has never left me....Every face I see seems to hide—and sometimes, fleetingly, to reveal—the mystery of another human being....Capturing this revelation became the goal and passion of my life." [24] Halsman's perpetual quest for hidden truth recalls his own private mystery, which he never openly discussed. Imprisoned for a crime he did not commit, Halsman experienced an ordeal that ended only when the world forced his jailers to recognize his innocence and he was set free. Halsman knew that the effort to establish one's identity had significance far beyond the needs of the celebrity marketplace. With that larger mission in mind, he strove to make records of individual character that defied distortion and could never be misunderstood.

The origins of Halsman's style reside in his early political experience, which inspired a perpetual need to seek the truth in himself and in others. But the real significance of his work comes from the way he responded to the opportunity he found in America. Like many artists of his generation, Halsman worked within the tradition of surrealism. Along with Wilfredo Lam, Salvador Dali, and Marc Chagall, Halsman found a way to suggest that another layer of meaning, dreamlike and real, lay just beneath the surface of everyday experience. Most used this insight to shock or disturb viewers. Halsman understood that the same strategy could provide great pleasure.

MARY PANZER
Curator of Photographs
National Portrait Gallery, Smithsonian Institution
Washington, D.C.
January 1998

19. Baird, "How Philippe Halsman Works," 100.

20. Philippe Halsman, *Philippe Halsman's Jump Book* (1959; reprinted New York: Harry N. Abrams, 1986), 9.

21. Halsman, *Jump Book,* 8.

22. Ruth Spencer, "Philippe Halsman," *British Journal of Photography* (10 October 1975): 919.

23. T. J. Maloney, "American Photography," *U.S. Camera Annual* 1950, 159.

24. Quoted in Howard Chapnick, *Truth Needs No Ally* (Columbia and London: University of Missouri Press, 1994), 274.

PHILIPPE HALSMAN : A RETROSPECTIVE

AUDREY Hepburn 1955

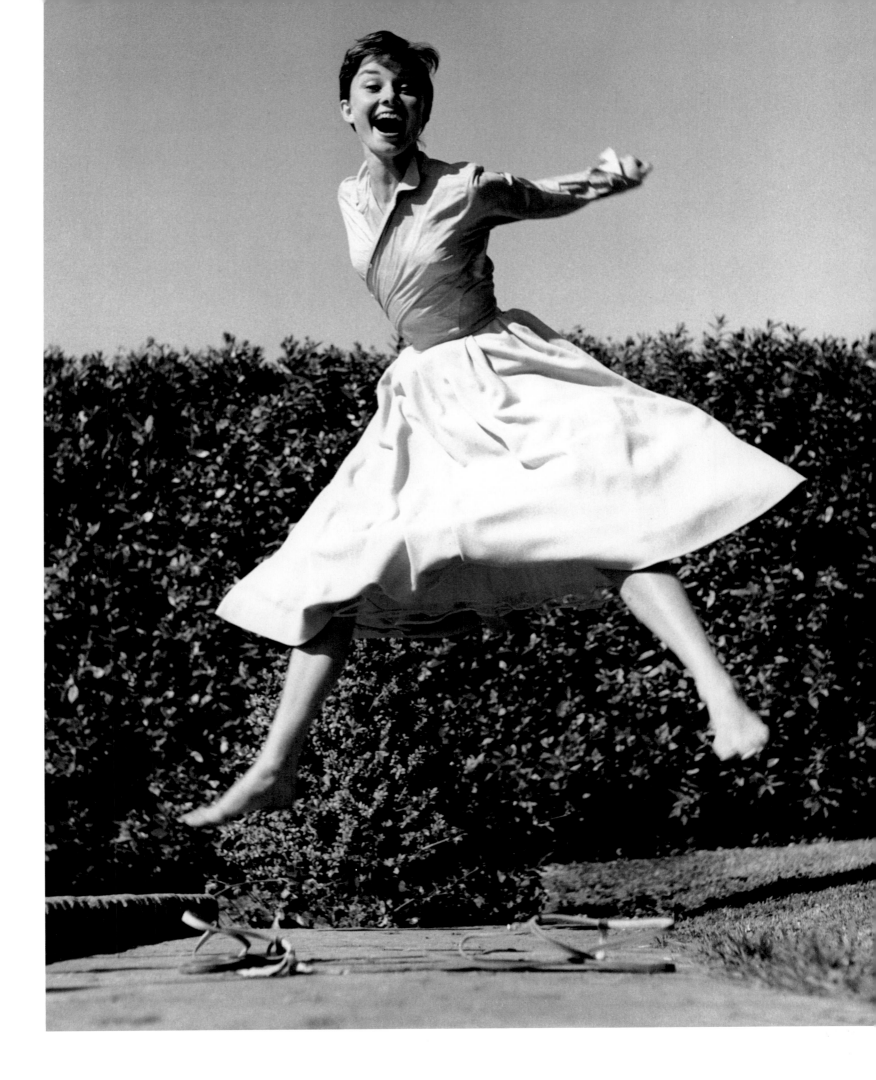

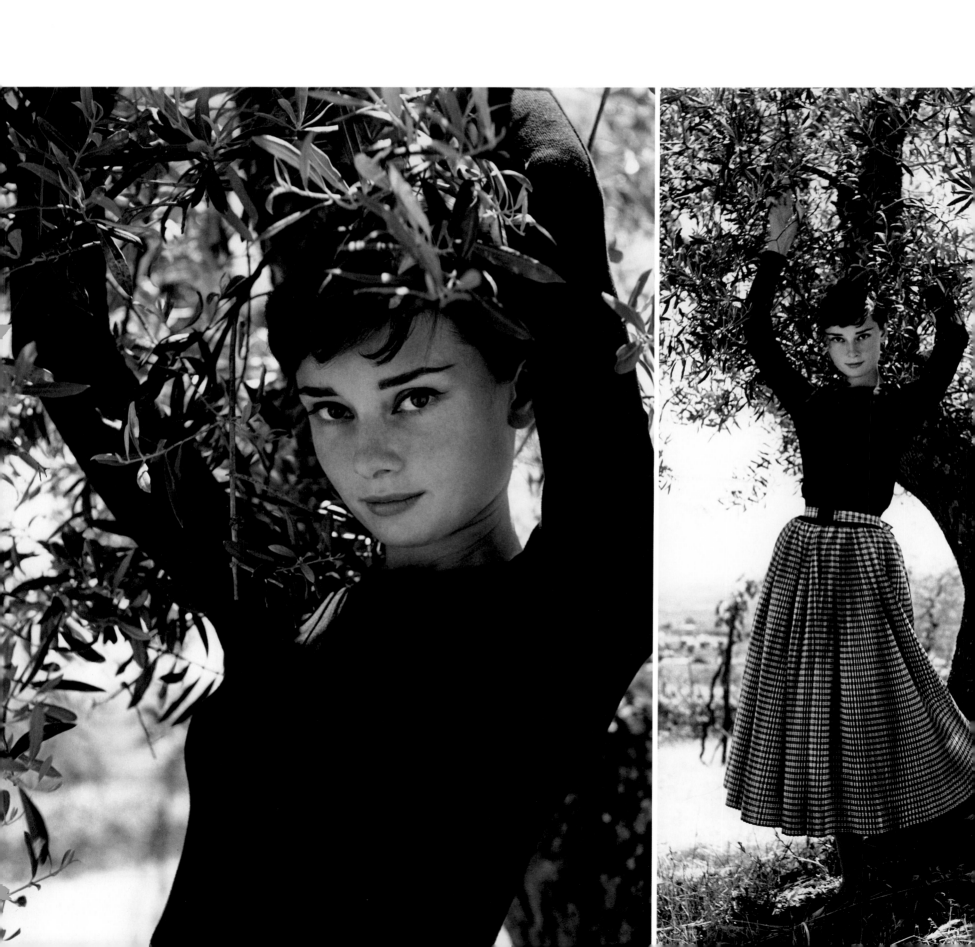

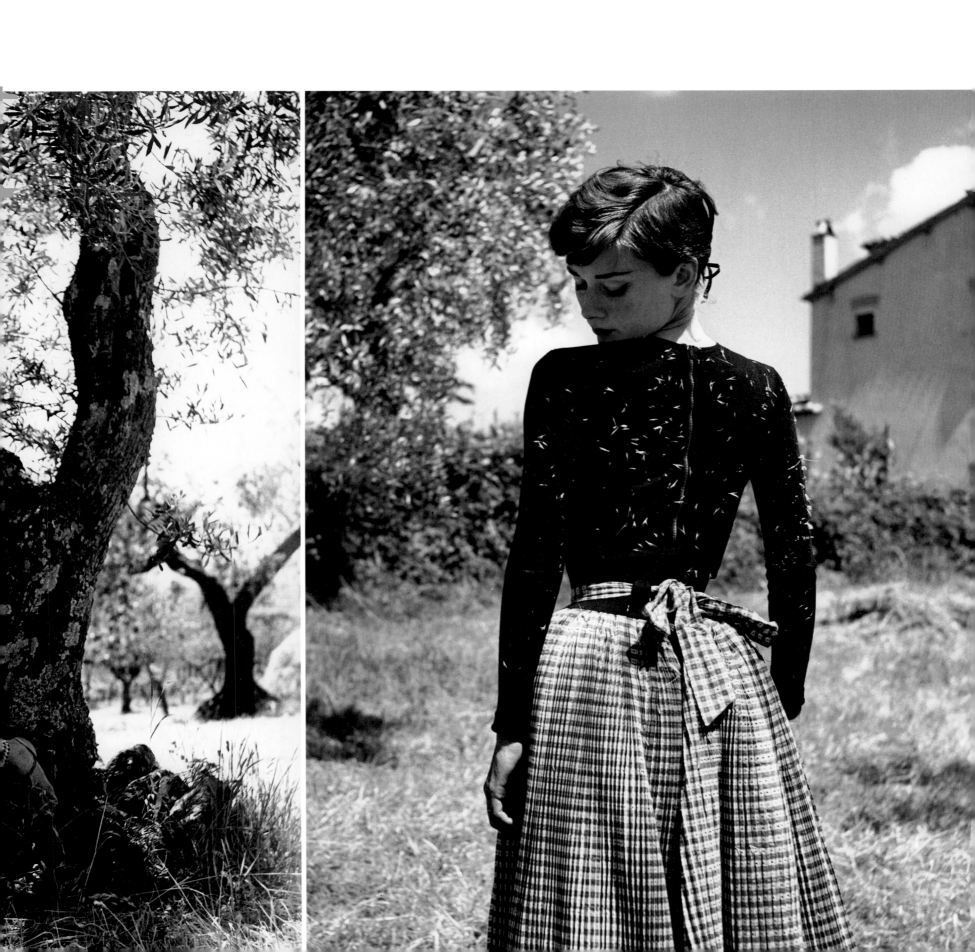

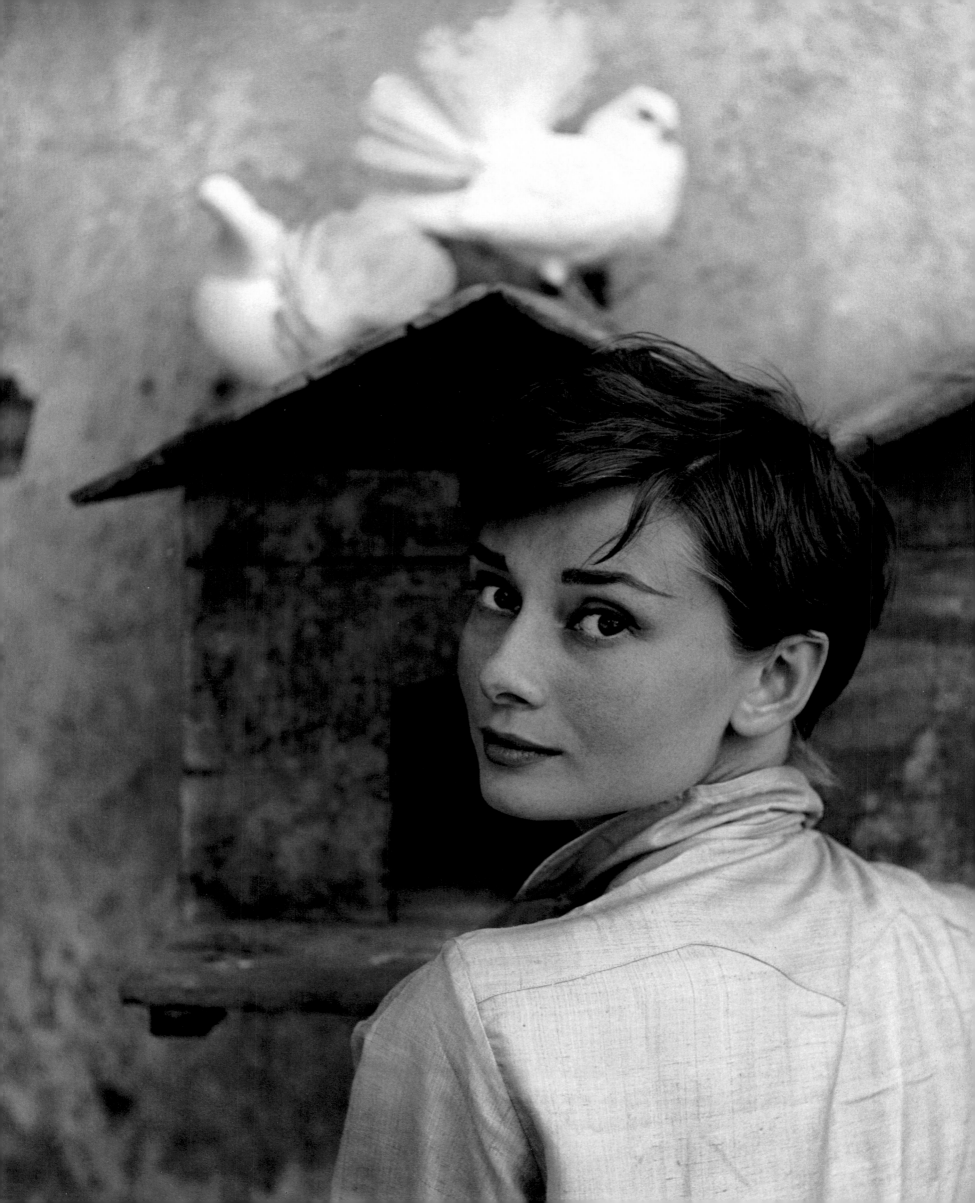

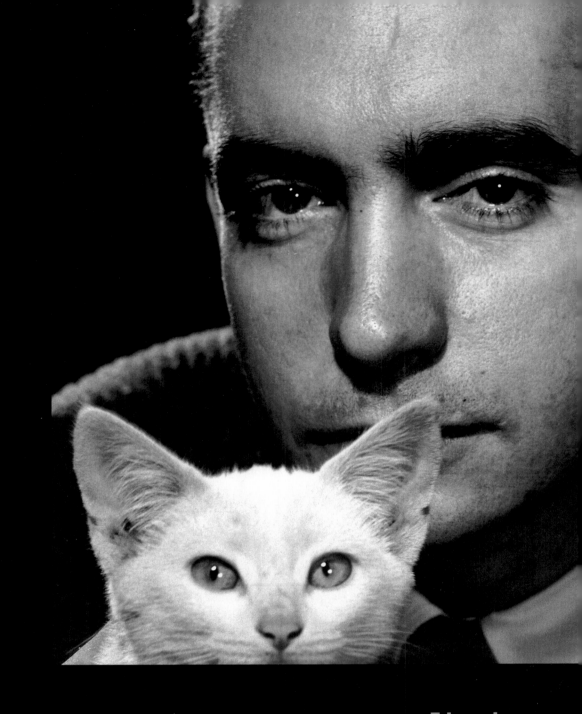

Edward
ALBEE
1961

Marian
ANDERSON
1945

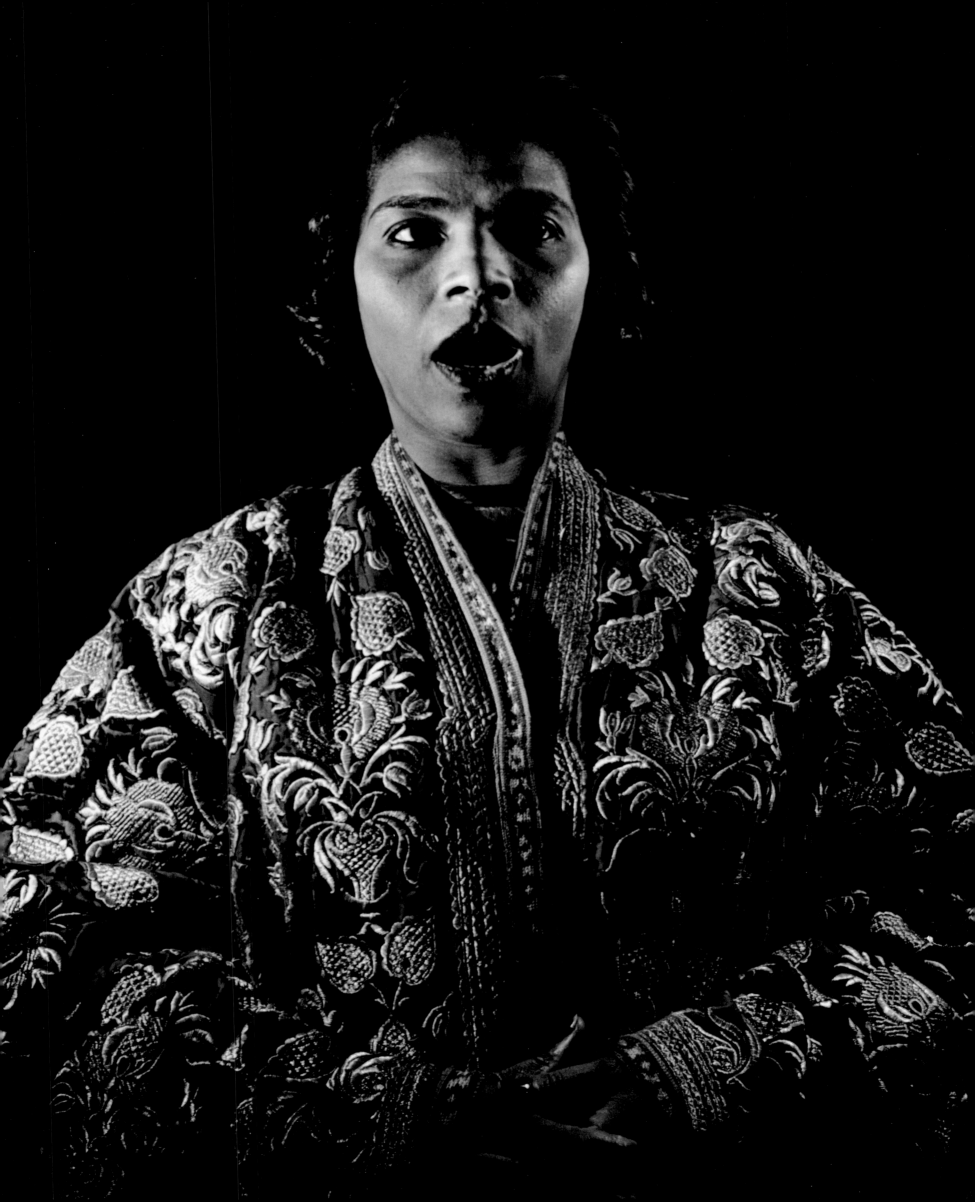

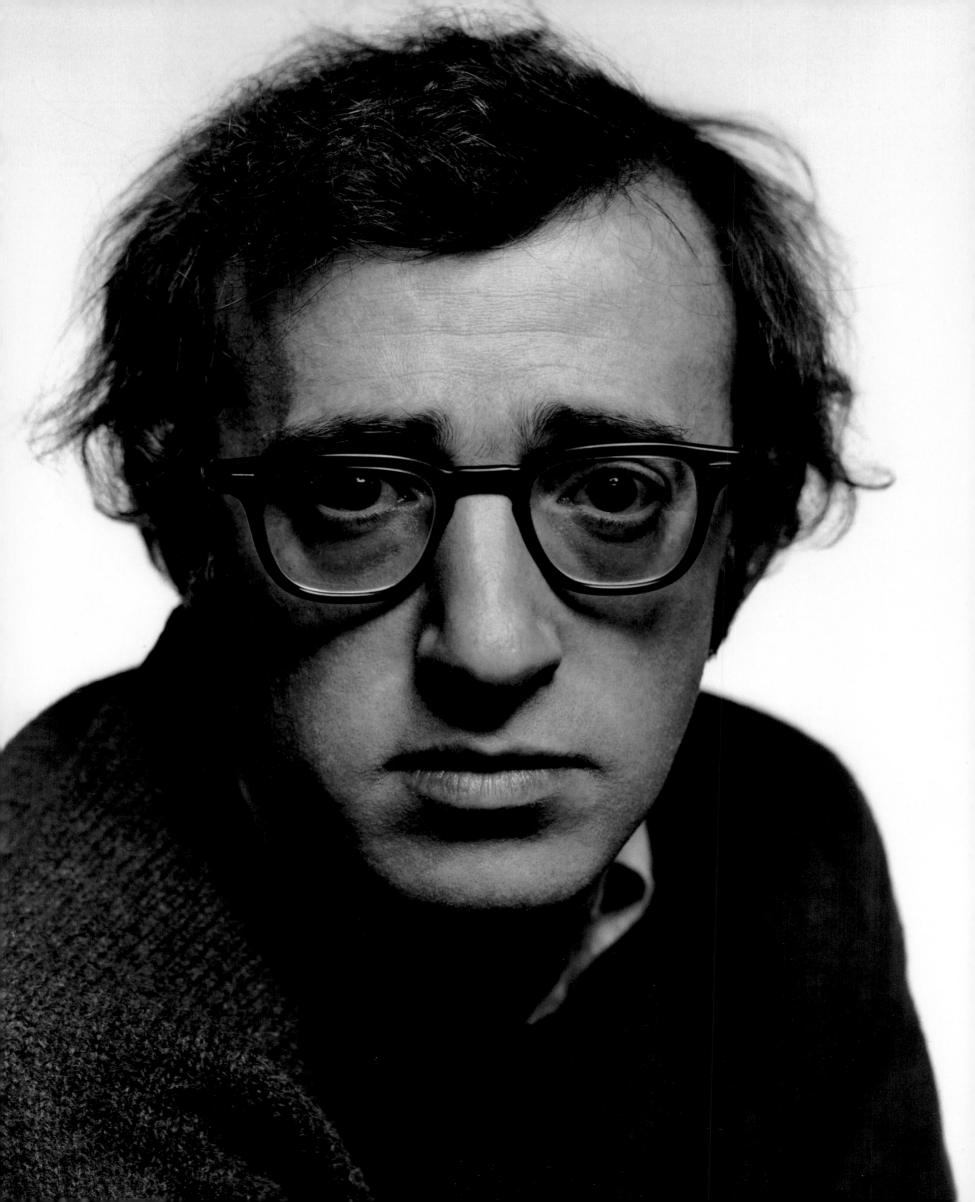

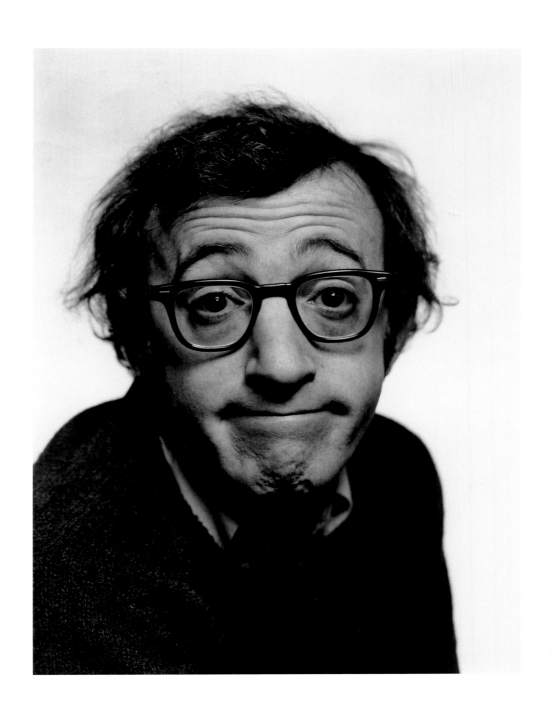

Woody ALLEN
1969

B

Marlon BRANDO
1950

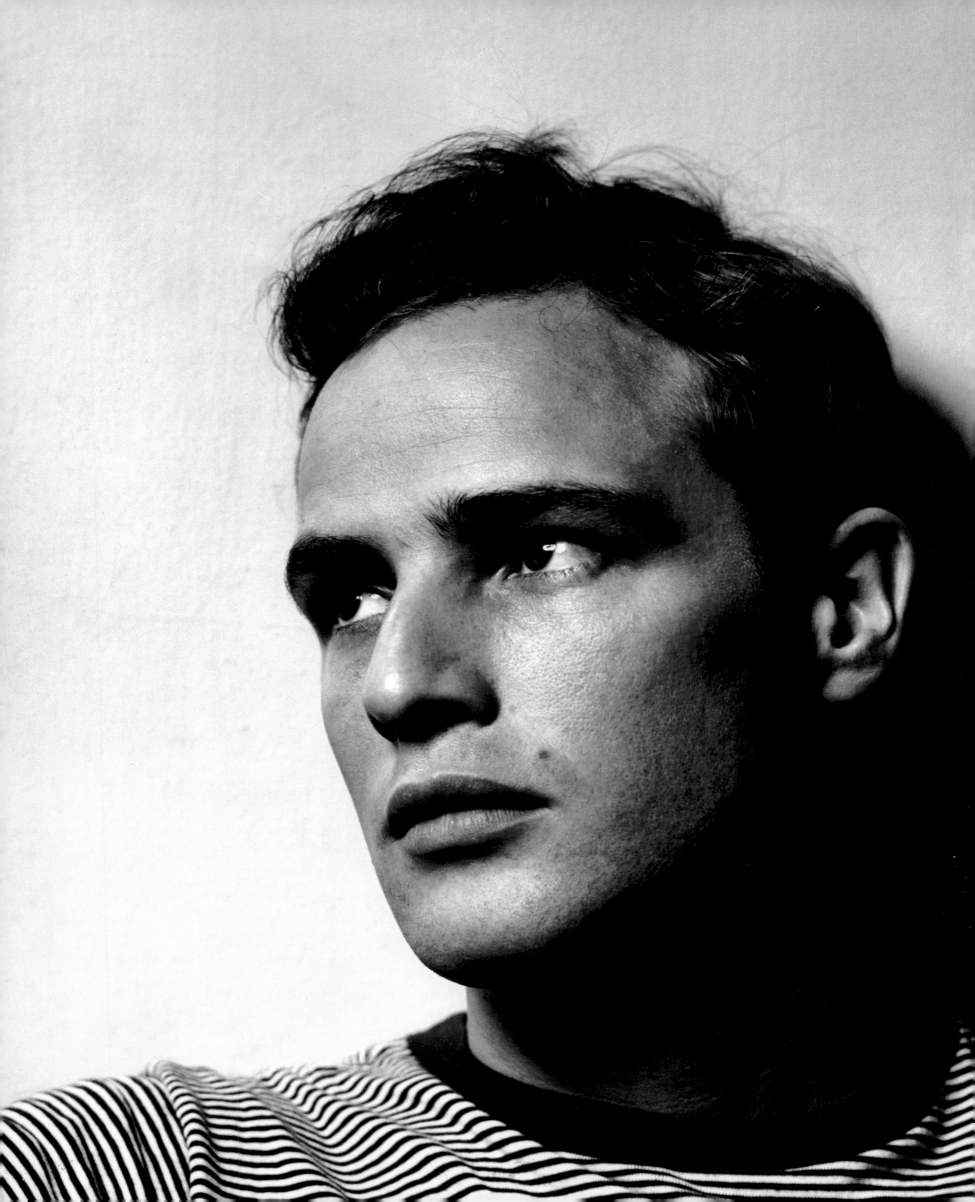

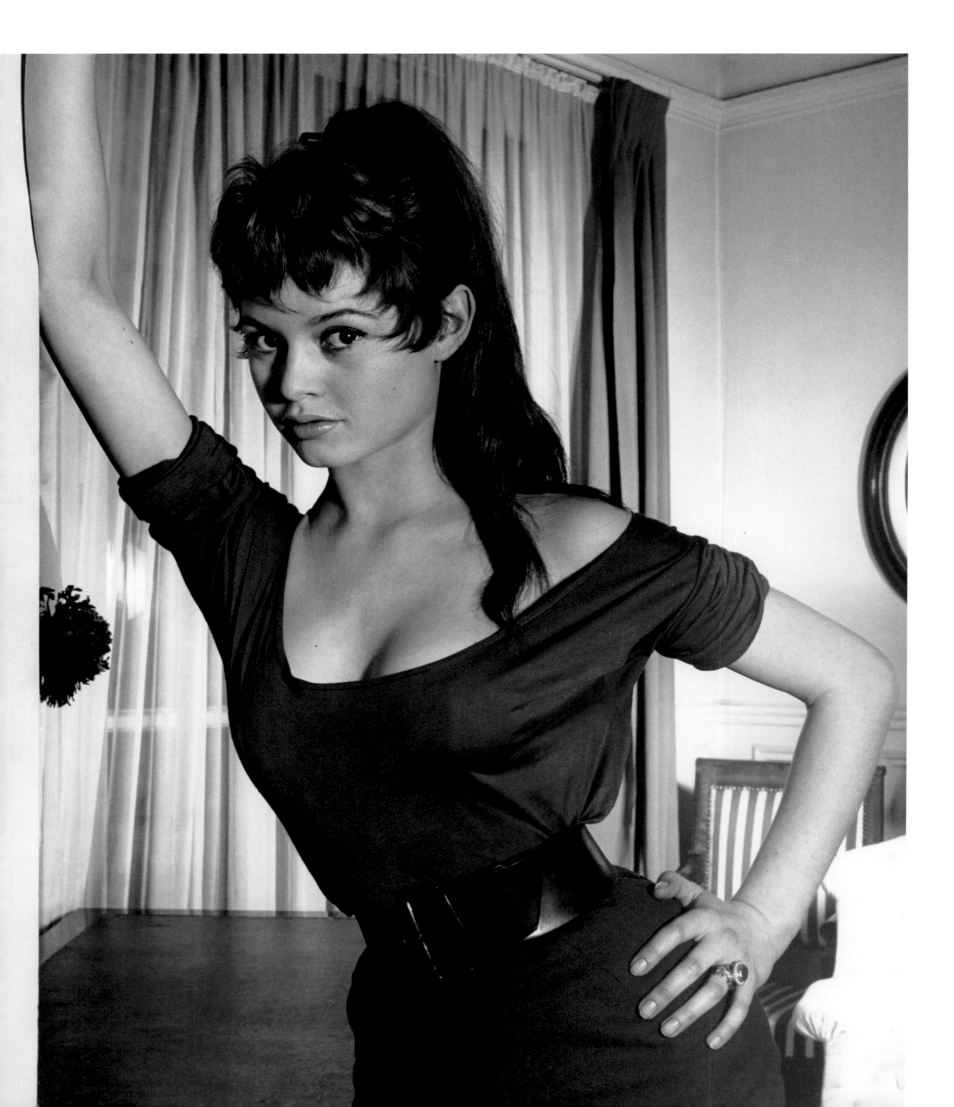

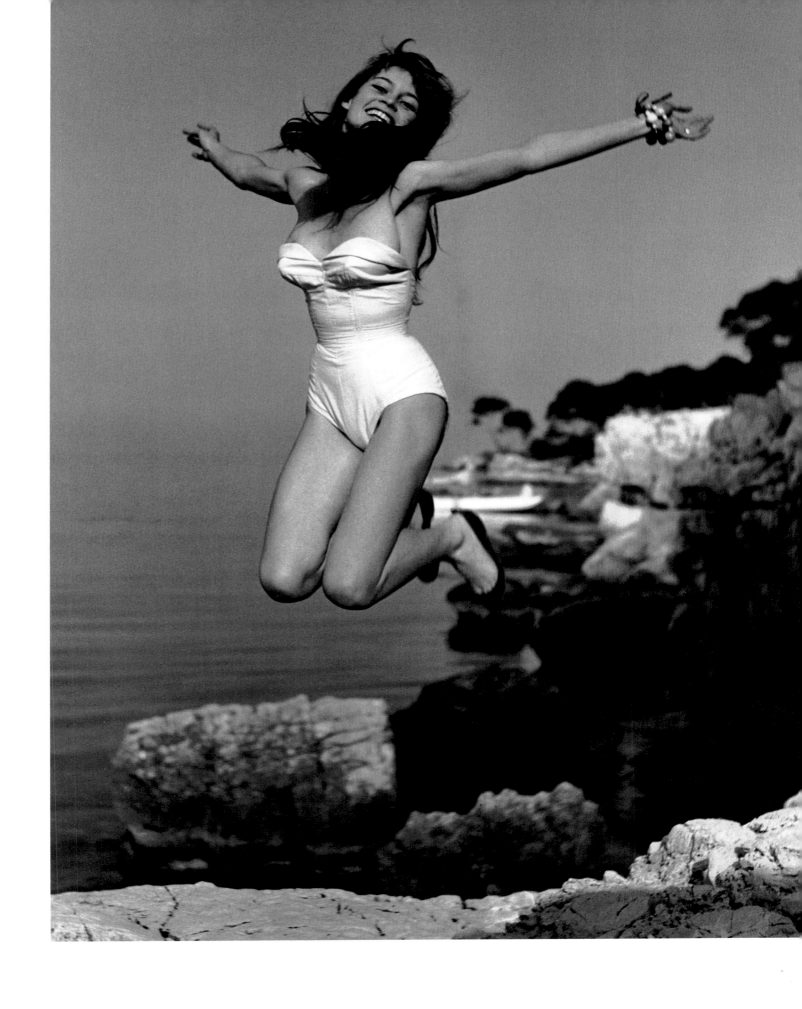

Brigitte **BARDOT**
1951, 1955

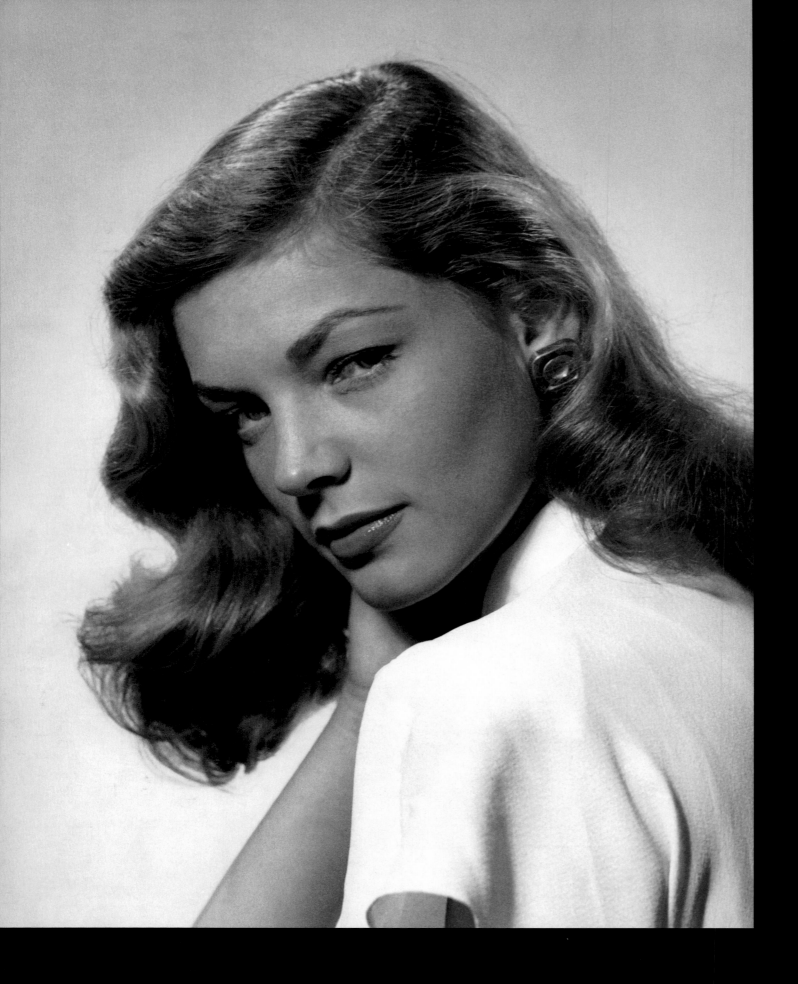

BACALL BOGART
1944 1944

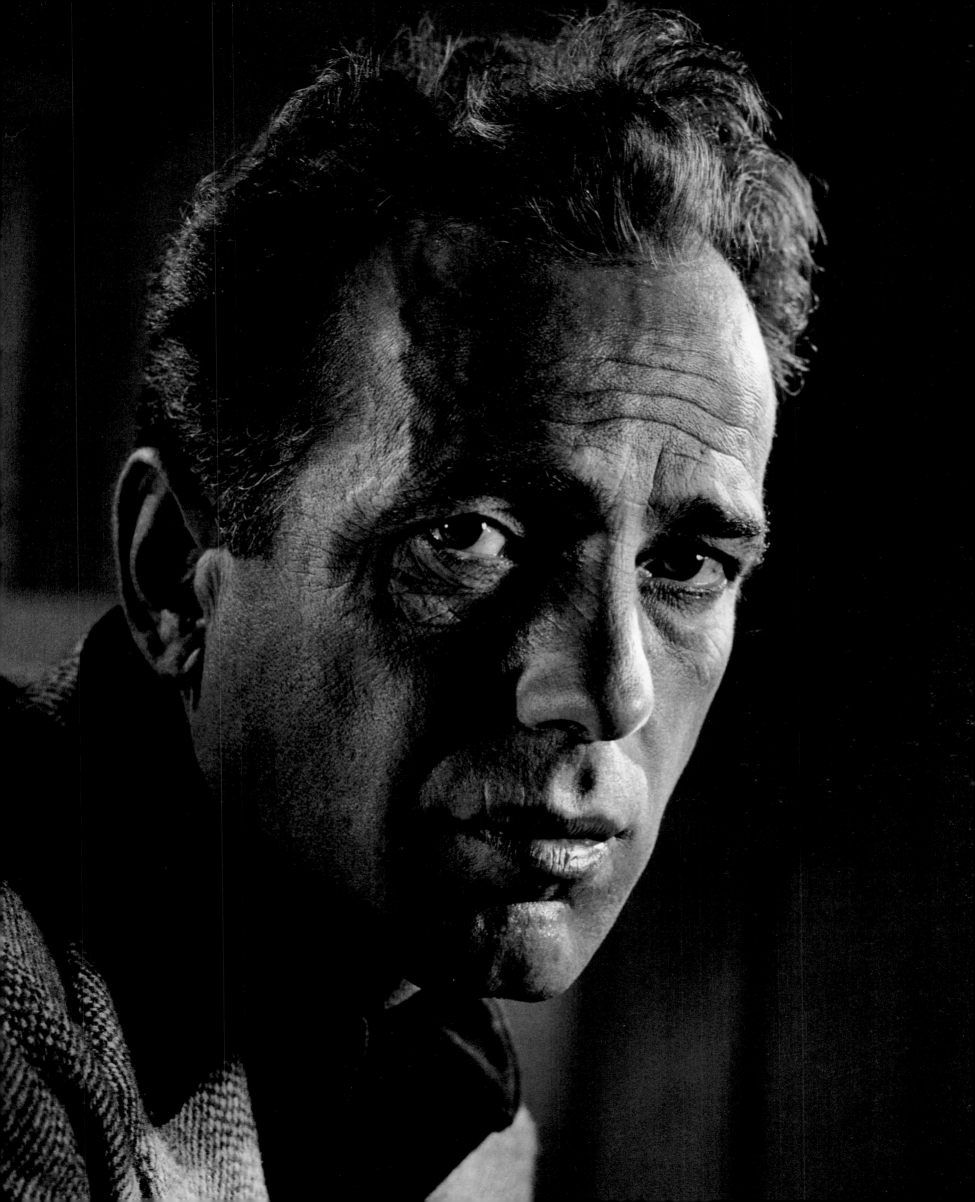

Joan BAEZ
1967

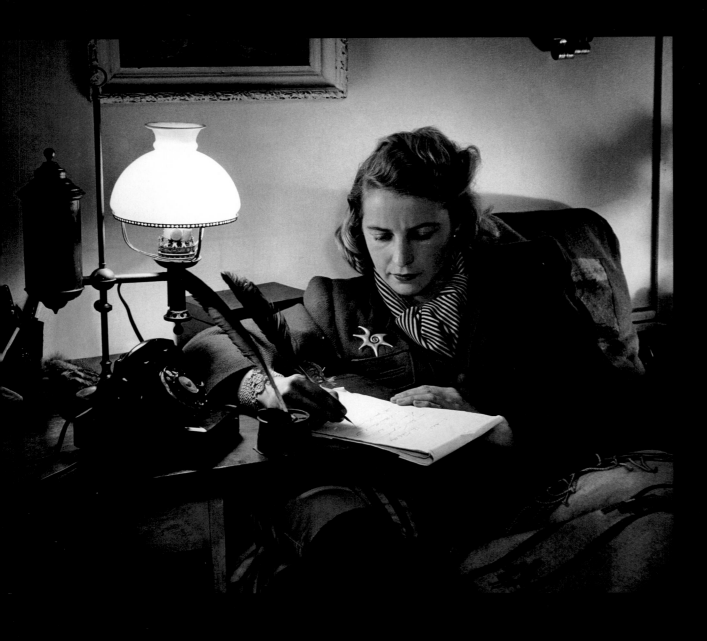

Margaret Wise BROWN
1946

William F. BUCKLEY, Jr.
1967

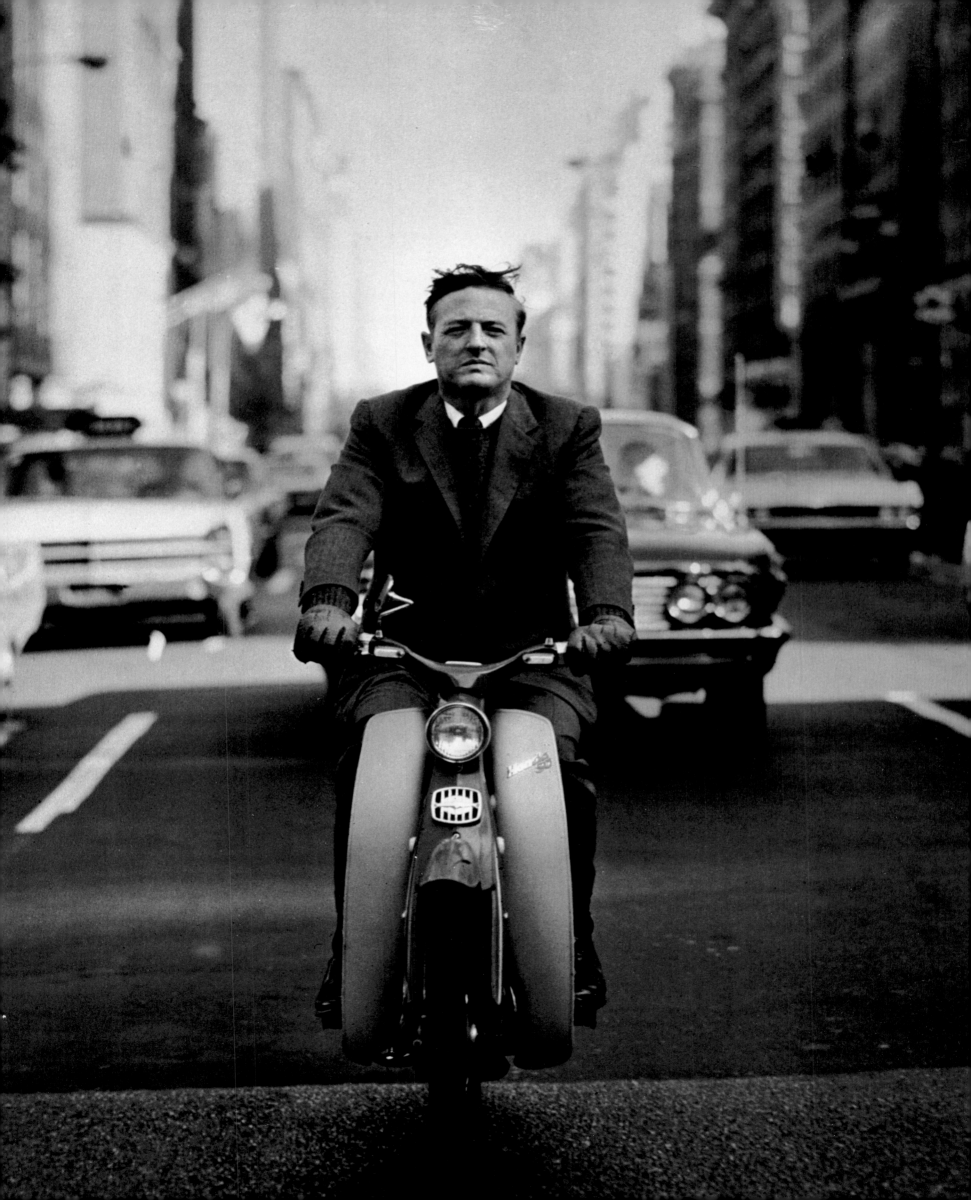

Lucille BALL
1950

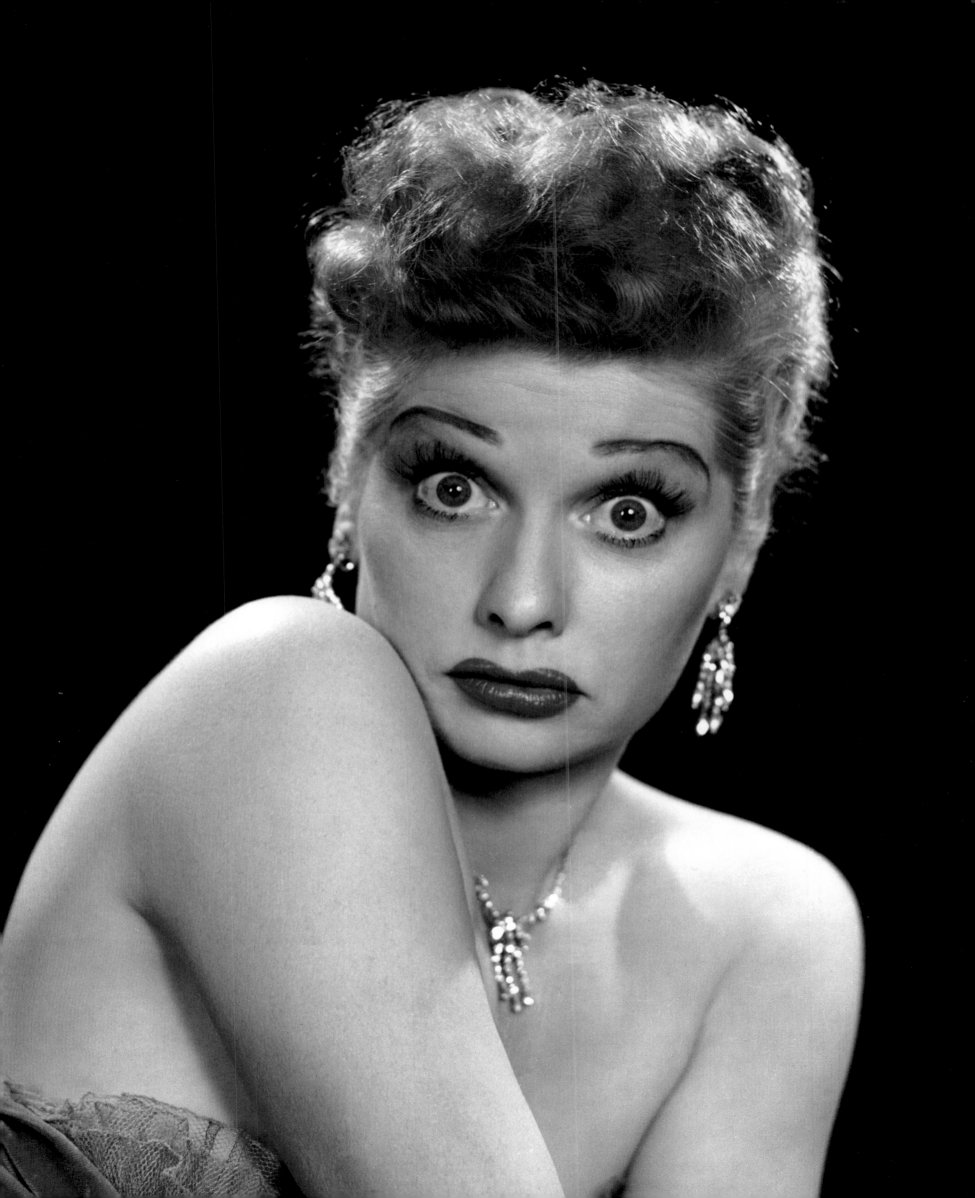

C

Winston CHURCHILL
1951

In his garden at Chartwell, Churchill struck a rather brisk pace. I had to hurry to get ahead of him in order to have a good view of his face. The old boy noticed it, and suddenly his competitive instinct awoke. Since I was on his right, he turned and walked to his left. I hurried and appeared on his left. Churchill immediately turned to his right. He continued playing this cat-and-mouse game, which he obviously enjoyed more than I. Eventually he reached the edge of the garden and sat down on a small rock. His poodle Rufus installed himself behind Churchill's back.

Churchill sat looking at the beautiful, typically English rolling landscape in front of him. I knew that if I emerged and faced him, Churchill would turn away. I quietly selected my position and shot Churchill's back.

Of the close-ups I had made earlier that day, one was used by Churchill on the jacket of his book as well as by *LIFE* on its cover. However, the most successful of all my photographs of Churchill turned out to be the view of his back, which I had shot almost out of desperation.

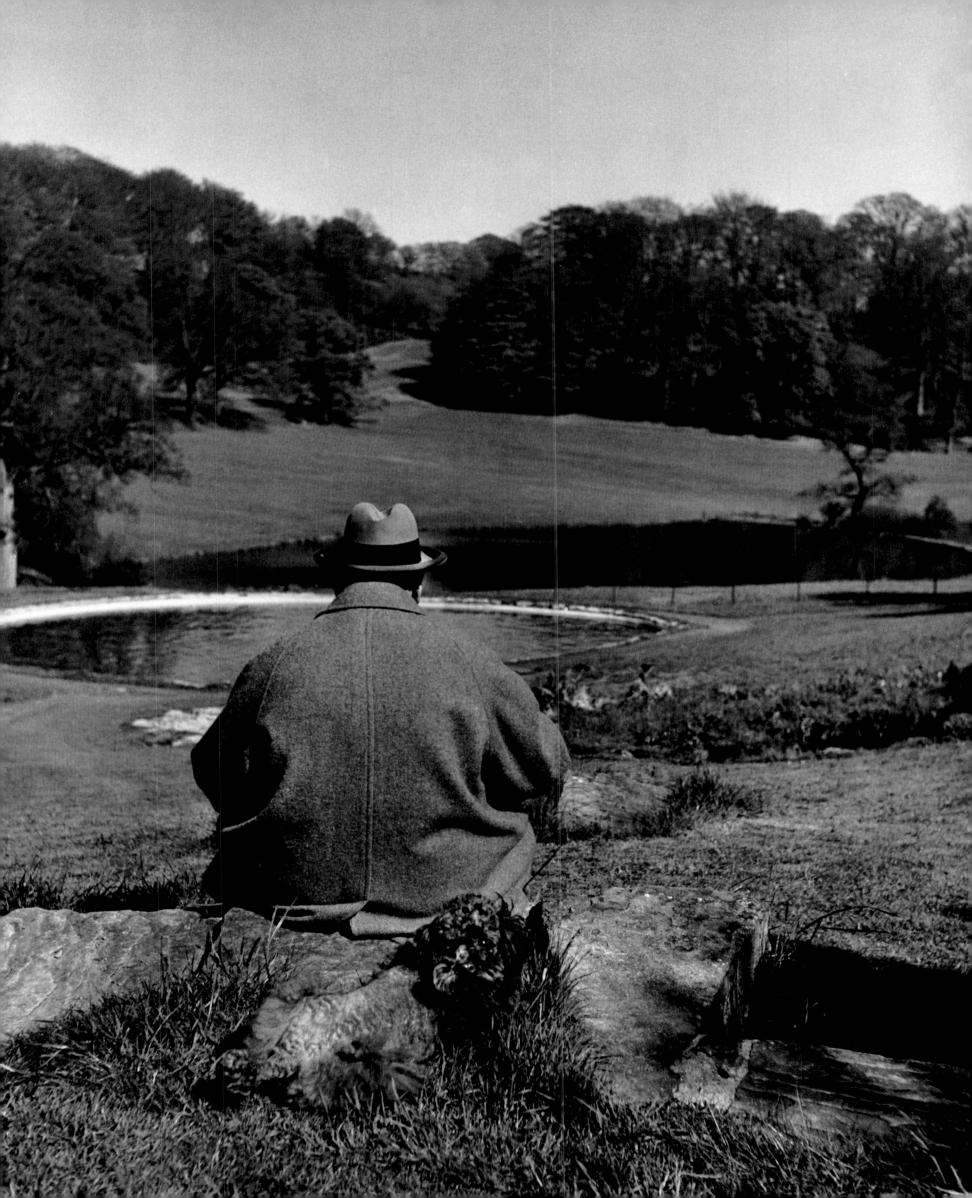

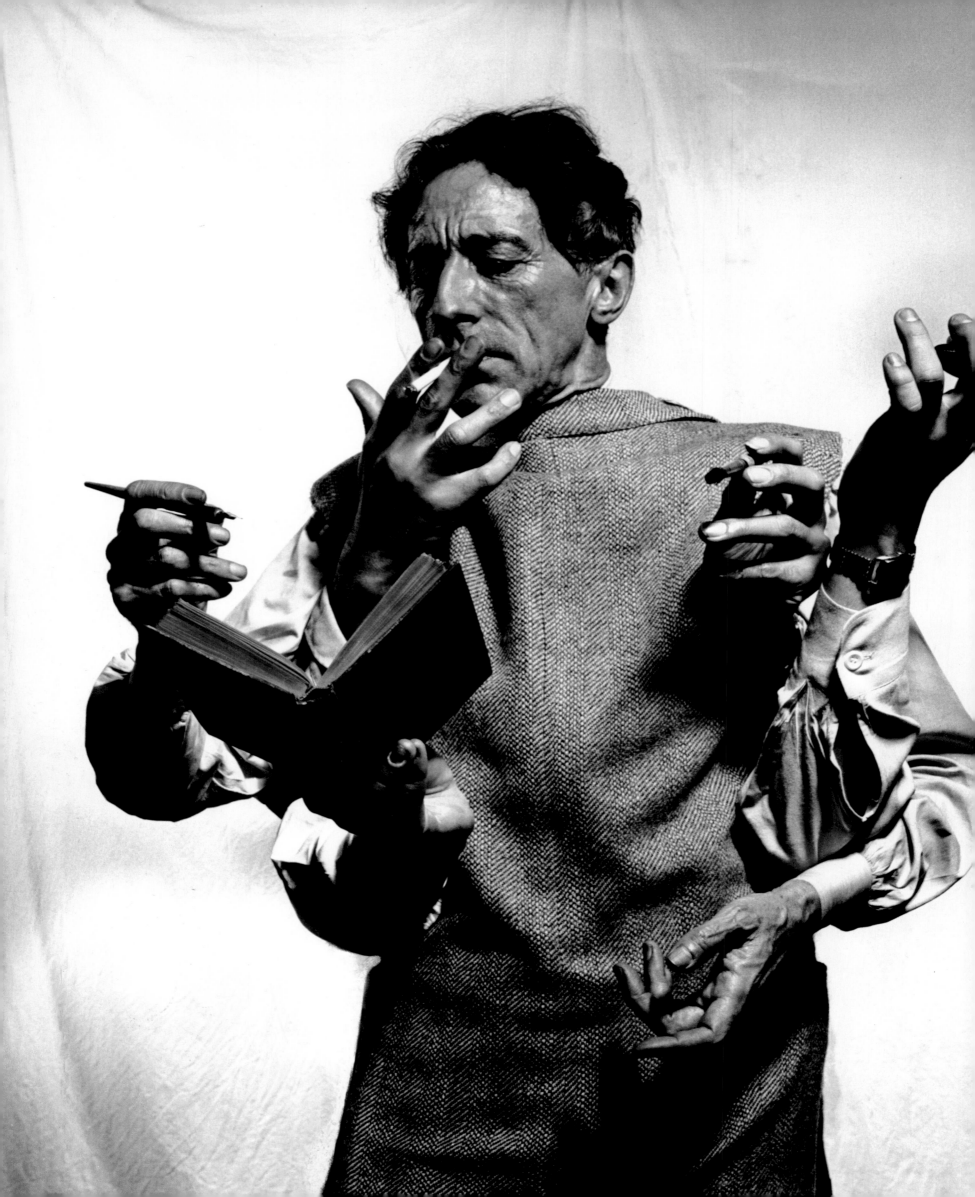

Jean
COCTEAU 1949

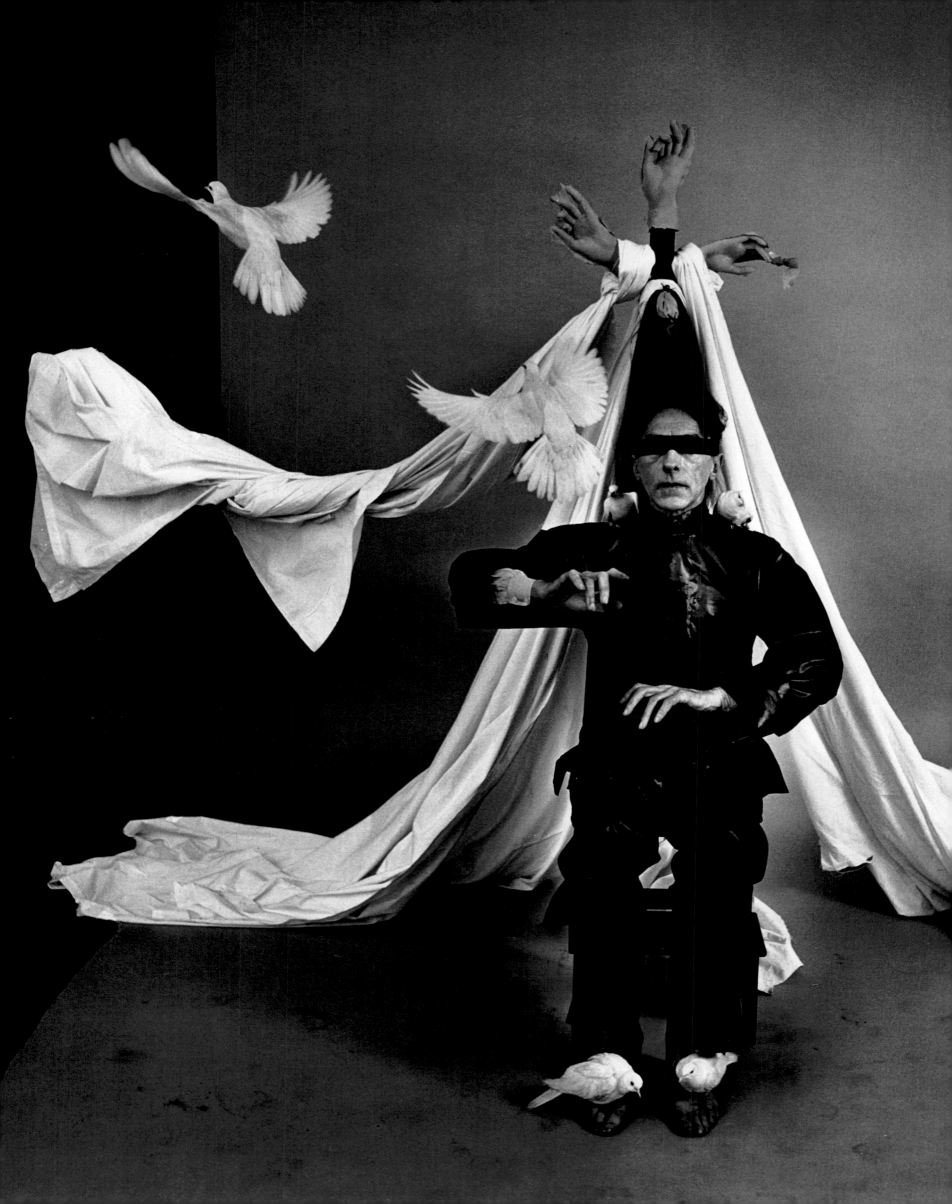

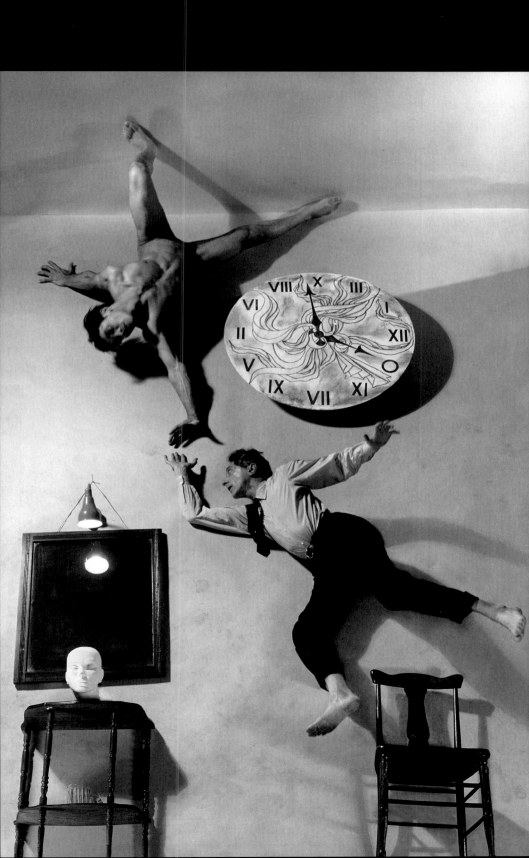

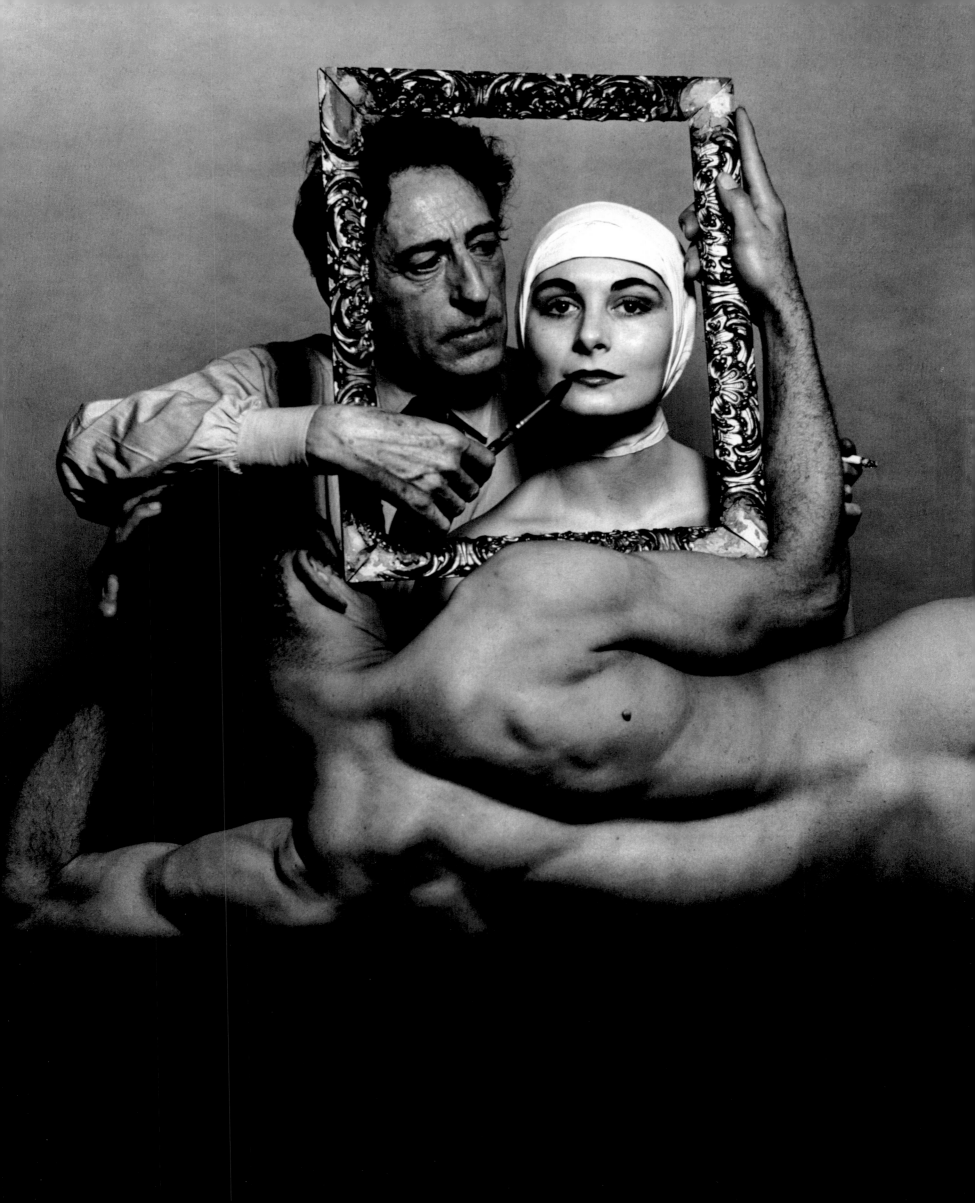

Hattie **CARNEGIE**
1944

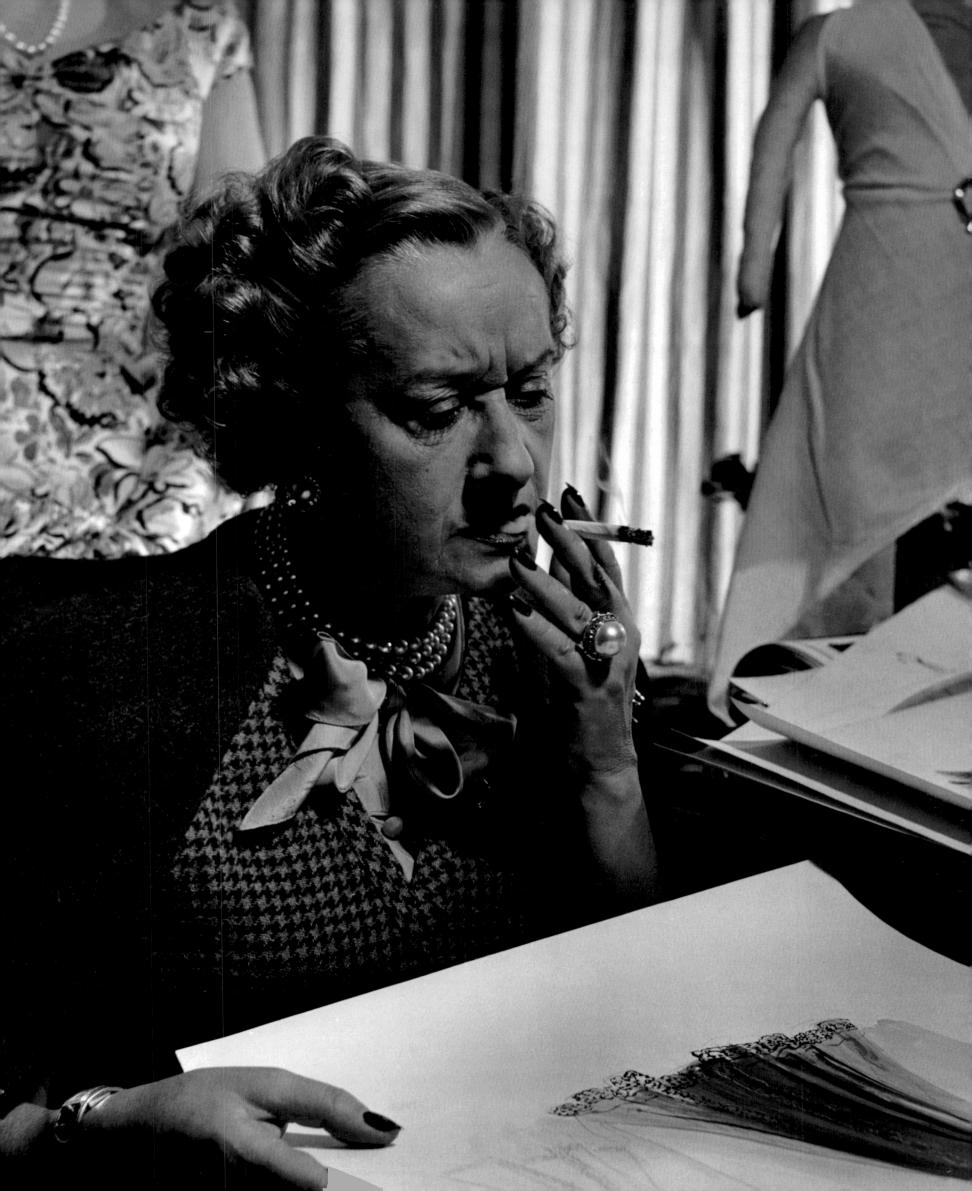

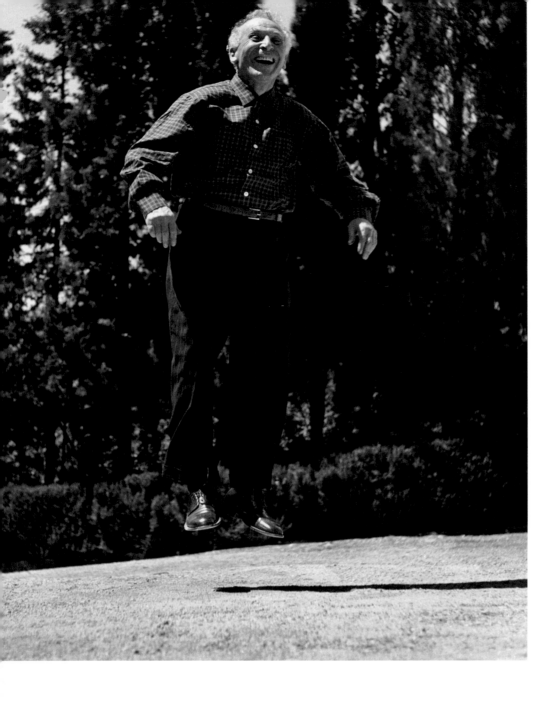

Marc CHAGALL
1955, 1935

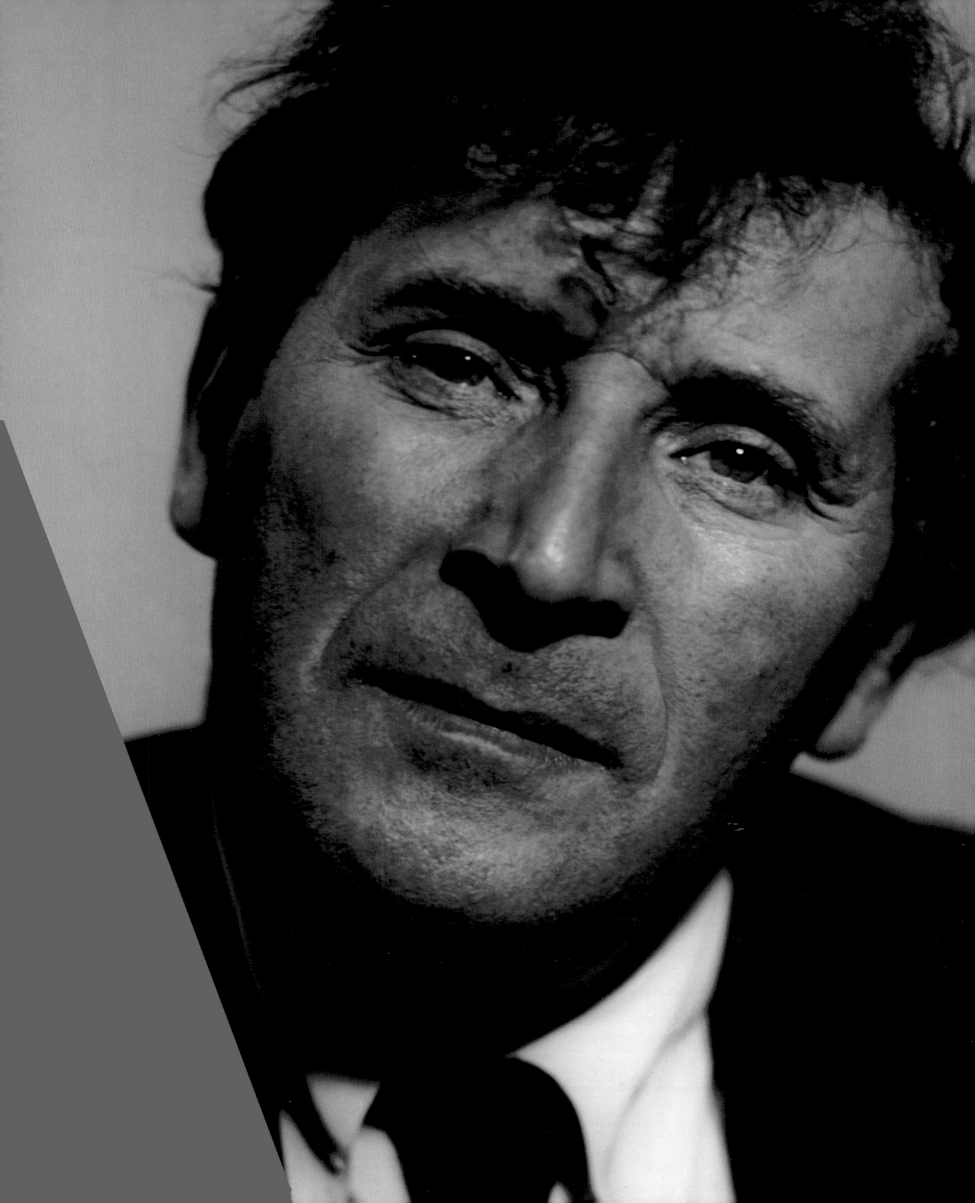

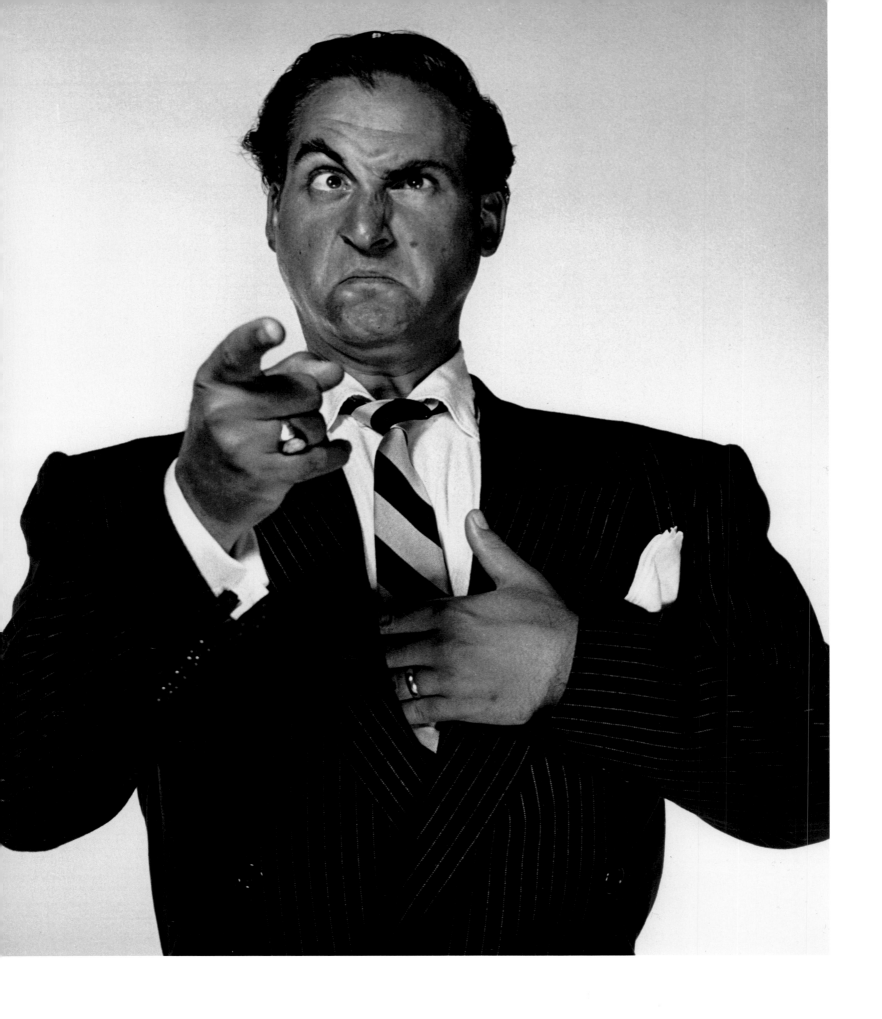

COMEDIANS Sid Caesar
 1950

Fred Allen Red Skelton
1950 **1952**

Bobby Clark Ed Wynn
1950 **1950**

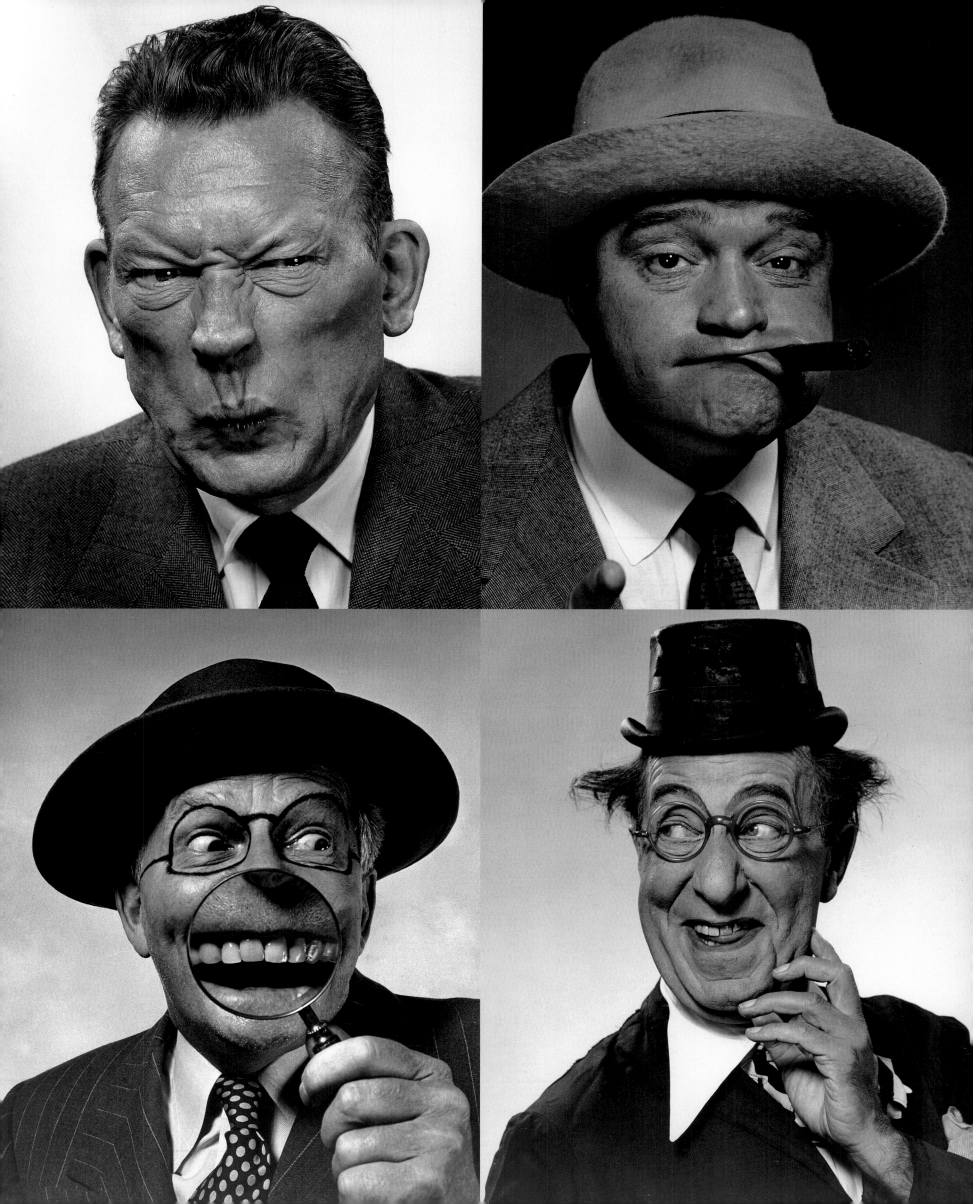

Salvador DALI 1953

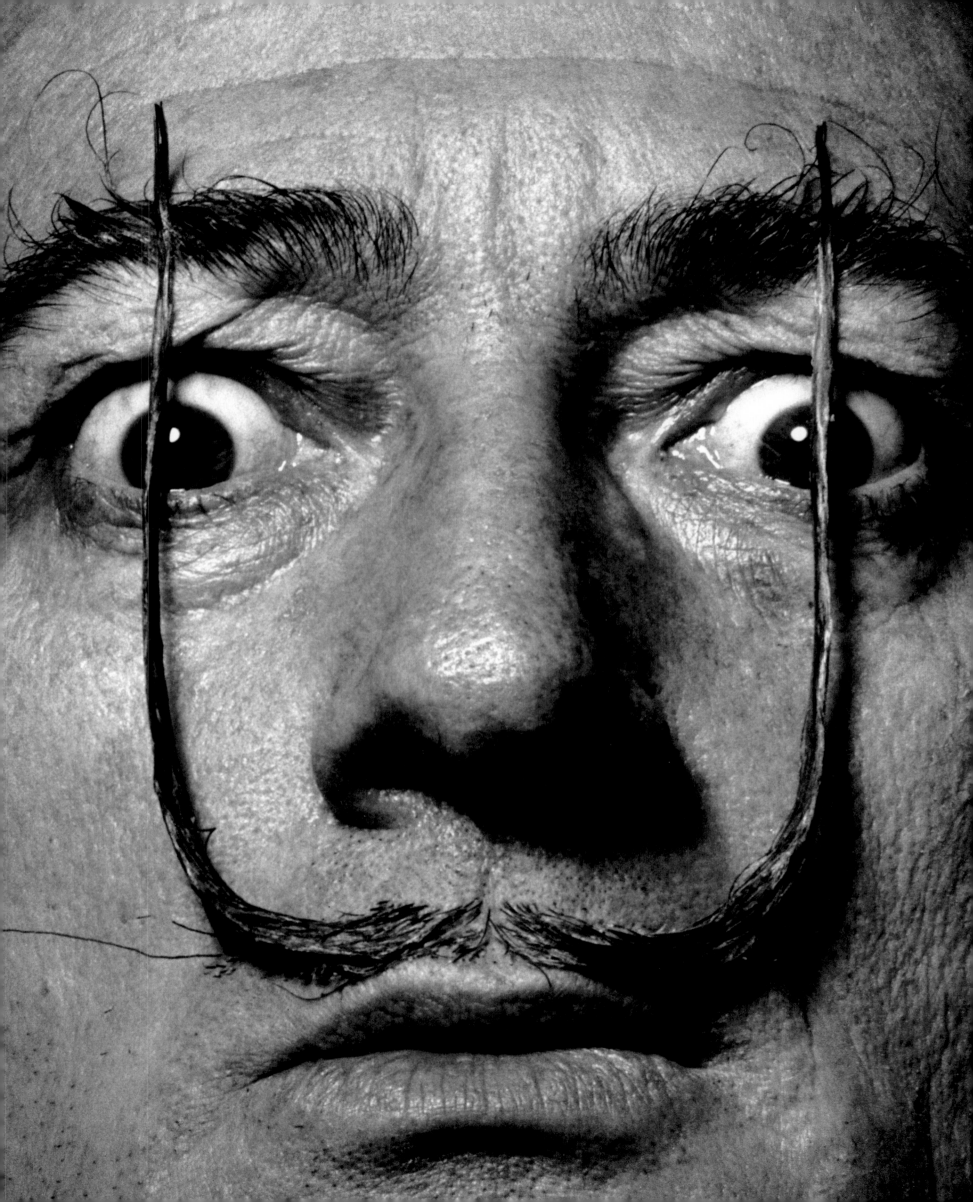

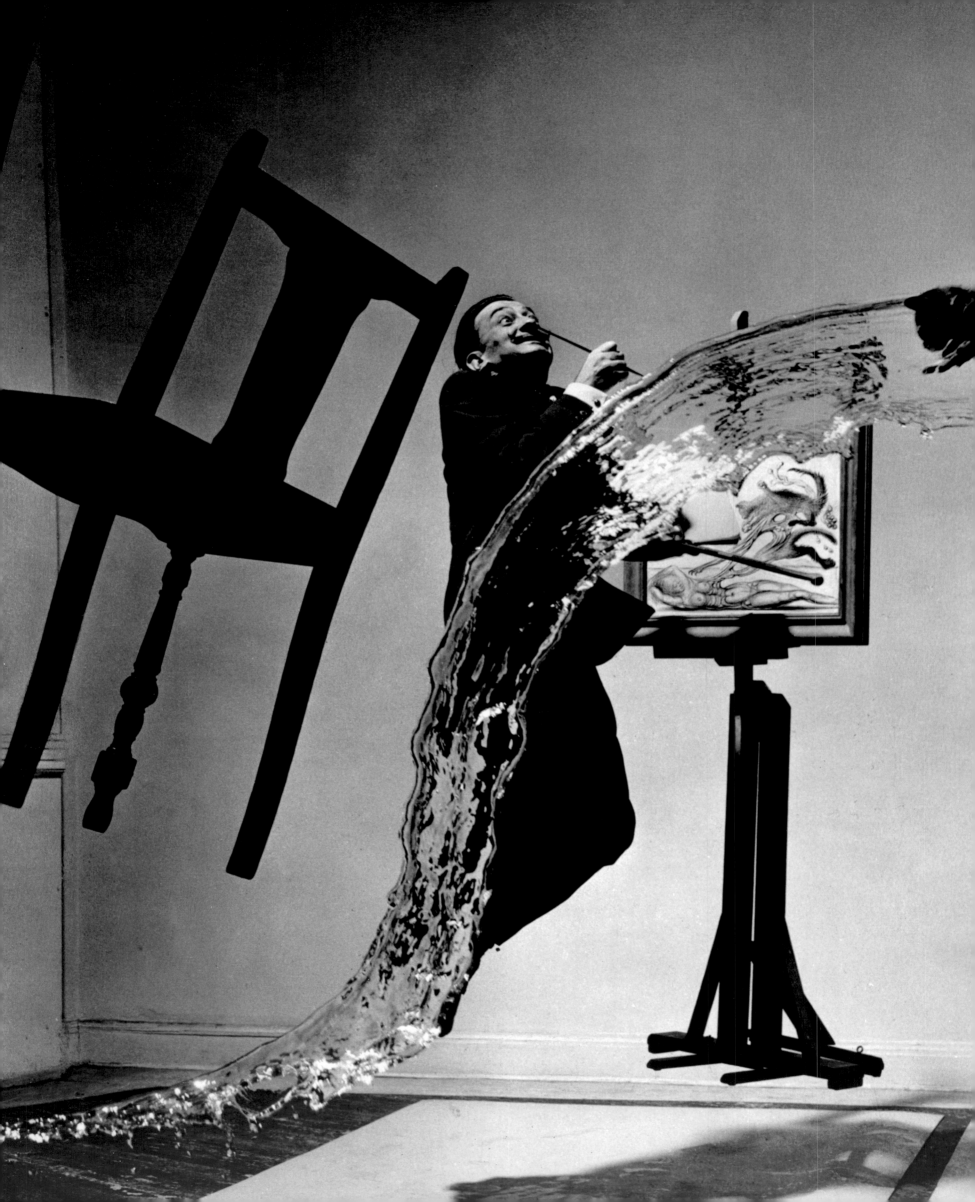

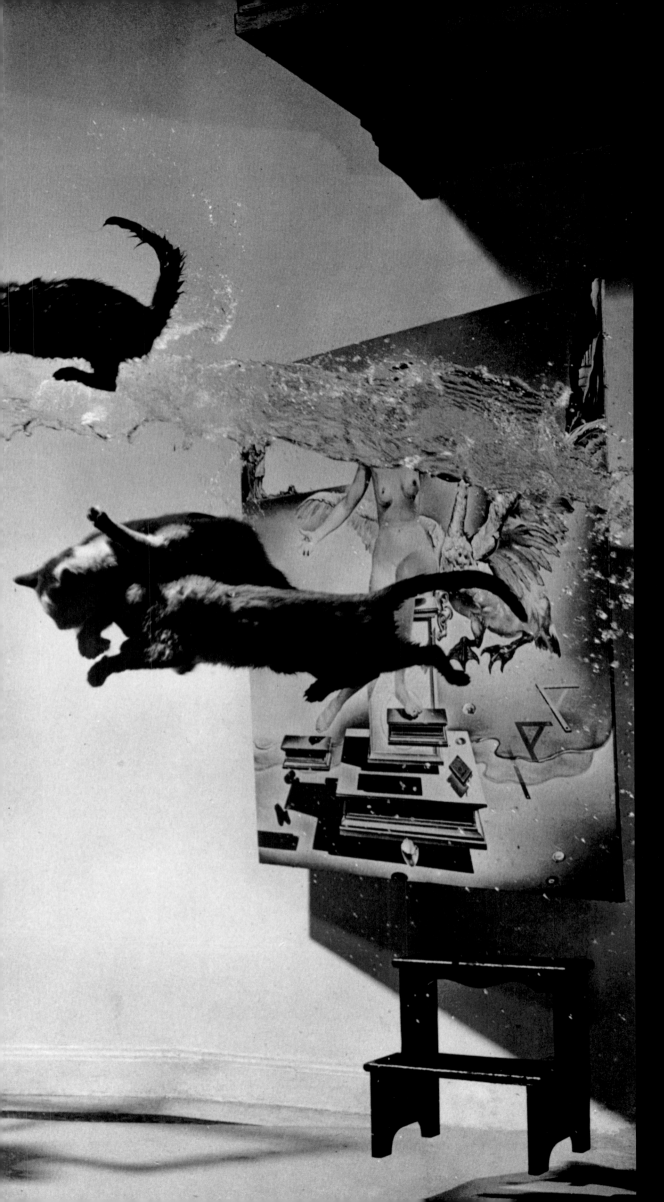

Dali Atomicus
1948

Dali was always known for his antics, without needing the help of my camera. However, he recognized in me a kindred soul the first time I approached him. I had read in the first chapter of his autobiography that he remembered his prenatal life. So I came to Dali and suggested that I'd like to photograph him as an embryo, and then I would superimpose the picture onto an egg. He immediately liked the idea and said, "For this photograph I must be naked." I photographed him this way, and he included the picture in his book *The Secret Life of Salvador Dali* (1942). That was the beginning of our thirty-year collaboration. When he had a good idea for a photograph he would phone, or I would phone when I would think one up. Some of the ideas we'd work out together, like the picture of the flying cats.

In 1948, Dali had an exhibit in which the most important painting was called *Leda Atomica.* It represented the naked Mrs. Dali as Leda, and showed her being embraced by the swan. Everything in this painting seemed to be suspended in midair: Mrs. Dali was not sitting but floating over a pedestal, the swan was not touching her, and even the wave breaking against the pedestal seemed not to have any contact with the bottom of the sea. I asked Dali why he called the painting *Leda Atomica,* and he replied, "Because in an atom everything is in suspension — the electrons, the protons, the neutrons, and other junk. And being the most modern painter of our atomic era, I have to paint everything as it is — in suspension."

The next morning I called him and said that I'd like to make a photograph that I would call *Dali Atomicus,* in which everything would be suspended. The easel would be in midair, Dali would be in midair, and even the subject of the painting would be in suspension. The painting would appear to have been created on the canvas in the fraction of a second it would take to get the photograph. Dali thought it a marvelous idea, and I was invited over to discuss the details.

Salvador DALI
1952

Dali & Gala
1942

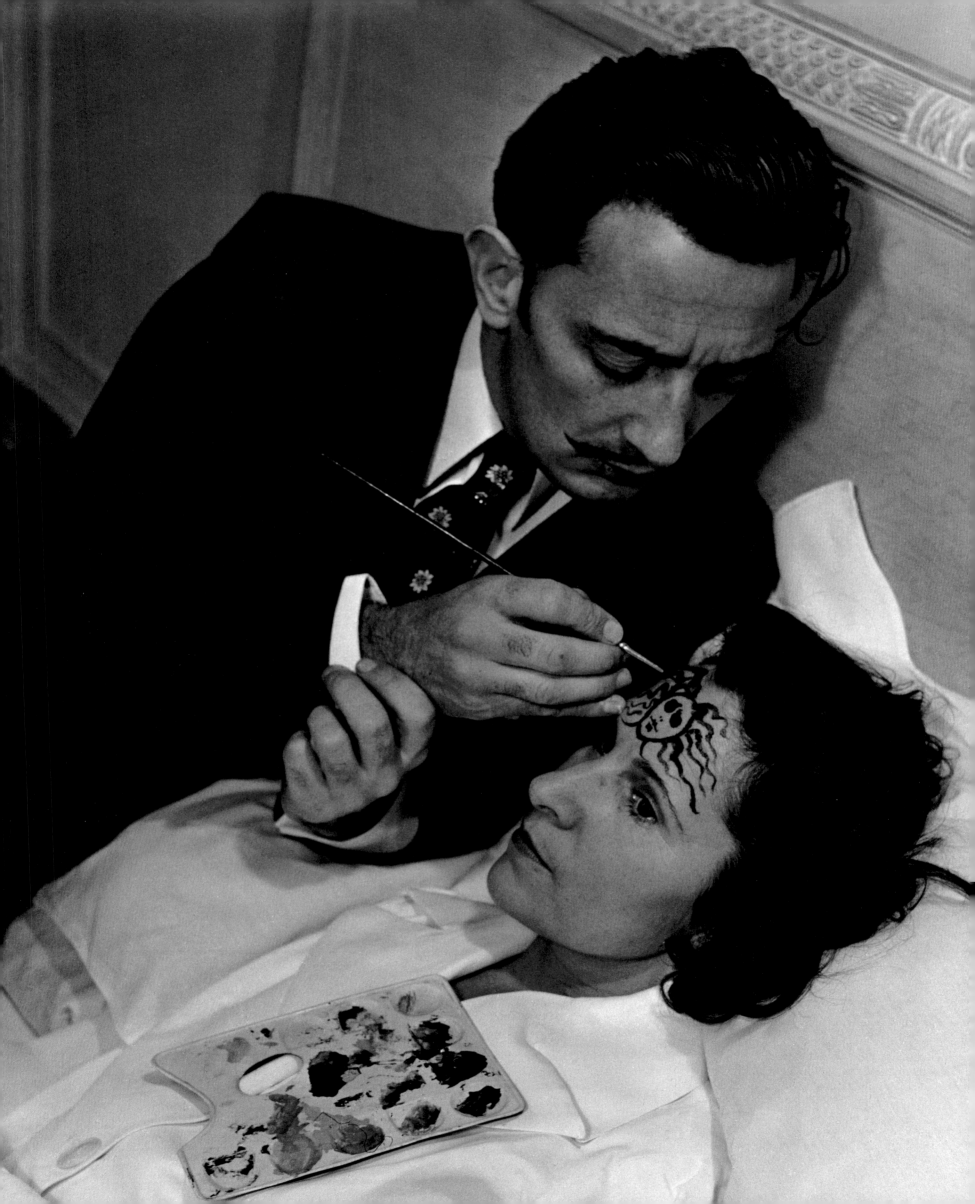

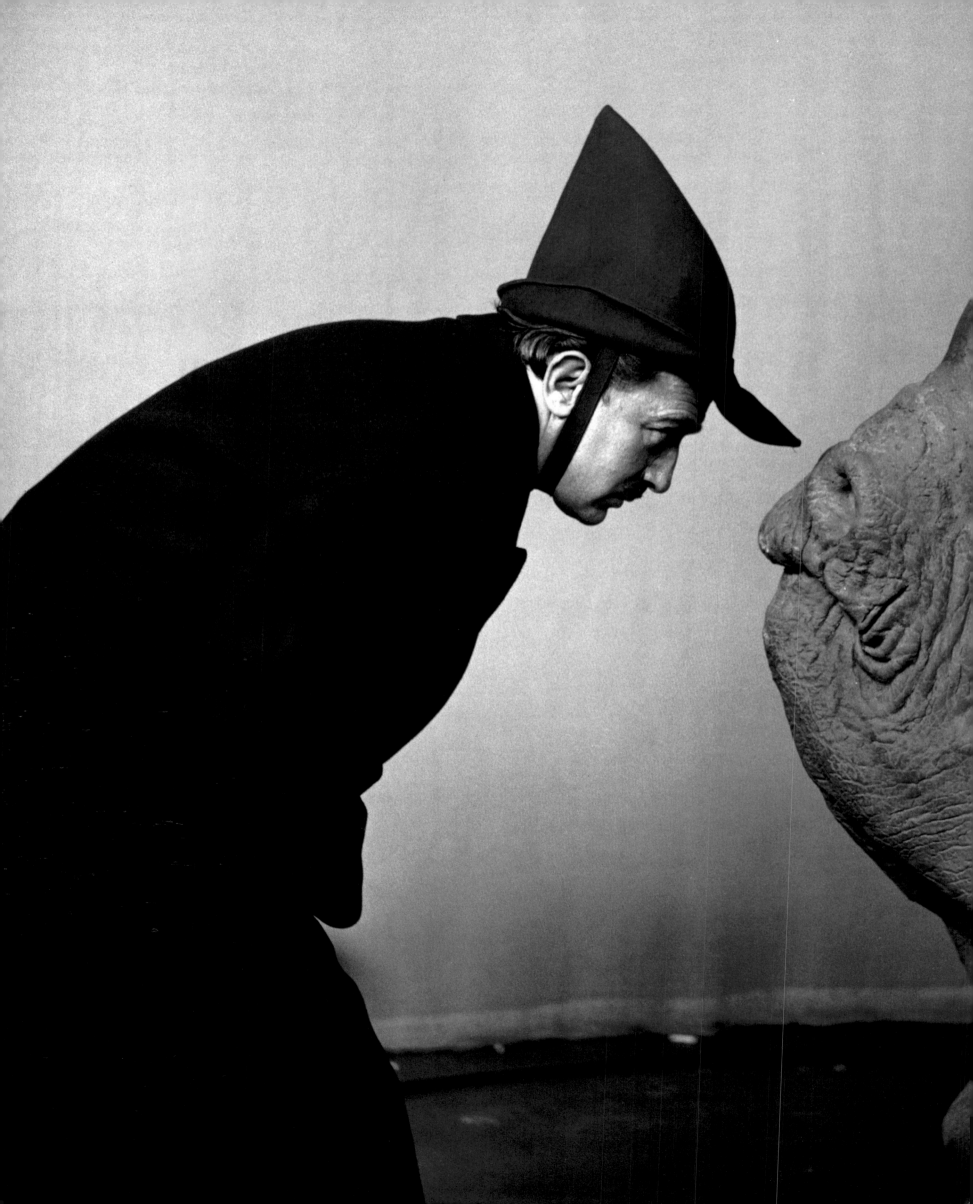

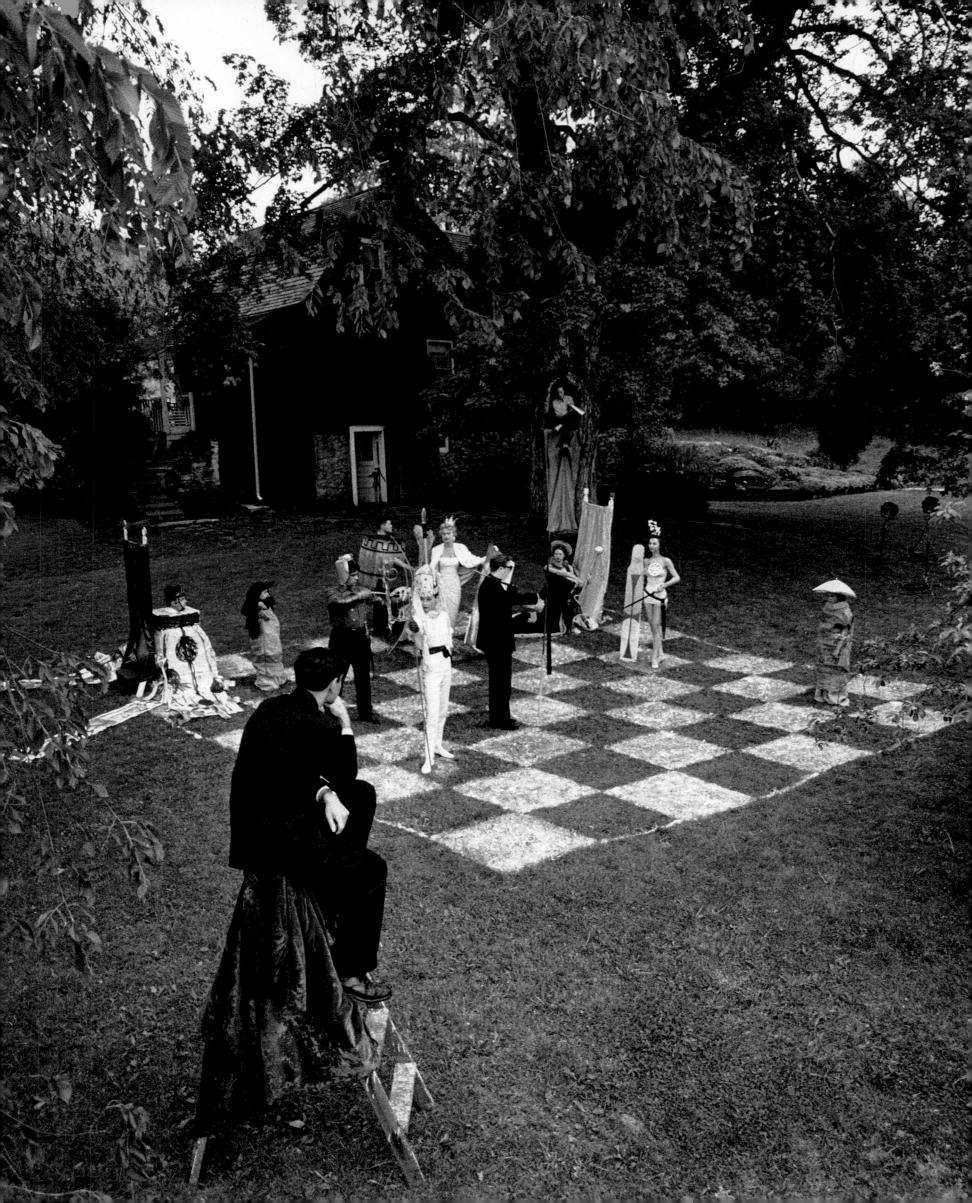

Dorothy DANDRIDGE
1954

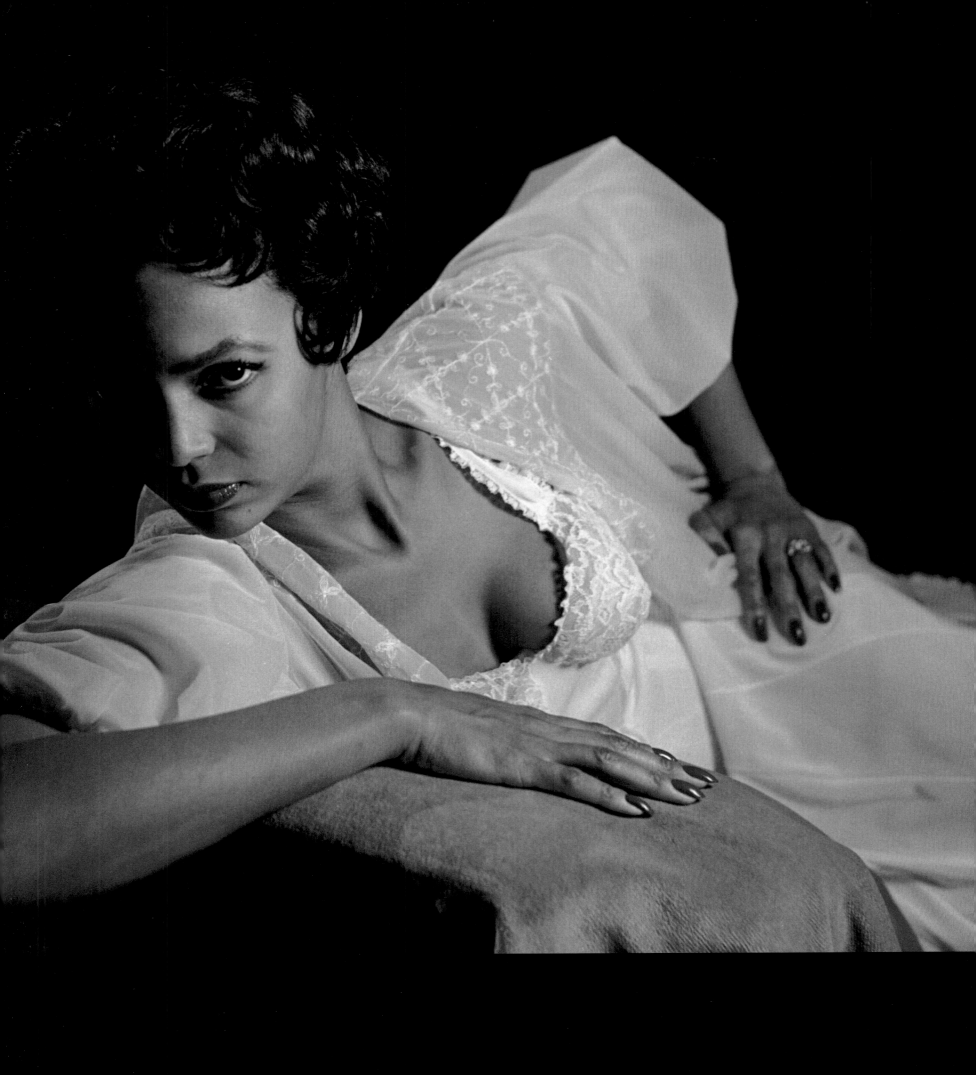

I admired Albert Einstein more than anyone I ever photographed, not only as the genius who single-handedly had changed the foundation of modern physics but even more as a rare and idealistic human being.

Personally, I owed him an immense debt of gratitude. After the fall of France, it was through his personal intervention that my name was added to the list of artists and scientists who, in danger of being captured by the Nazis, were given emergency visas to the United States.

After my miraculous rescue I went to Princeton to thank Einstein, and I remember vividly my first impression. Instead of a frail scientist I saw a deep-chested man with a resonant voice and a hearty laugh. The long hair, which in some photographs gave him the look of an old woman, framed his marvelous face with a kind of leonine mane. He wore slacks, a gray sweater with a fountain pen stuck in its collar, black leather shoes, and no socks.

On my third visit I had the courage to ask him why he did not wear any socks. His secretary, Miss Dukas, who overheard me, said, "The professor never wears socks. Even when he was invited by Mr. Roosevelt to the White House, he did not wear any socks." I looked with surprise at Professor Einstein.

He smiled and said, "When I was young I found out that the big toe always ends up by making a hole in the sock. So I stopped wearing socks." As slight as this remark was, it made an indelible impression on me. It seemed symbolic of Einstein's absolute and total independence of thought. It was this independence that gave him the courage when he was an unknown twenty-six-year-old patent clerk to publish a scientific paper which overthrew all the axioms held sacrosanct by the greatest physicists of his time.

The question of how to capture the essence of such a man in a portrait filled me with apprehension. Finally, in 1947, I had the courage to bring on one of my visits my Halsman camera and a few floodlights. After tea, I asked for permission to set up my lights in Einstein's study. The professor sat down and started peacefully working on his mathematical calculations. I took a few pictures. Ordinarily, Einstein did not like photographers, whom he called *Lichtaffen* (light monkeys). But he cooperated because I was his guest and, after all, he had helped save me.

Suddenly, looking into my camera, he started talking. He spoke about his despair that his formula $E=mc^2$ and his letter to President Roosevelt had made the atomic bomb possible, that his scientific search had resulted in the death of so many human beings. "Have you read," he asked, "that powerful voices in the United States are demanding that the bomb be dropped on Russia now, before the Russians have time to perfect their own?" With my entire being I felt how much this infinitely good and compassionate man was suffering from the knowledge that he had helped to put in the hands of politicians a monstrous weapon of devastation and death.

He grew silent. His eyes had a look of immense sadness. There was a question and a reproach in them.

The spell of this moment almost paralyzed me. Then, with an effort, I released the shutter of my camera. Einstein looked up, and I asked him, "So, you don't believe that there will ever be peace?"

"No," he answered. "As long as there will be man there will be wars."

Albert EINSTEIN
1947

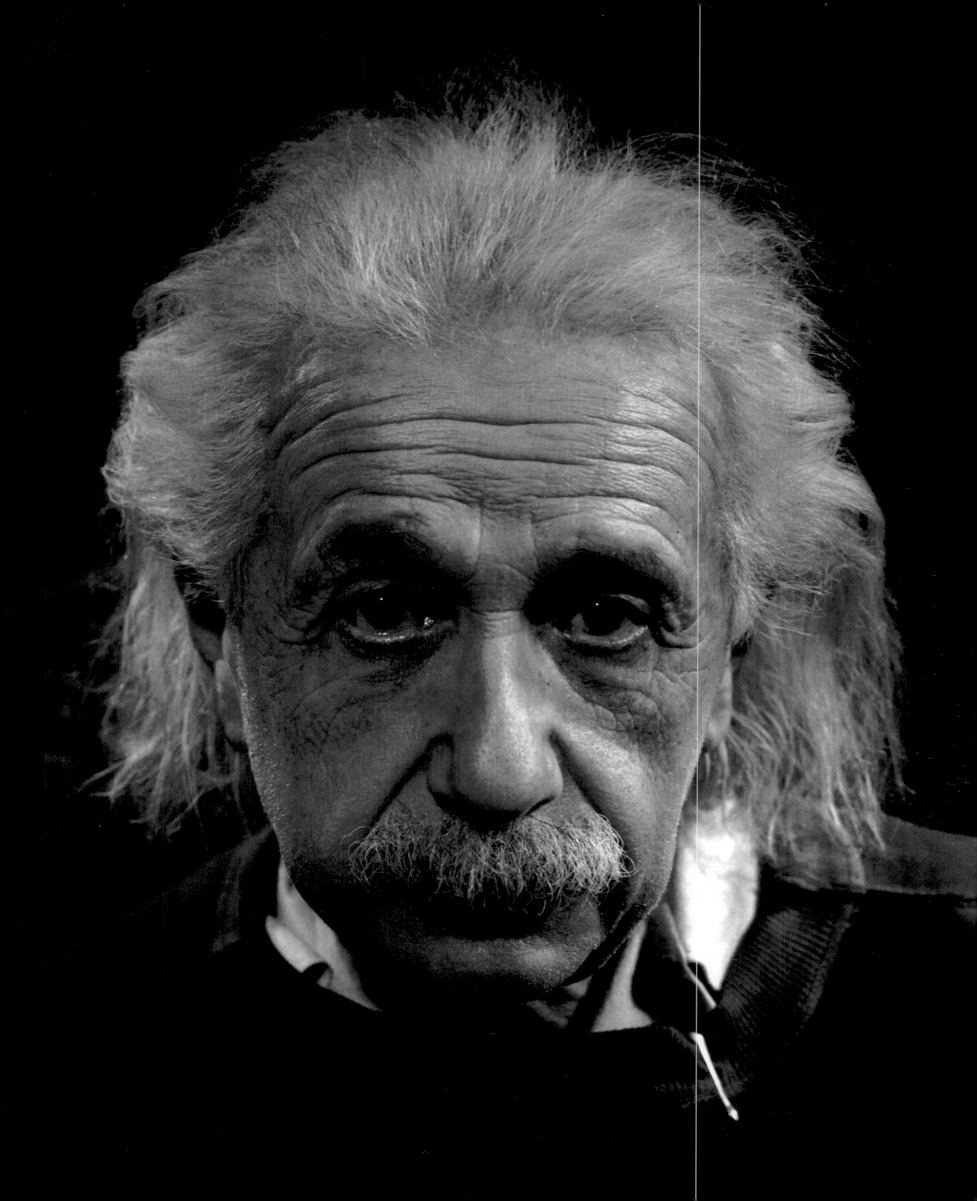

Mia FARROW
1964

Bobby **FISCHER**
1968

FIRST
cover for
LIFE
1942

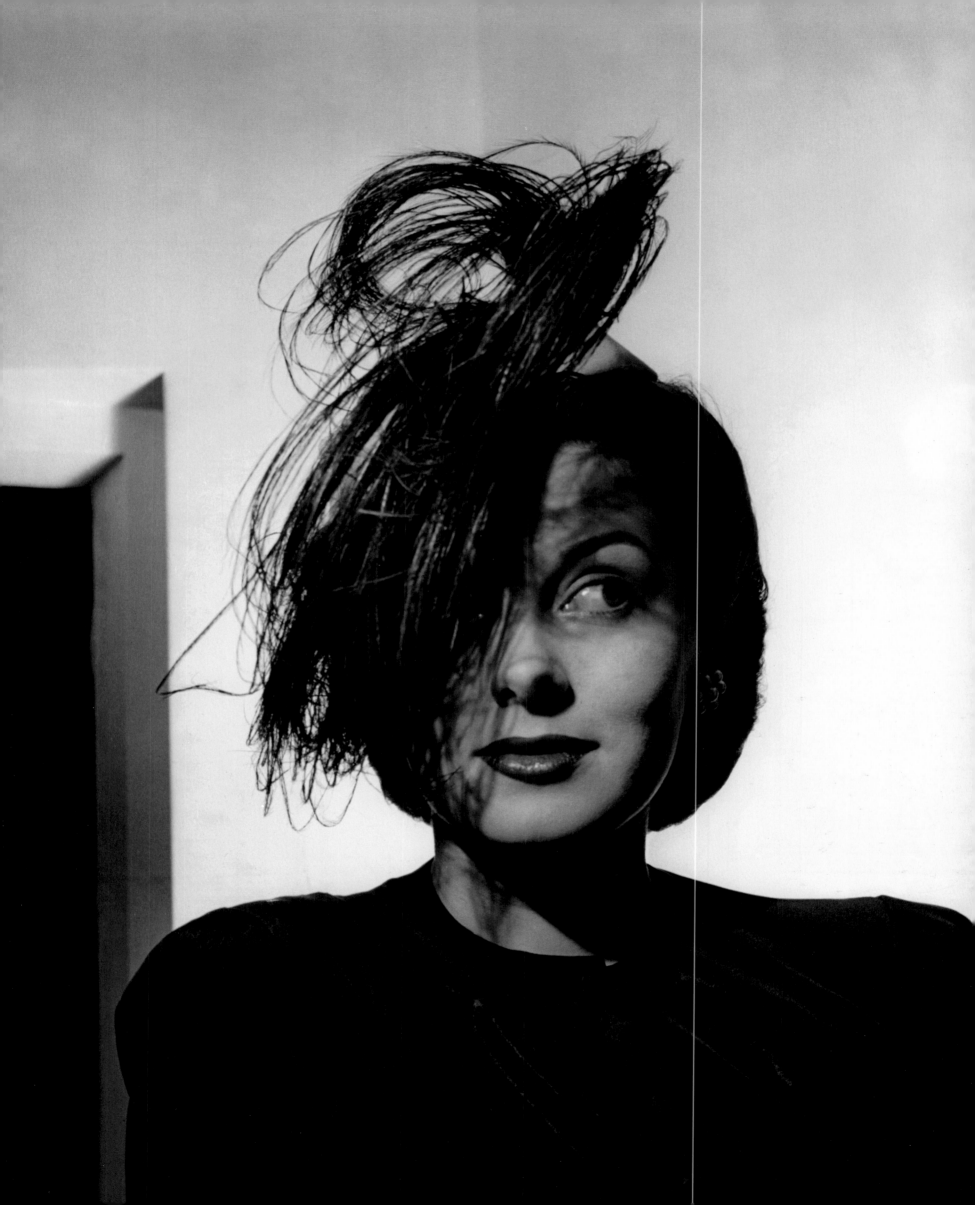

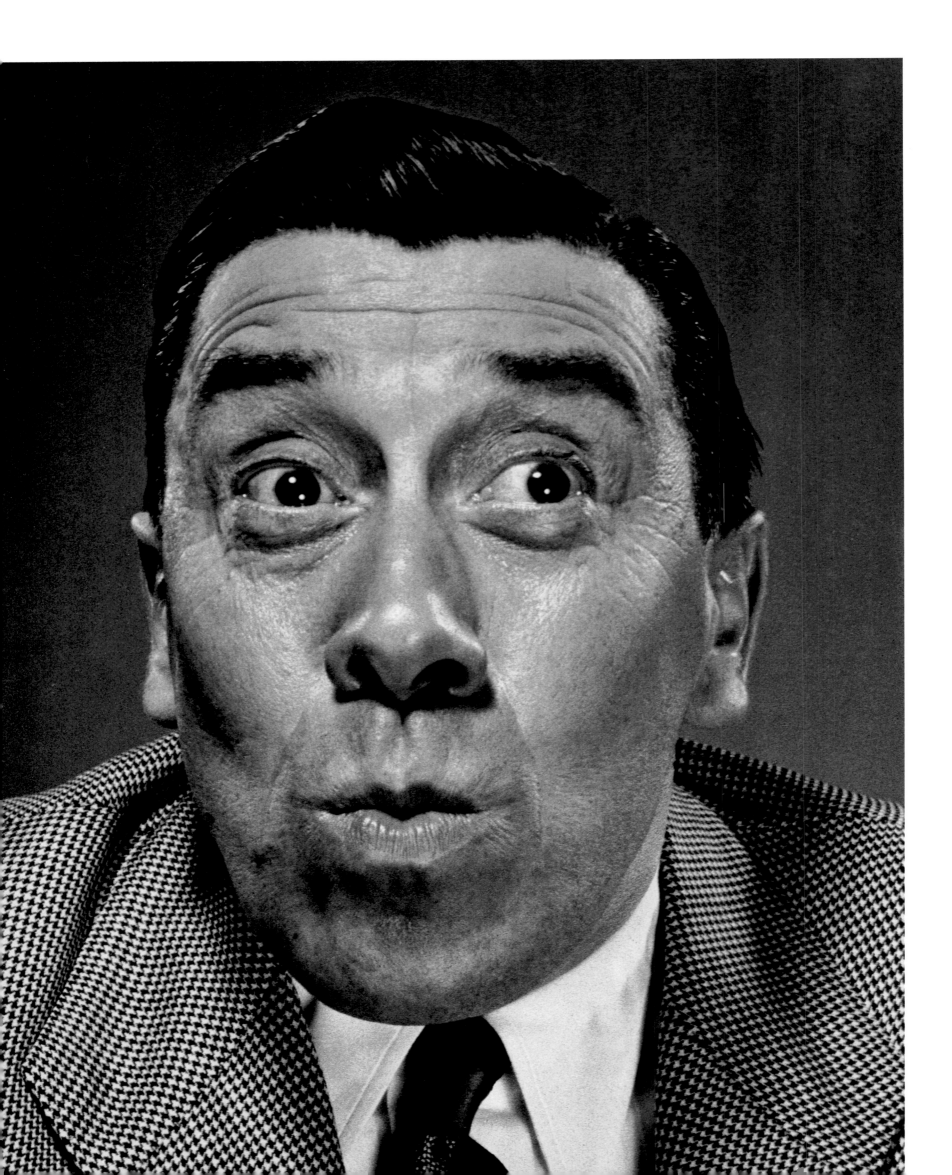

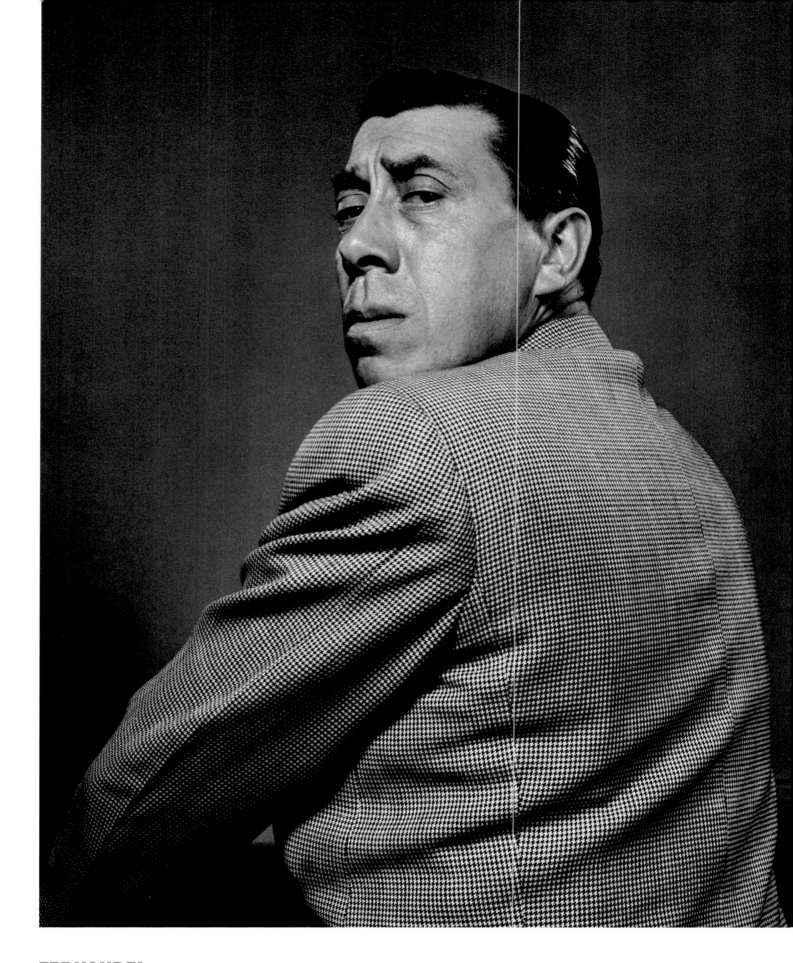

FERNANDEL
1948

Connie FORD
1941

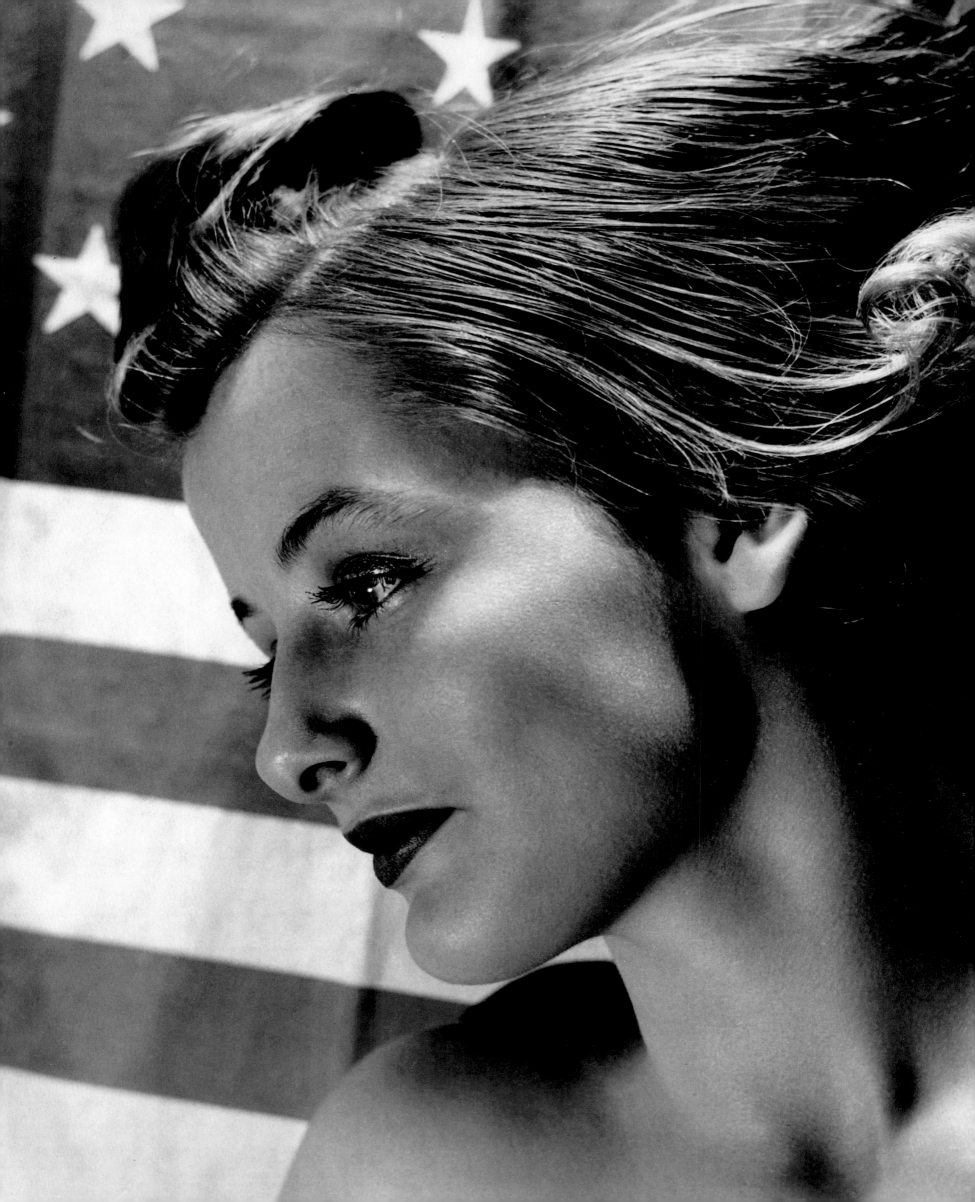

G Judy GARLAND
1944

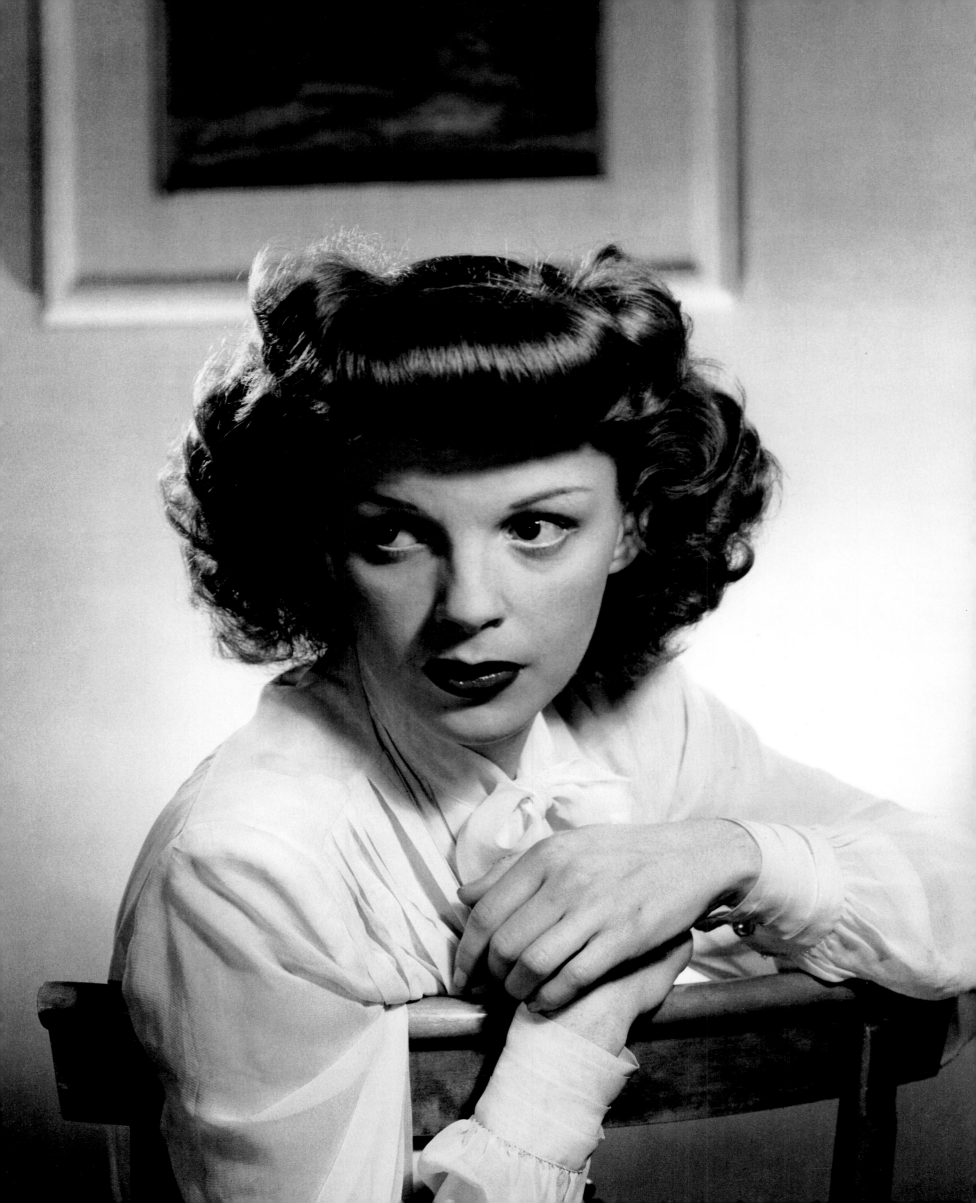

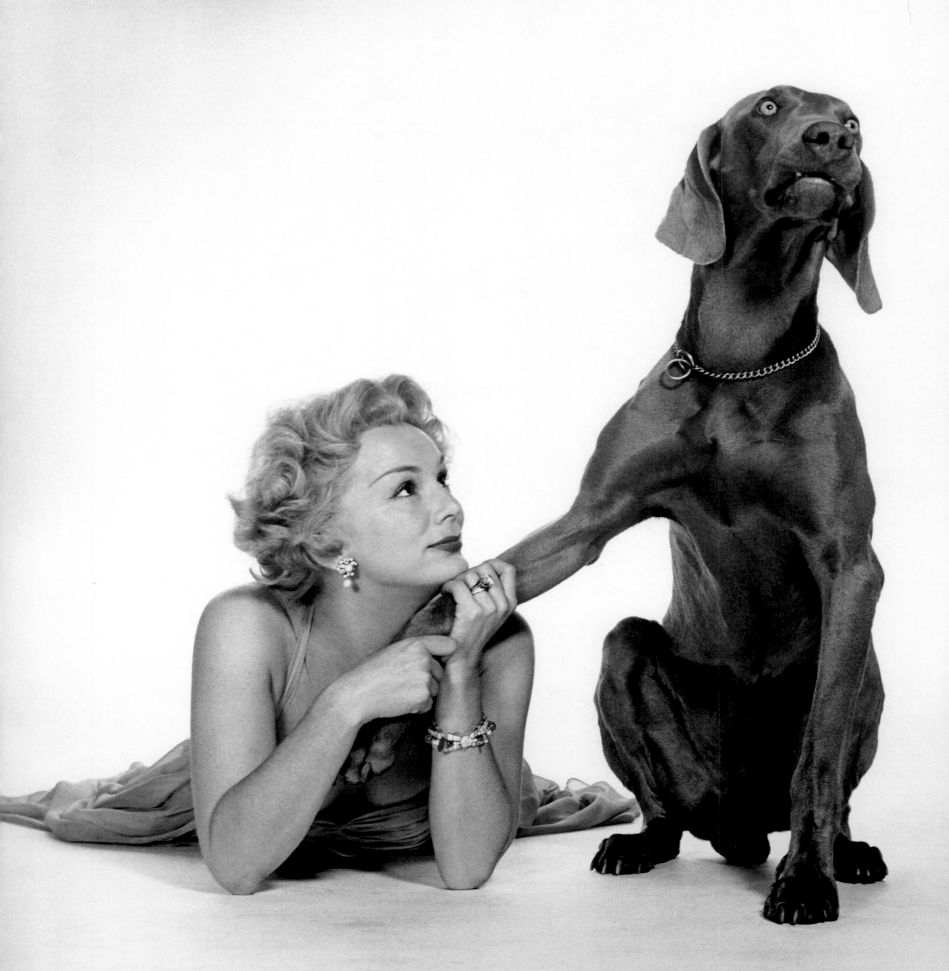

Eva GABOR
1953

André **GIDE**
1935

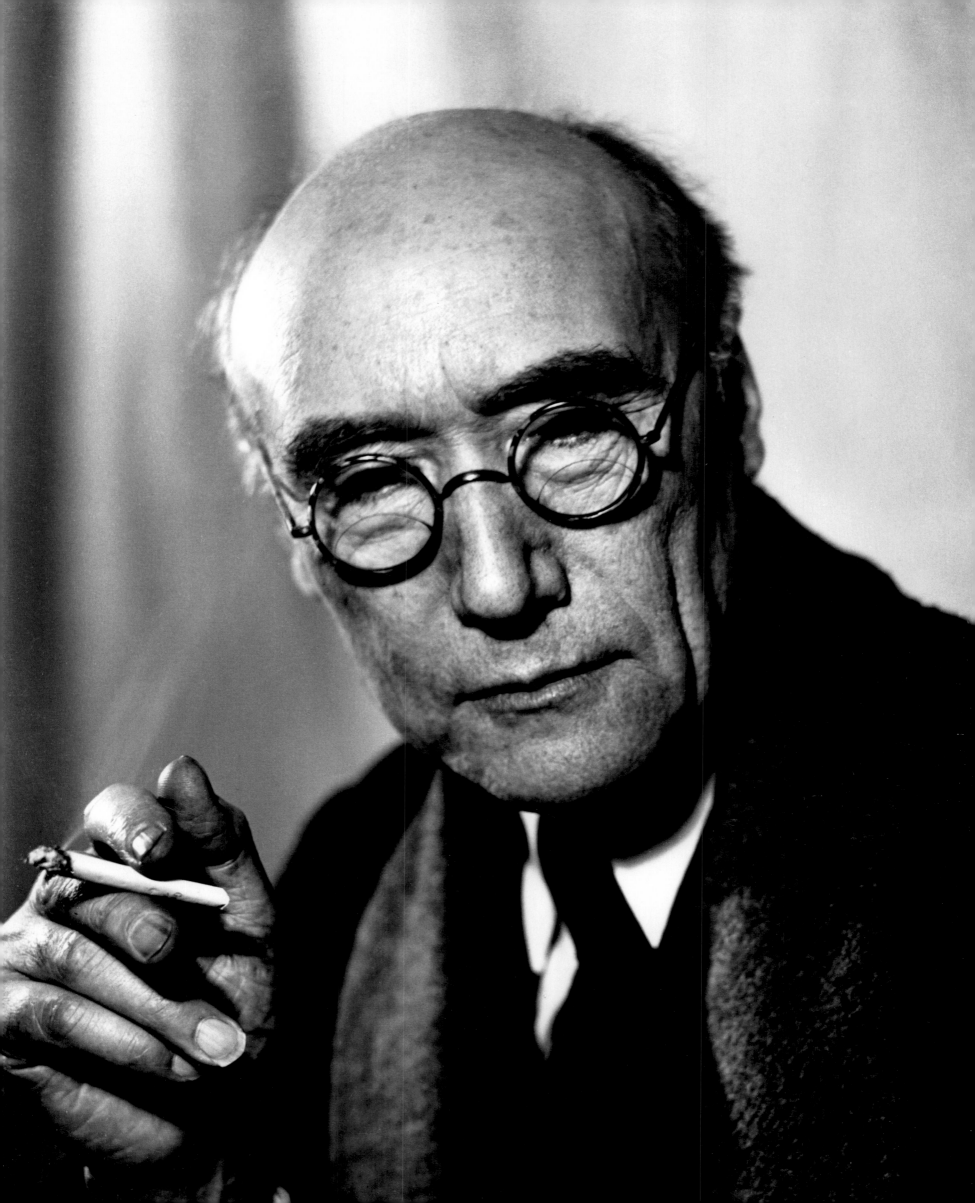

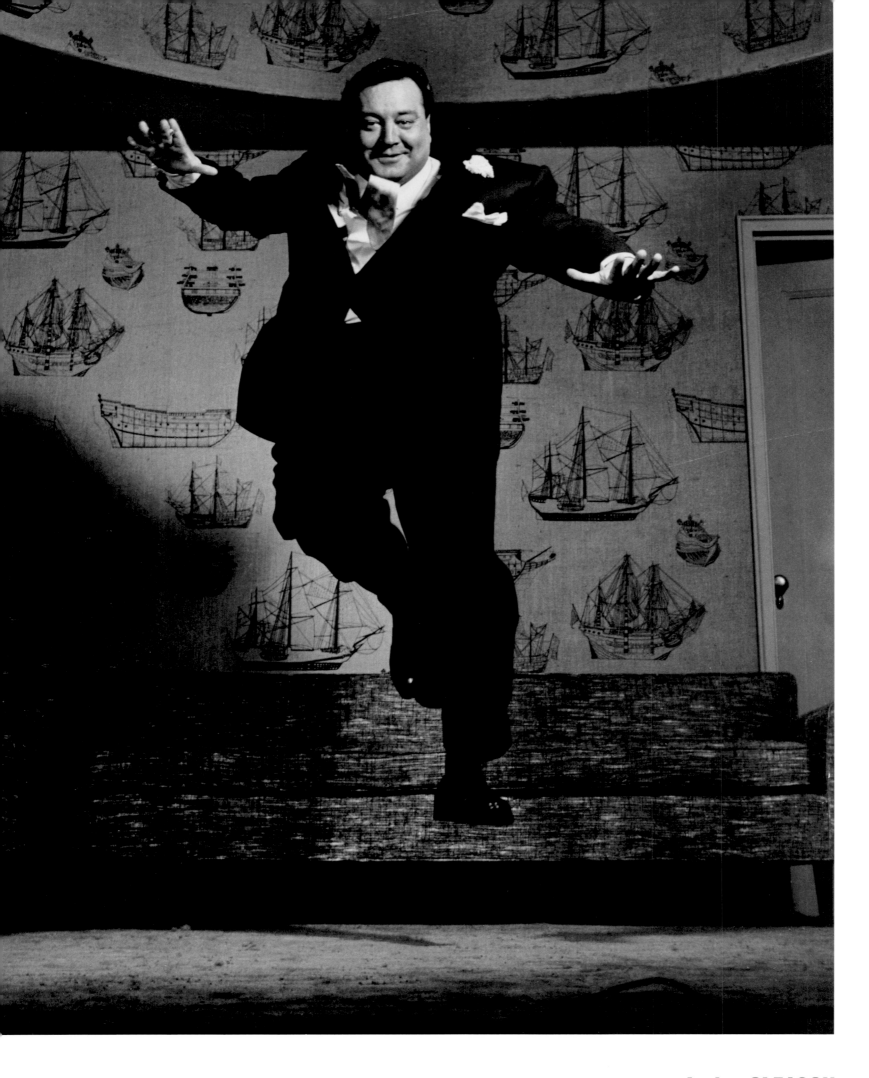

Jackie GLEASON
1955

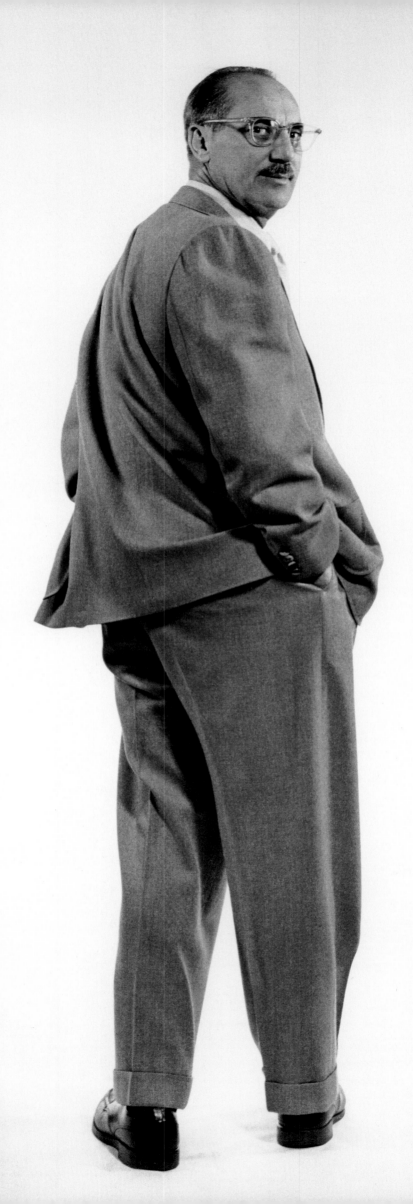

GROUCHO Marx
1952

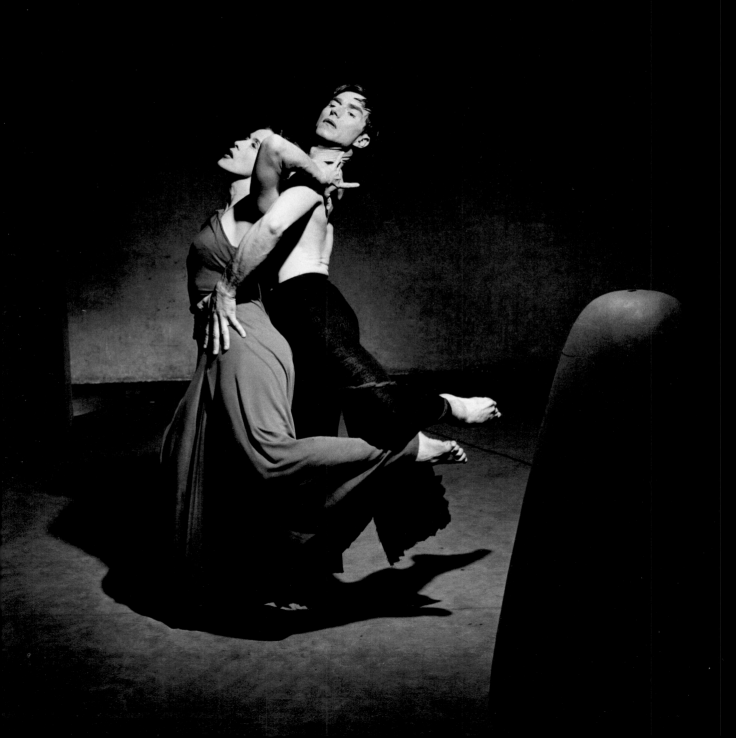

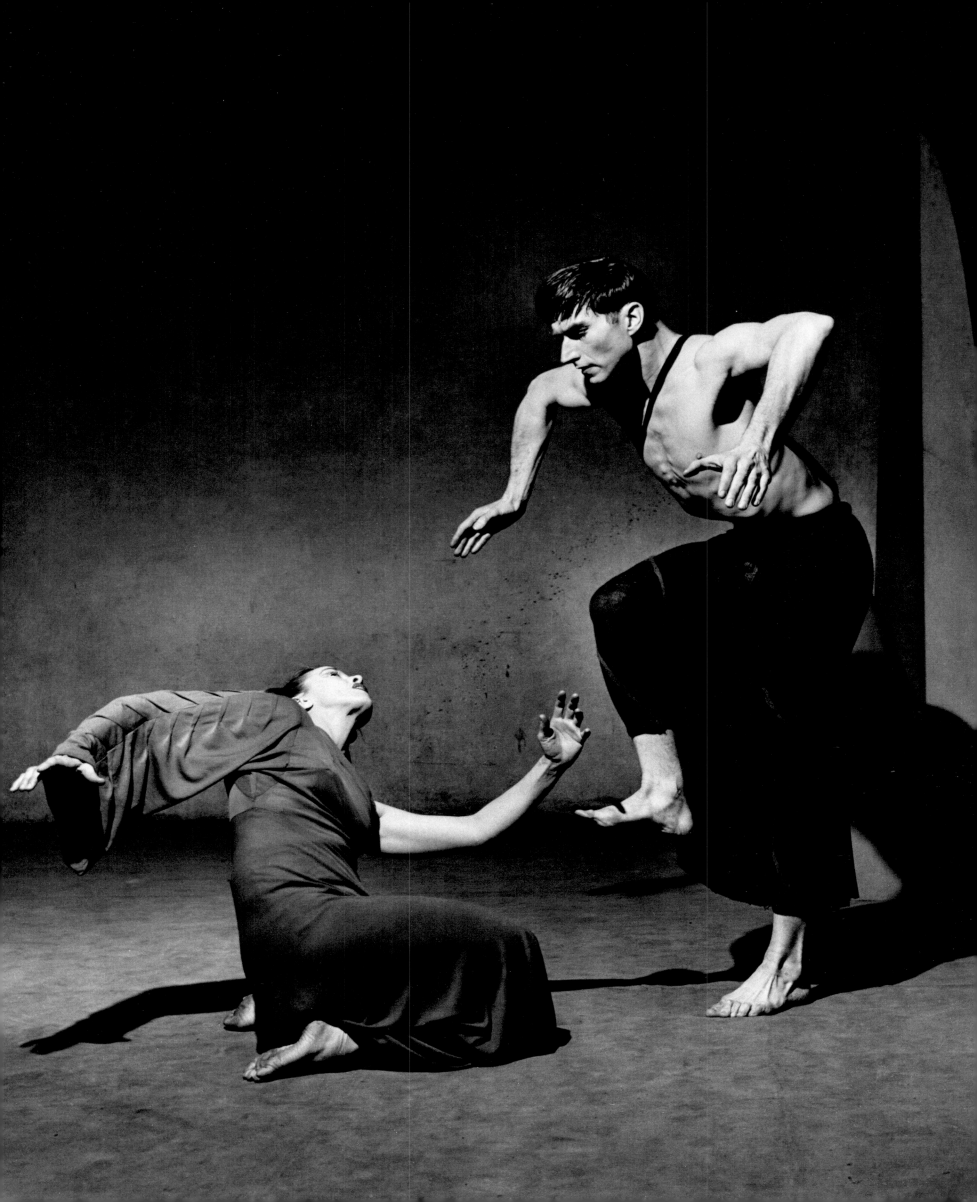

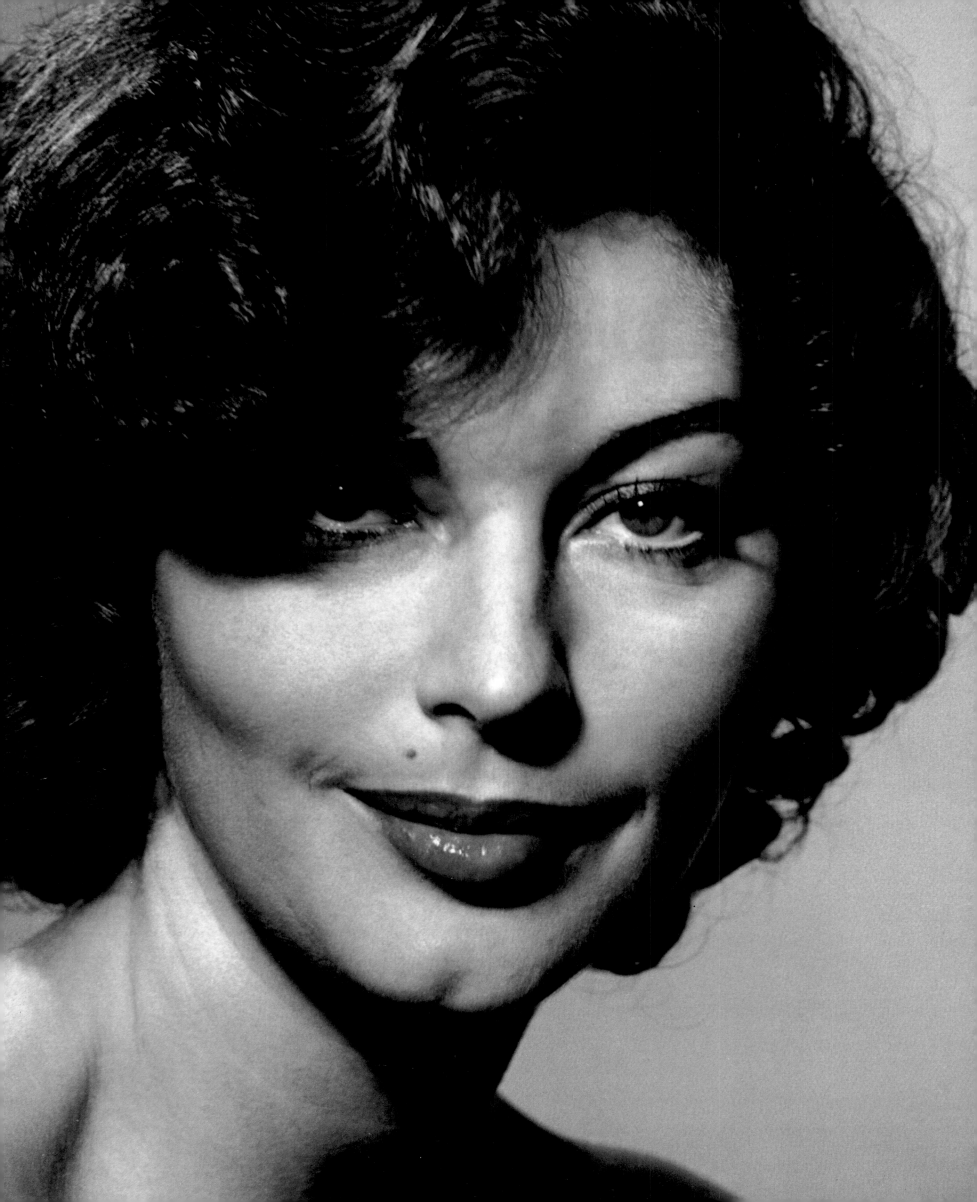

Ava GARDNER
1954

H

Alfred **HITCHCOCK** 1963

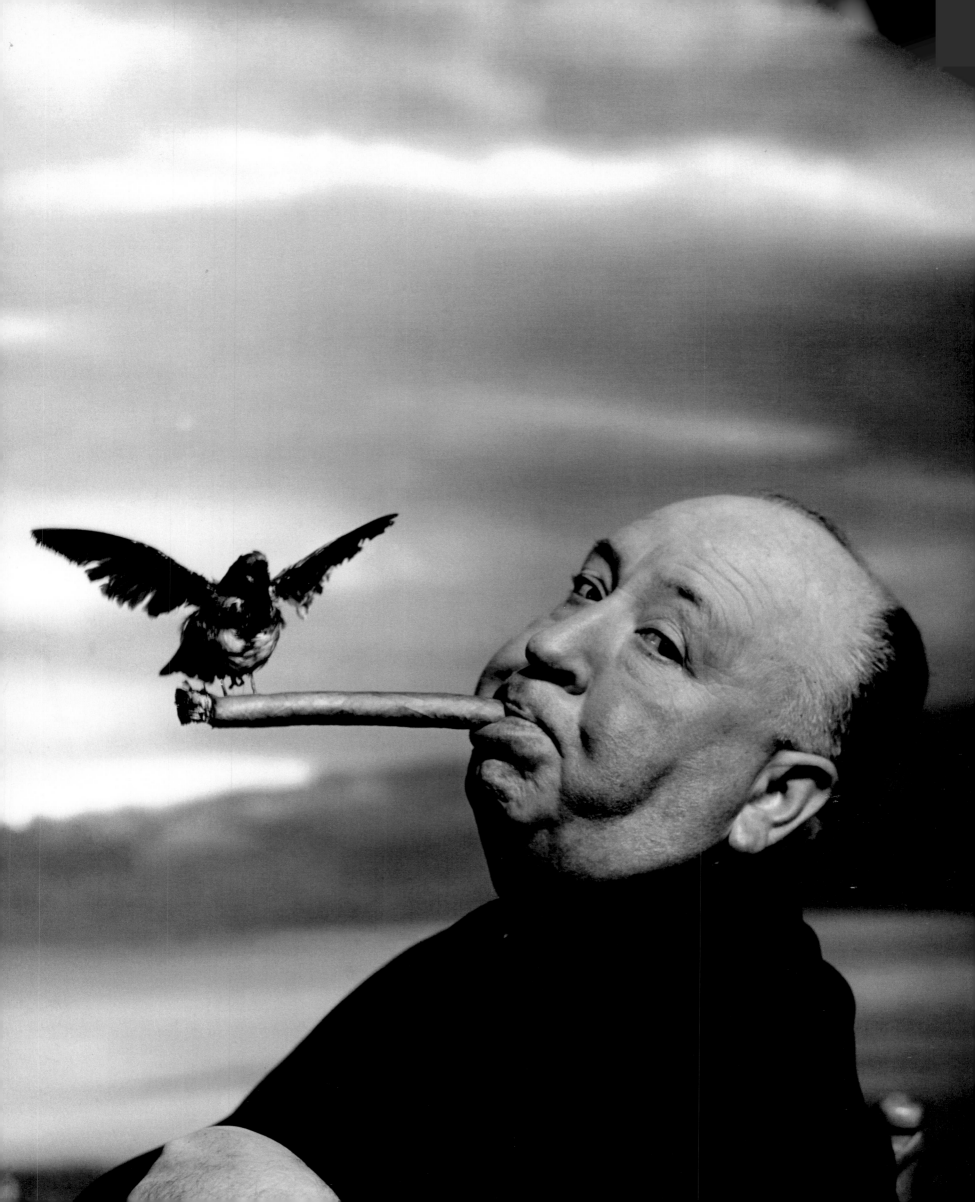

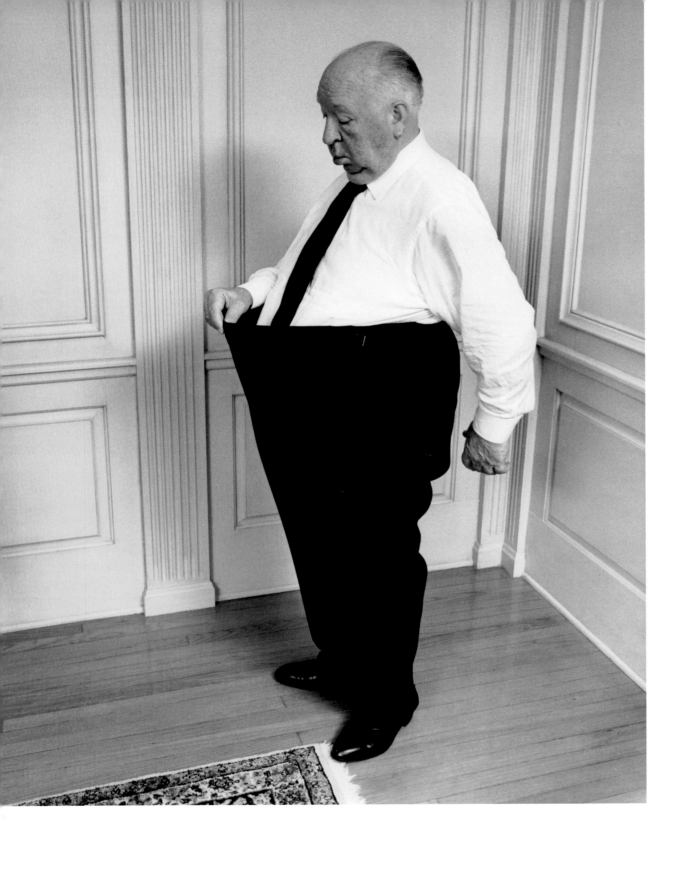

Alfred HITCHCOCK
1974

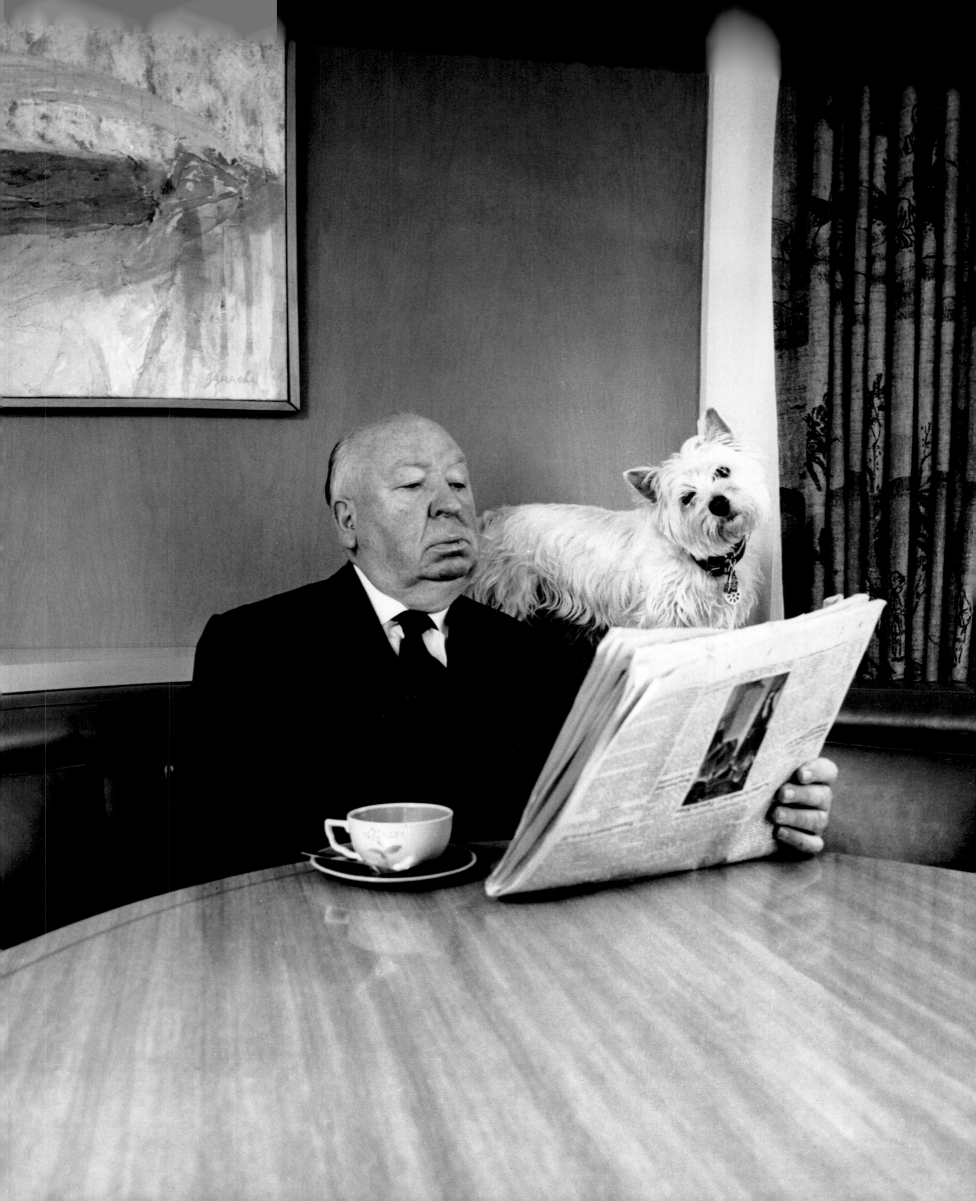

Aldous HUXLEY
1958

I had read Huxley's *Point Counter Point* and *Brave New World,* and I knew that he was becoming blind. And so against the brick wall of my fireplace, I visualized Huxley's aristocratic face with a calm, inward expression. I put an armchair in front of the fireplace and carefully arranged several floodlights around it.

Huxley arrived at my studio—tall, lanky, almost completely sightless, but surprisingly lively in his movements. Since it was a hot day he took off his jacket, sat down in the armchair, and almost immediately we were engaged in an animated conversation.

Huxley had just returned from Mexico, where he had tried the sacred mushroom, peyote. The term "psychedelic drugs" was as yet unknown, but Huxley was aware that he had opened the door into a new world. His animation increased; his gestures became more and more lively. I realized how wrong my idea had been of making a calm and static portrait of him.

Switching in the midst of a sitting from floodlights to electronic flash is probably more difficult than switching horses in midstream, but with breathless hurry my assistant and I disconnected and switched lights. From my big camera I switched to a Hasselblad, using an exposure of one-thousandth of a second. Now I could instantly shoot every gesture, every new expression. Huxley was speaking about the future. He foresaw governments controlling the minds of their citizens, altering their desire to work or their sex drive, making people more peaceful or more bellicose and patriotic. Huxley grew more stimulated and more stimulating. His hands accentuated his words, shooting forward like two slender birds.

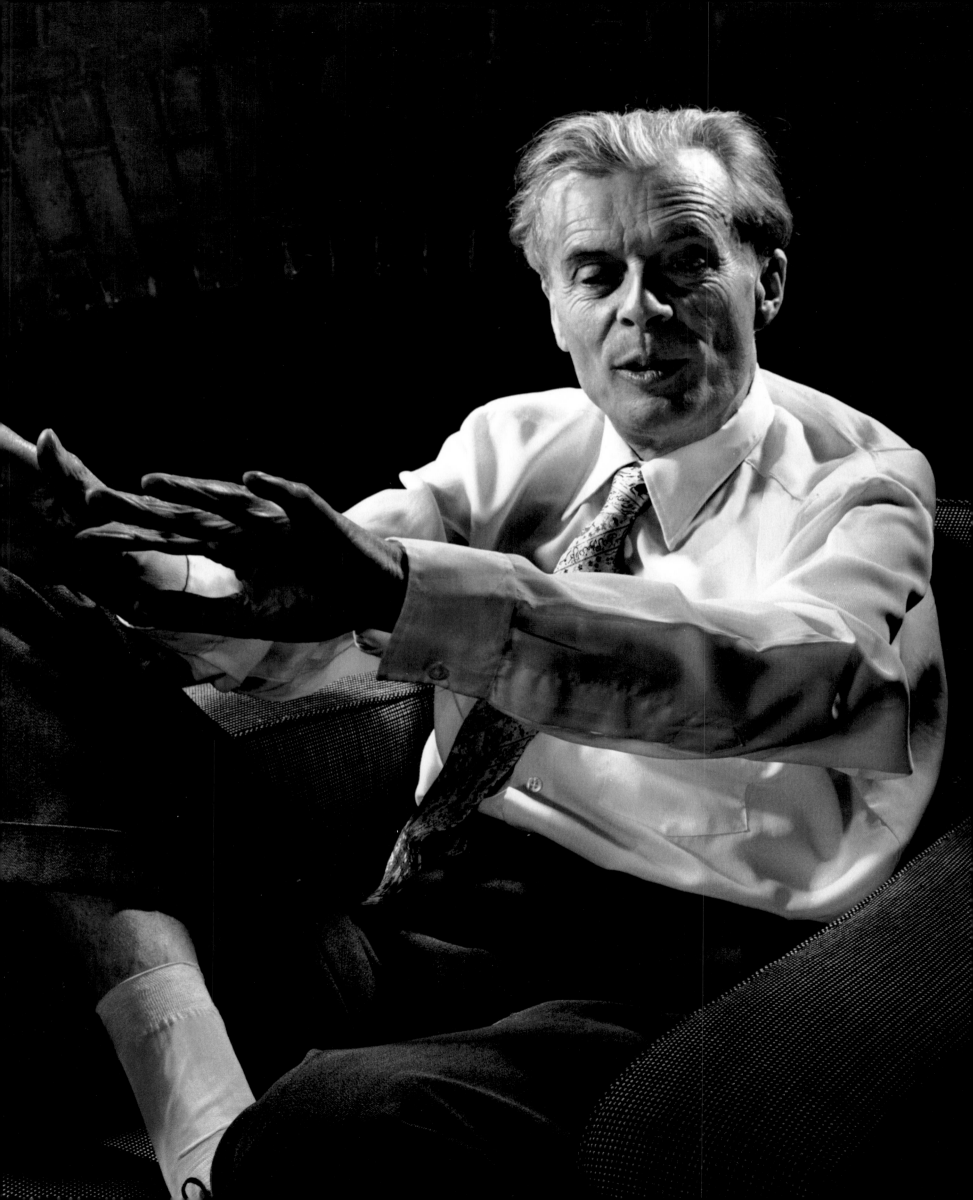

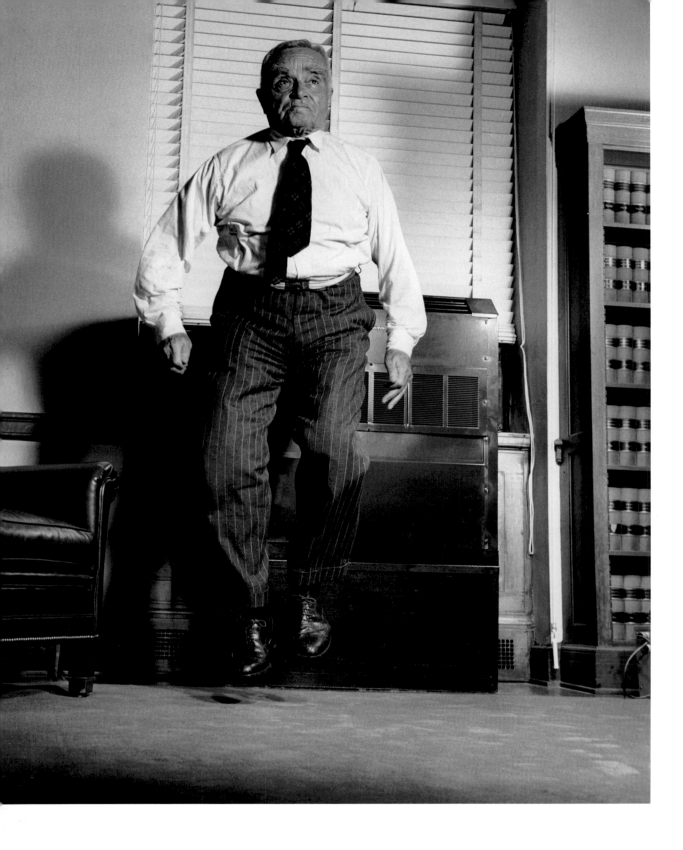

Judge Learned HAND
1957

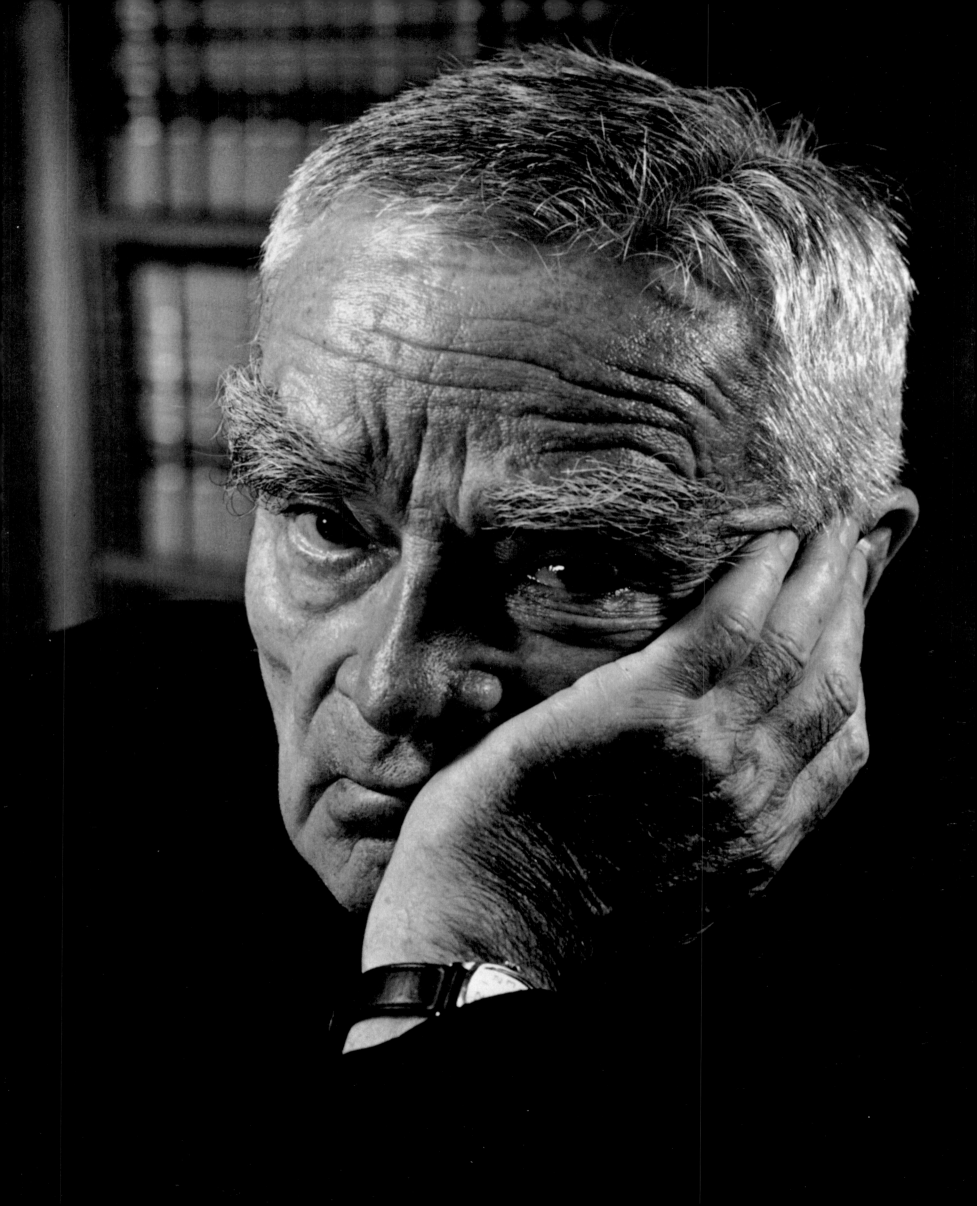

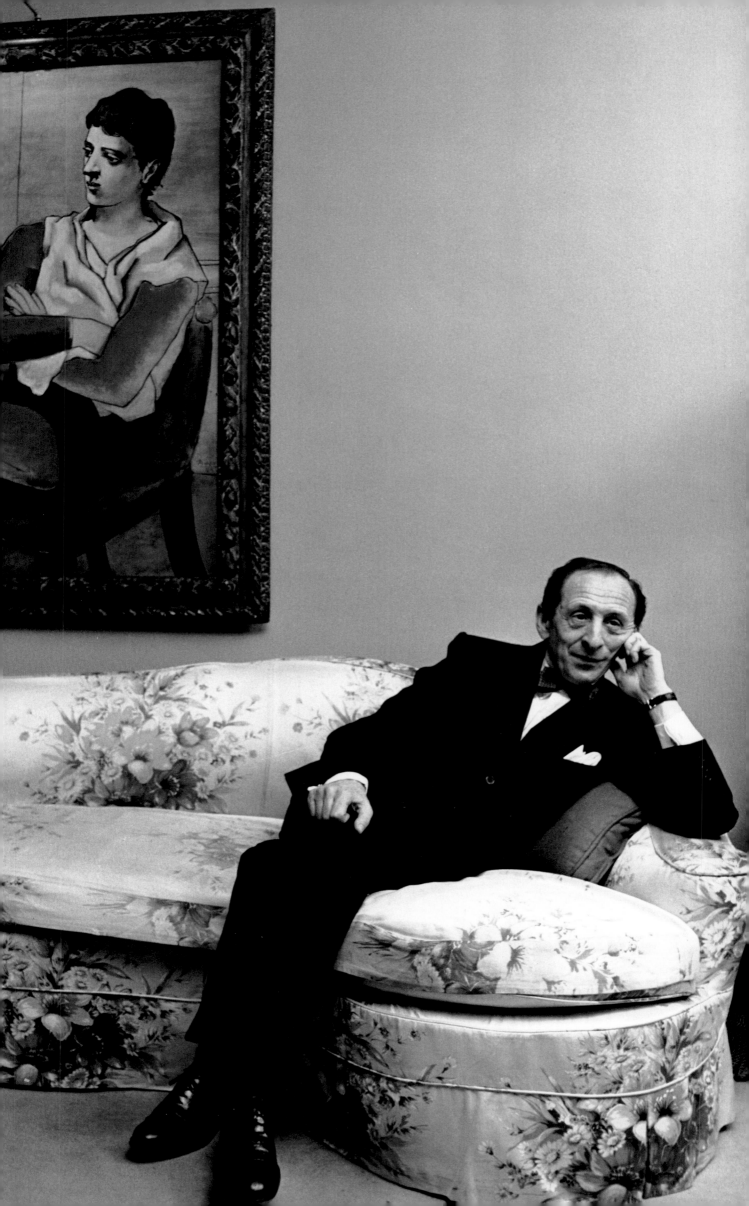

John HUSTON
1968

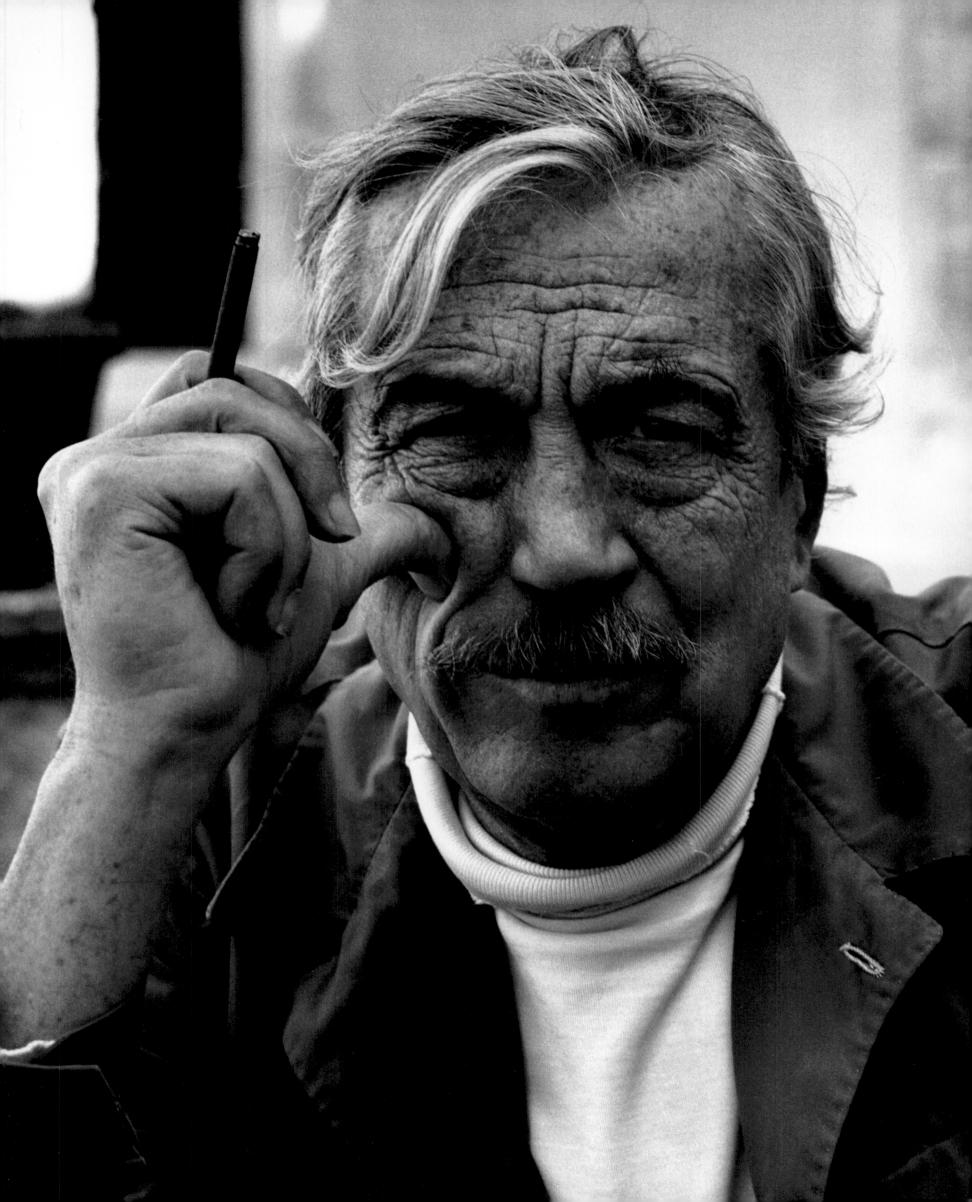

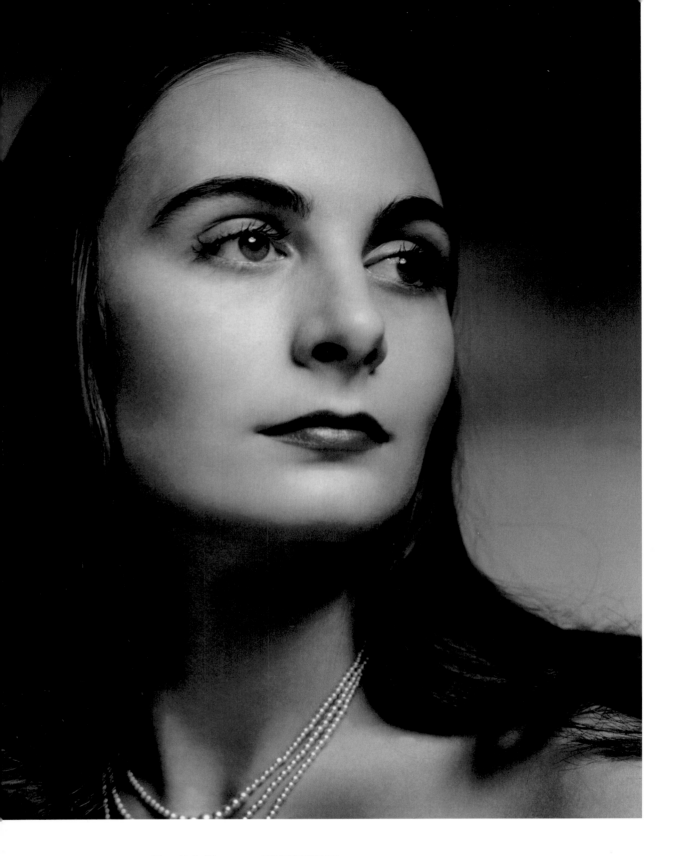

Ricki Soma HUSTON
1946

Anjelica HUSTON
1968

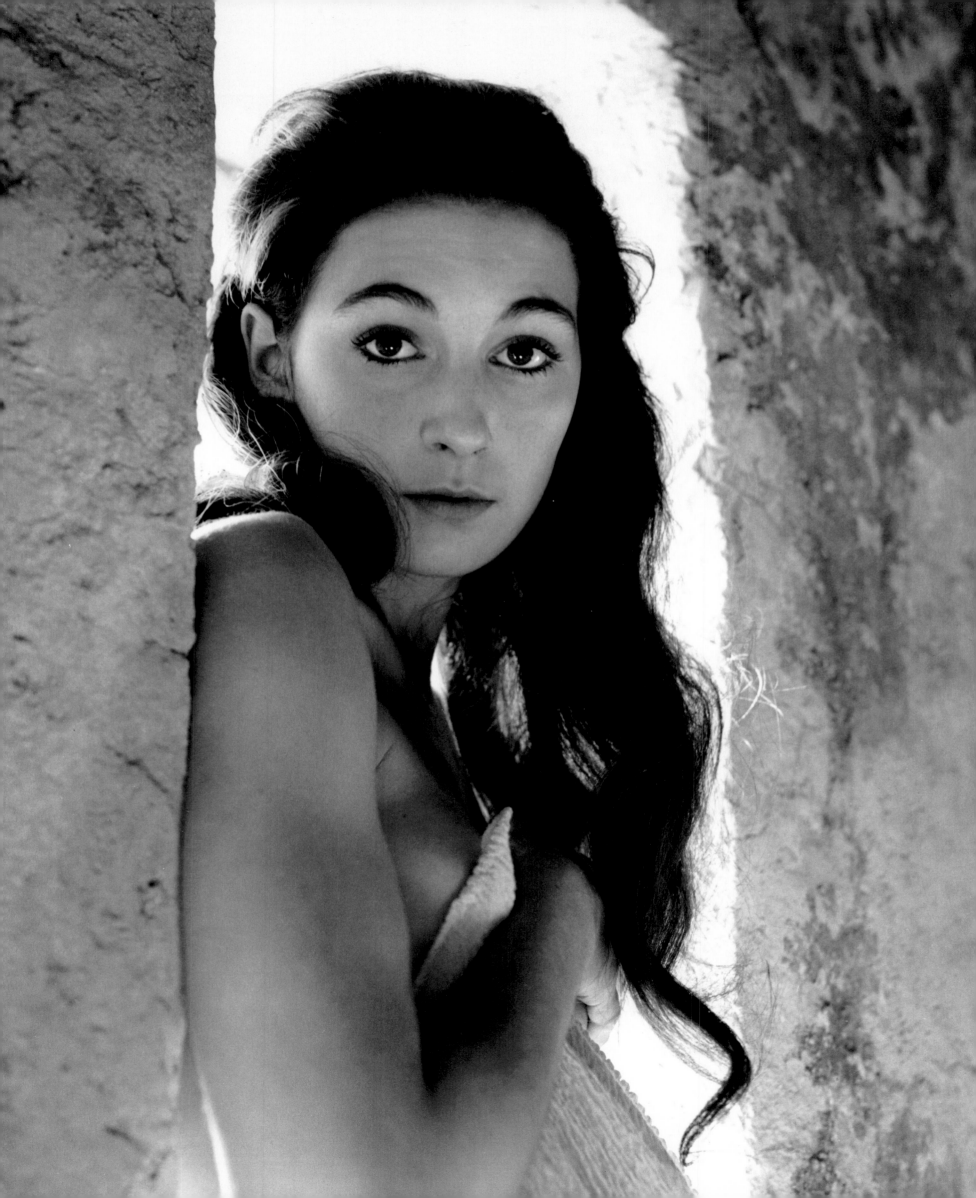

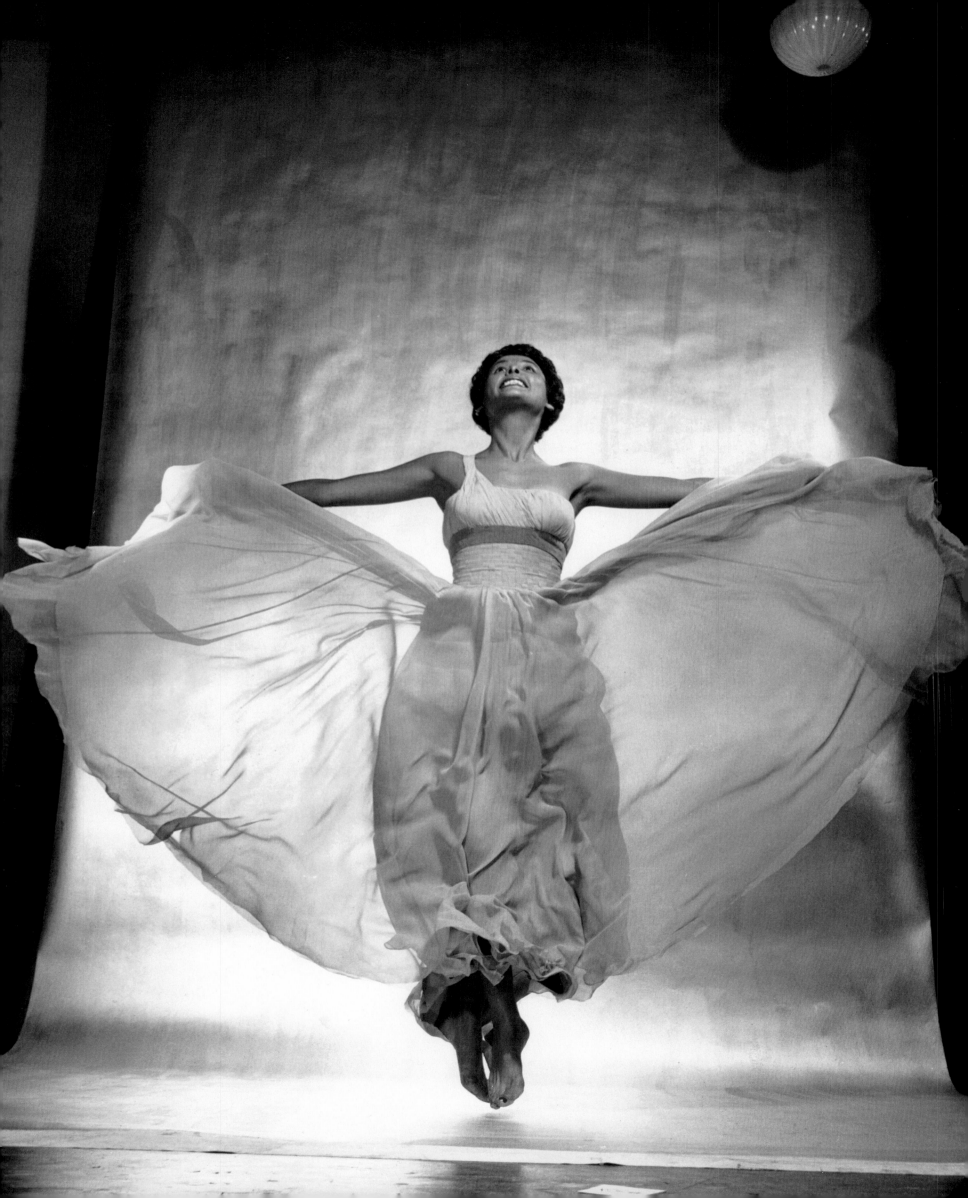

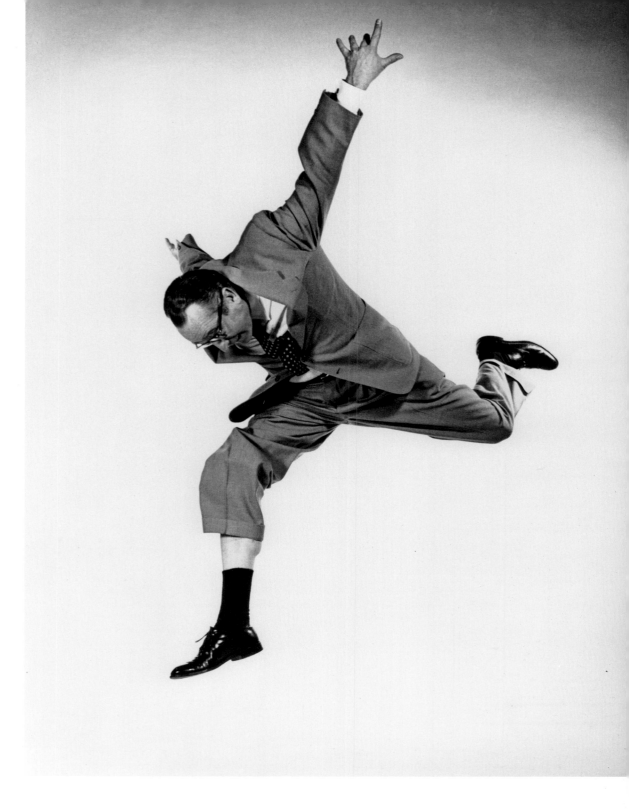

HAROLD Lloyd
1953

Lena HORNE
1954

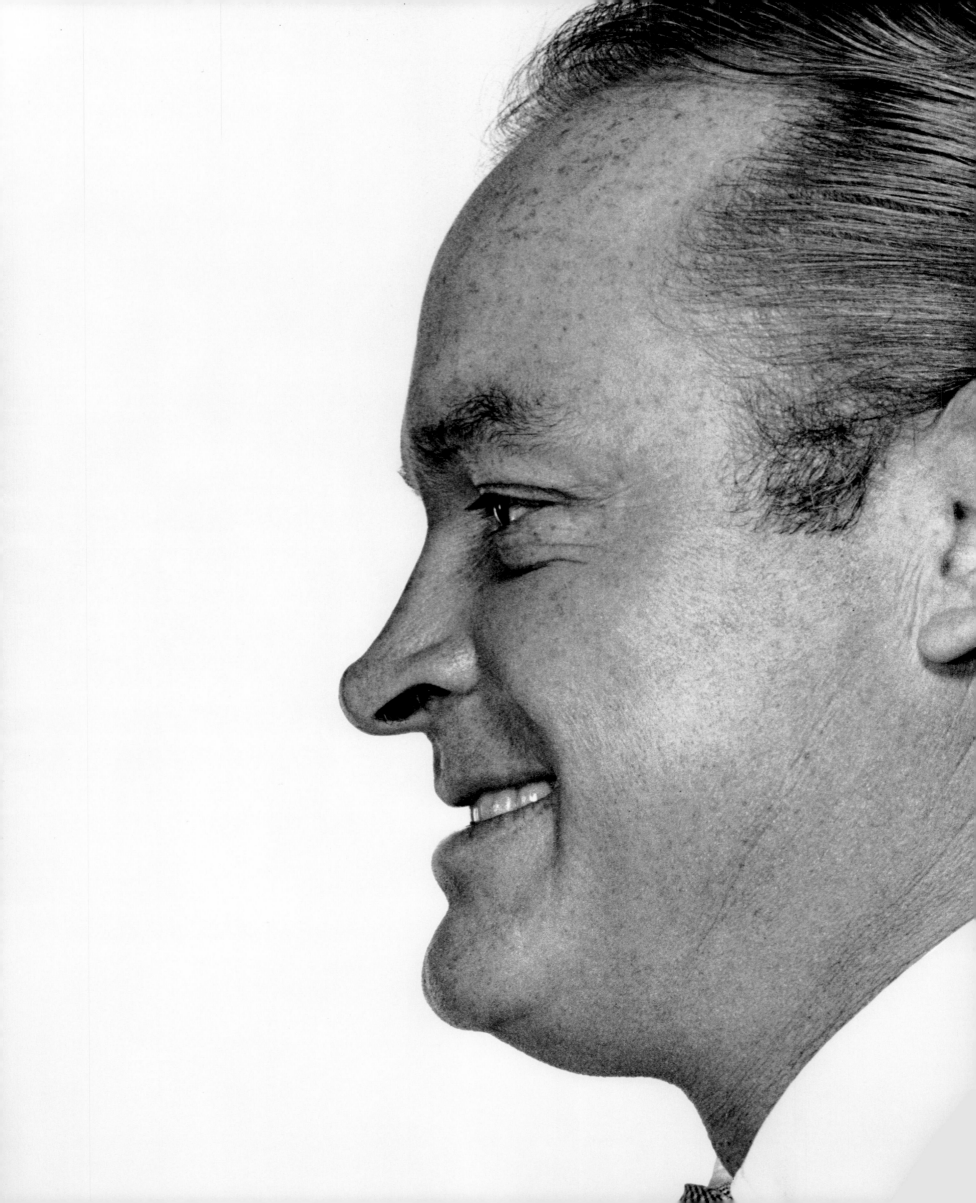

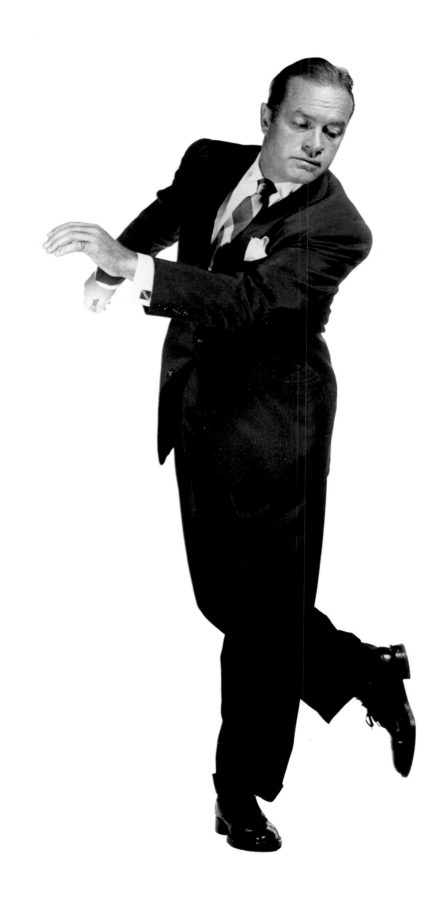

Bob HOPE
1950

Rita **HAYWORTH**
1943

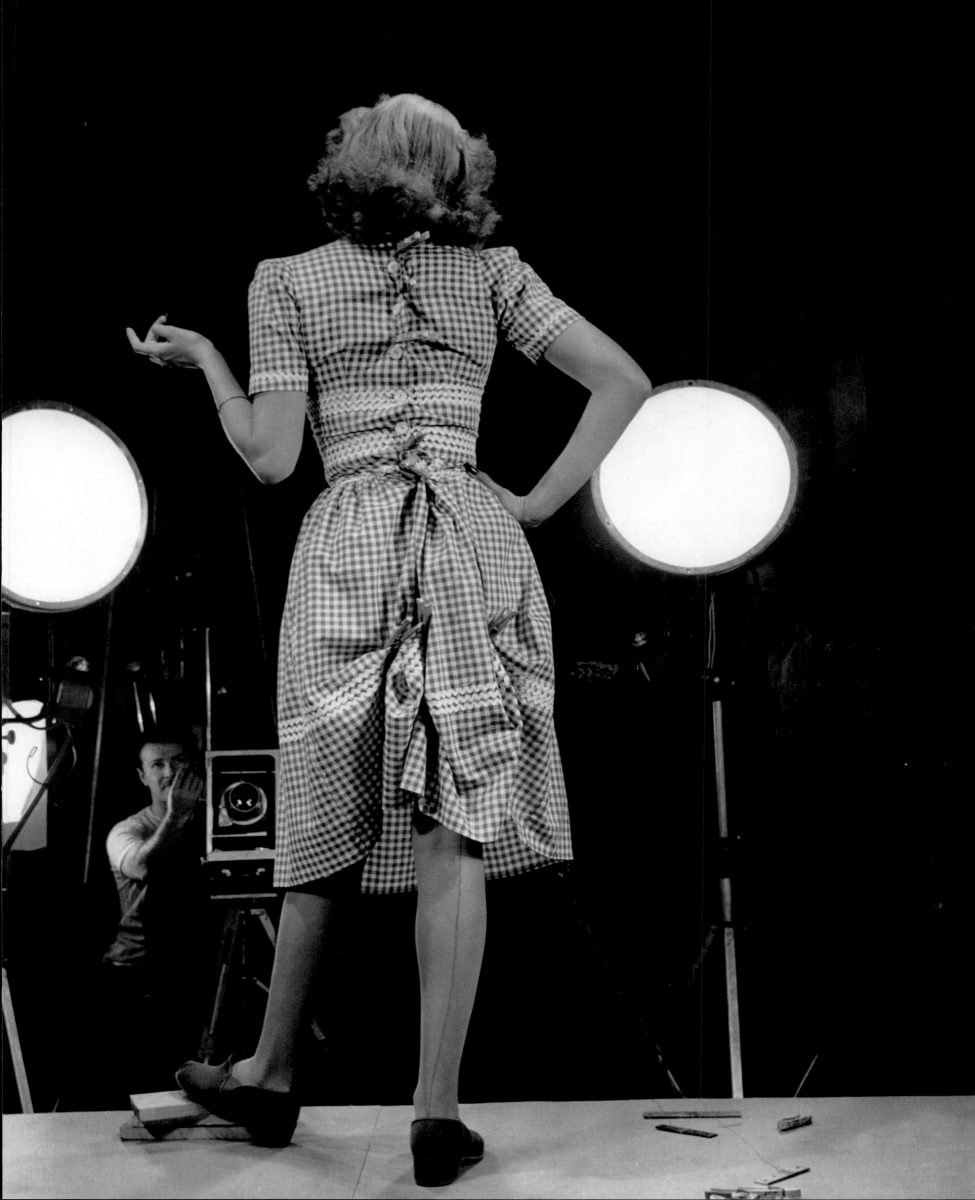

INGRID Bergman
1944

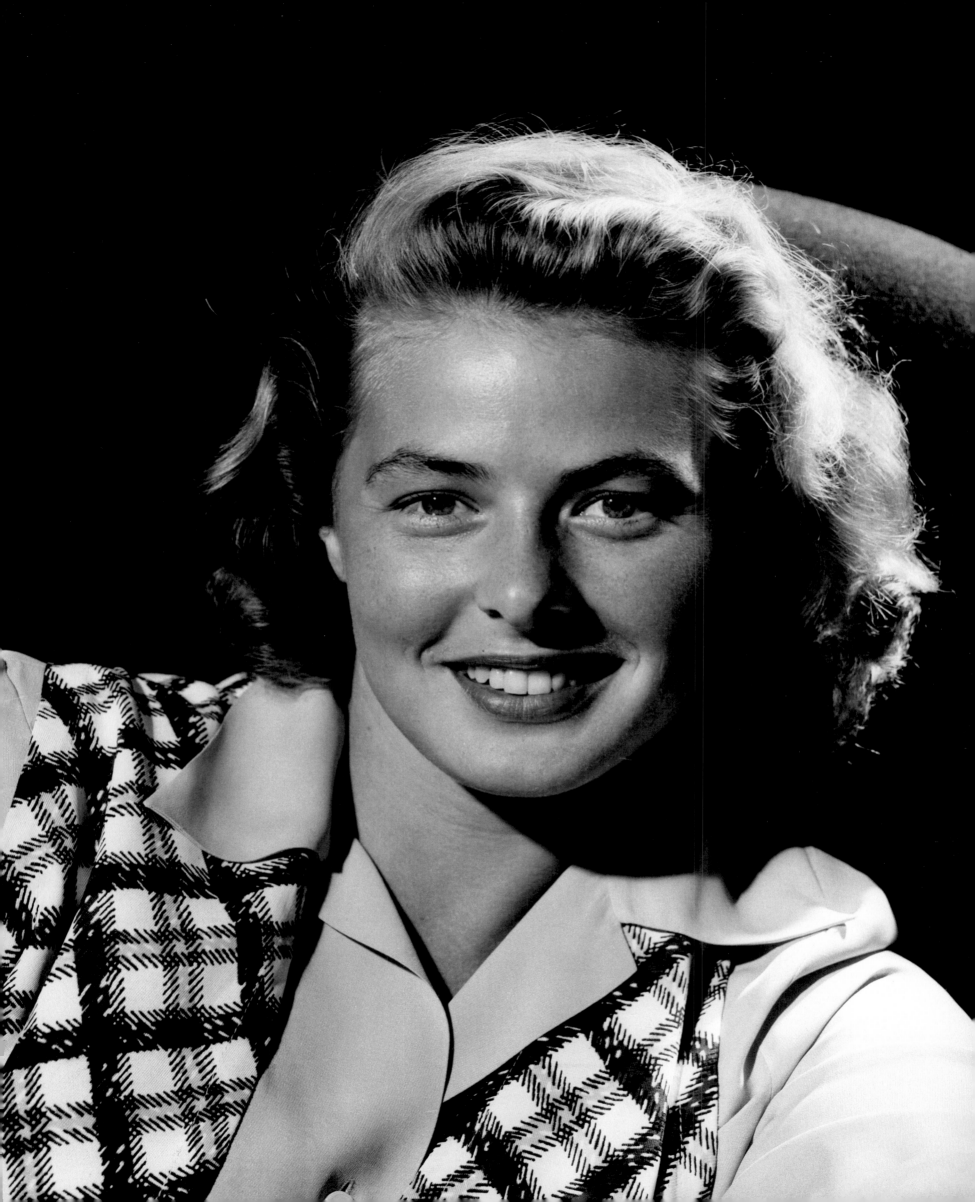

Dean Martin JERRY Lewis 1951

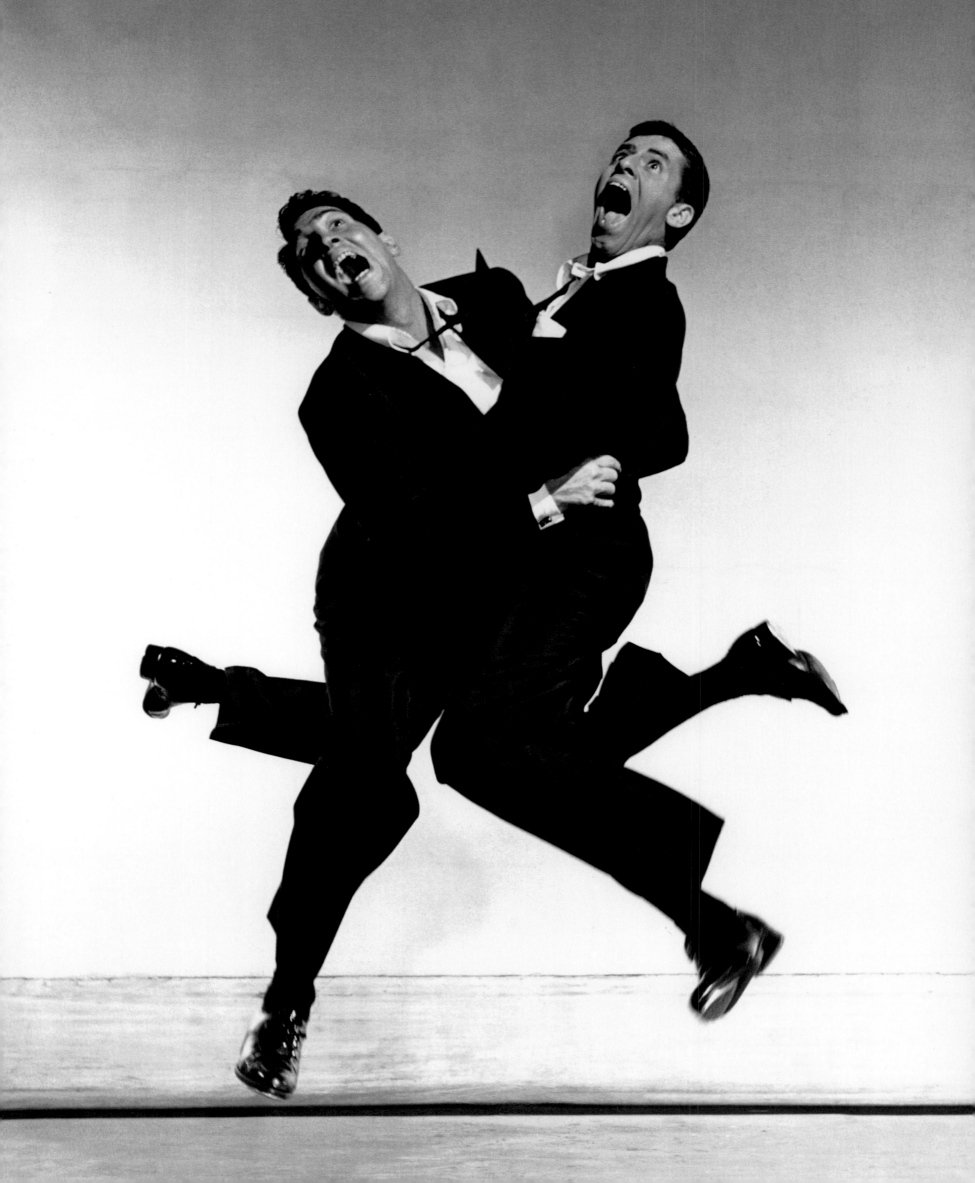

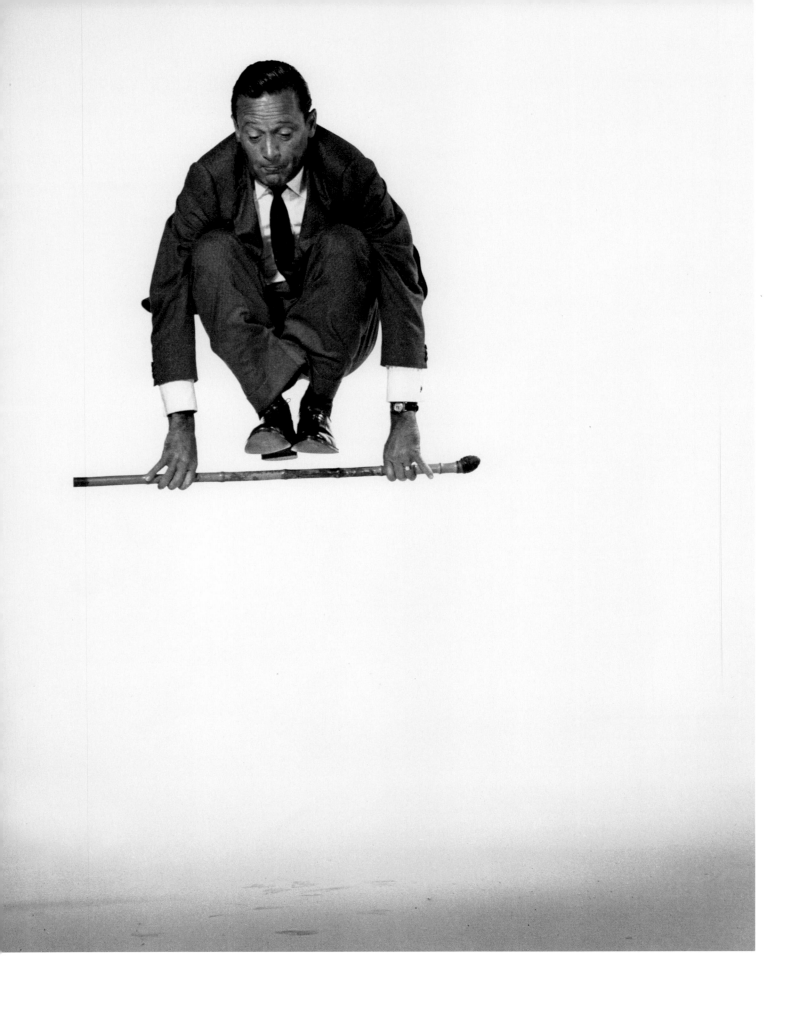

JUMPS

William Holden
1954

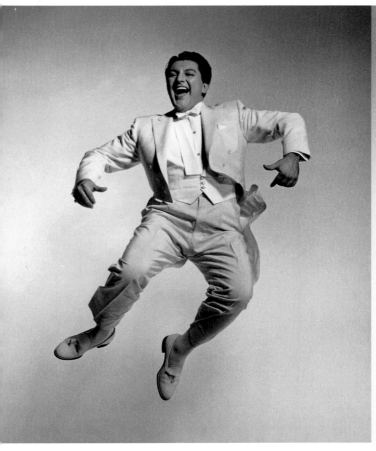

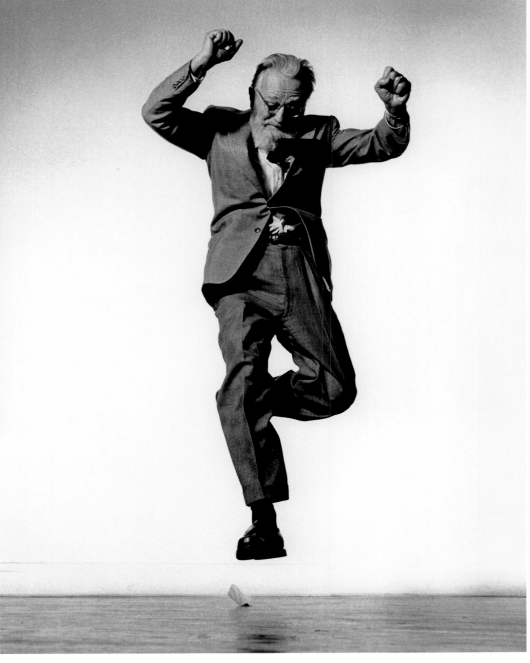

Liberace
1954

Edward Steichen
1959

Grace KELLY
1954

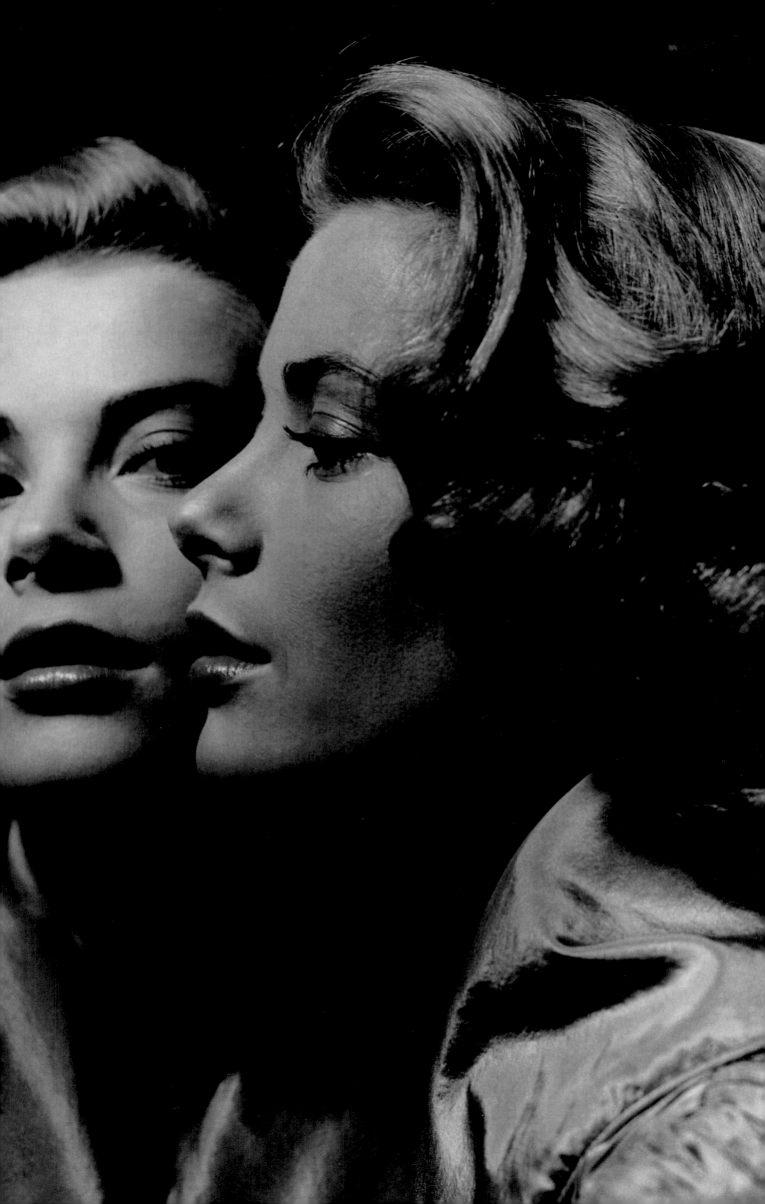

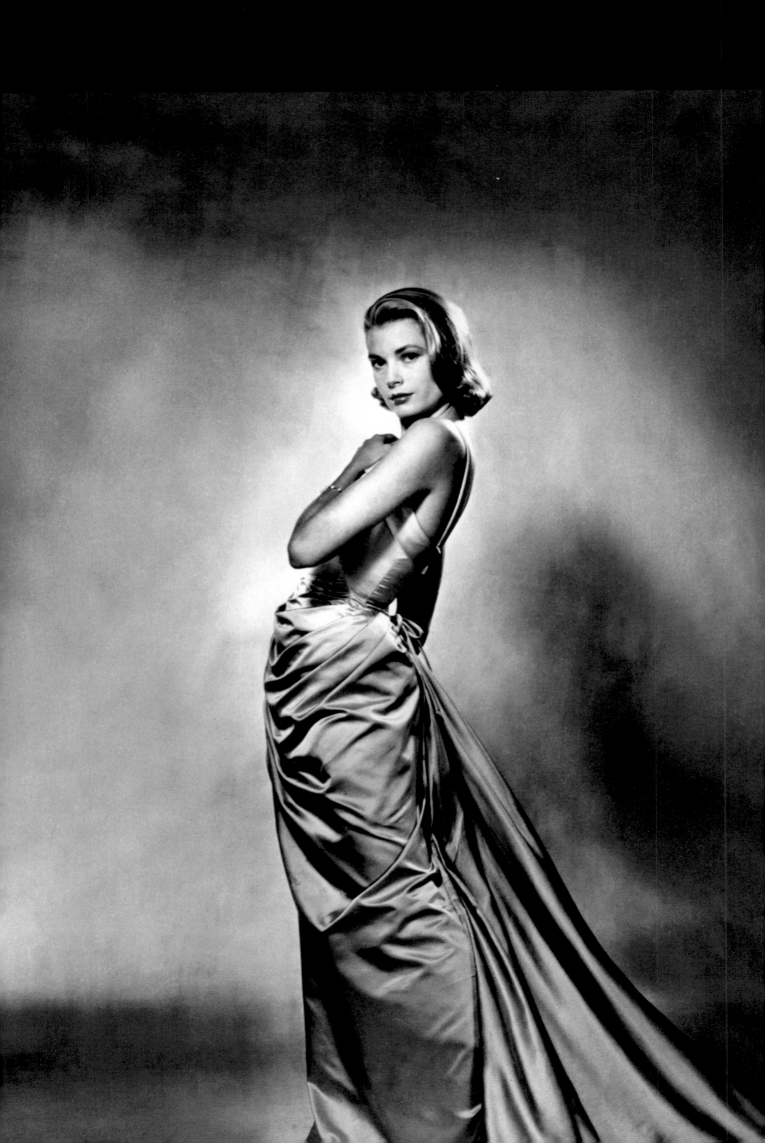

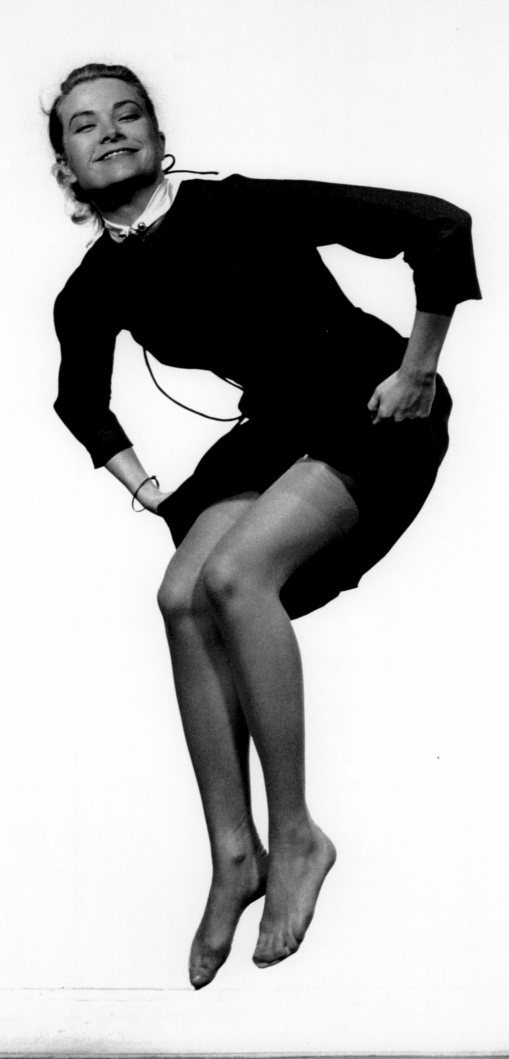

Grace KELLY

1955

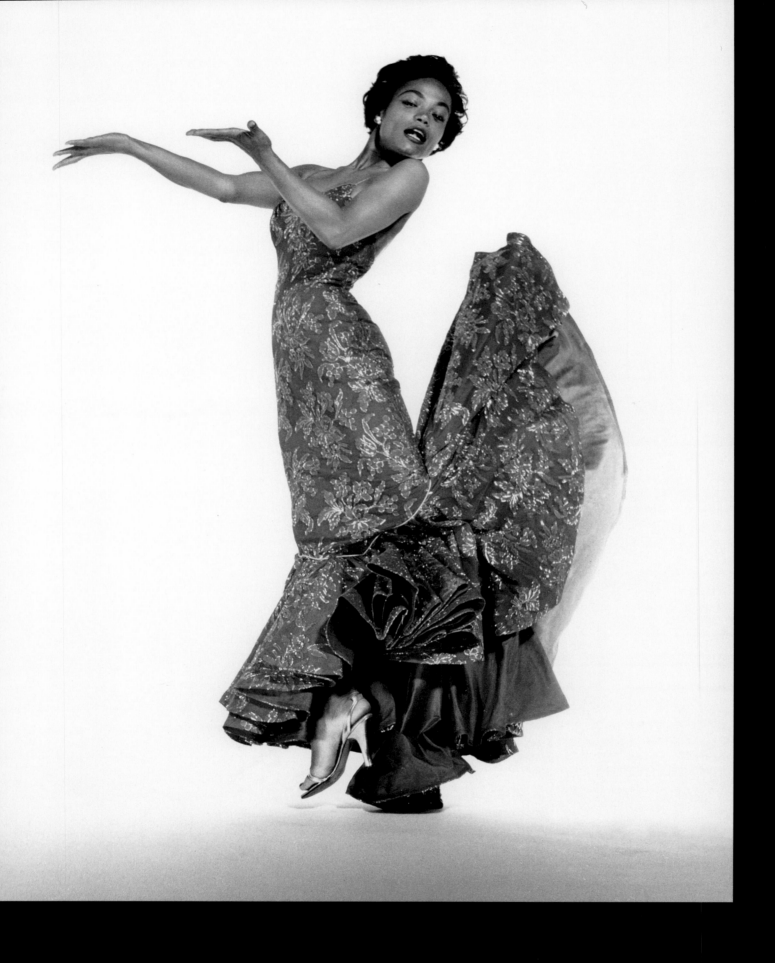

Eartha KITT

1954

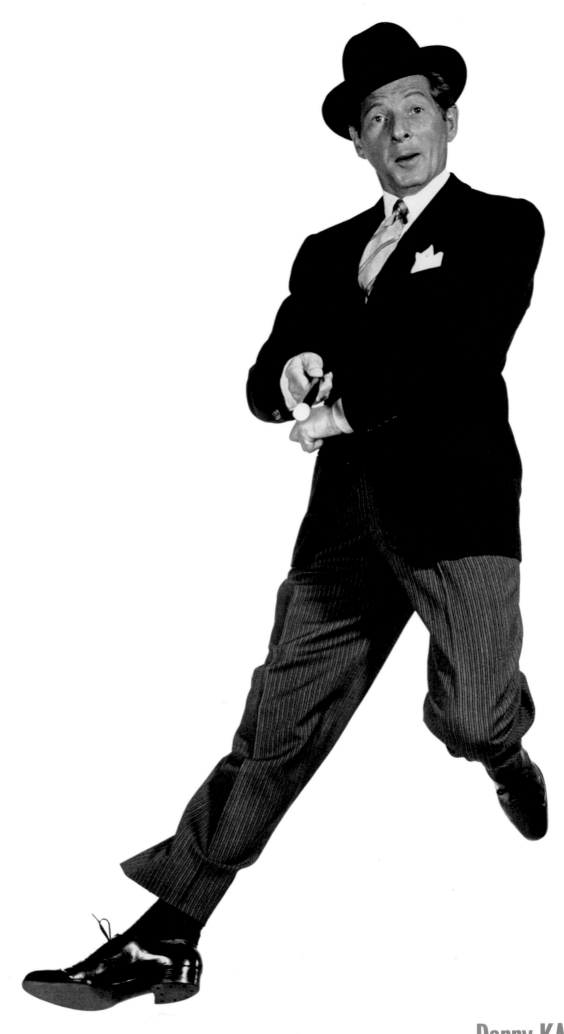

Danny KAYE
1954

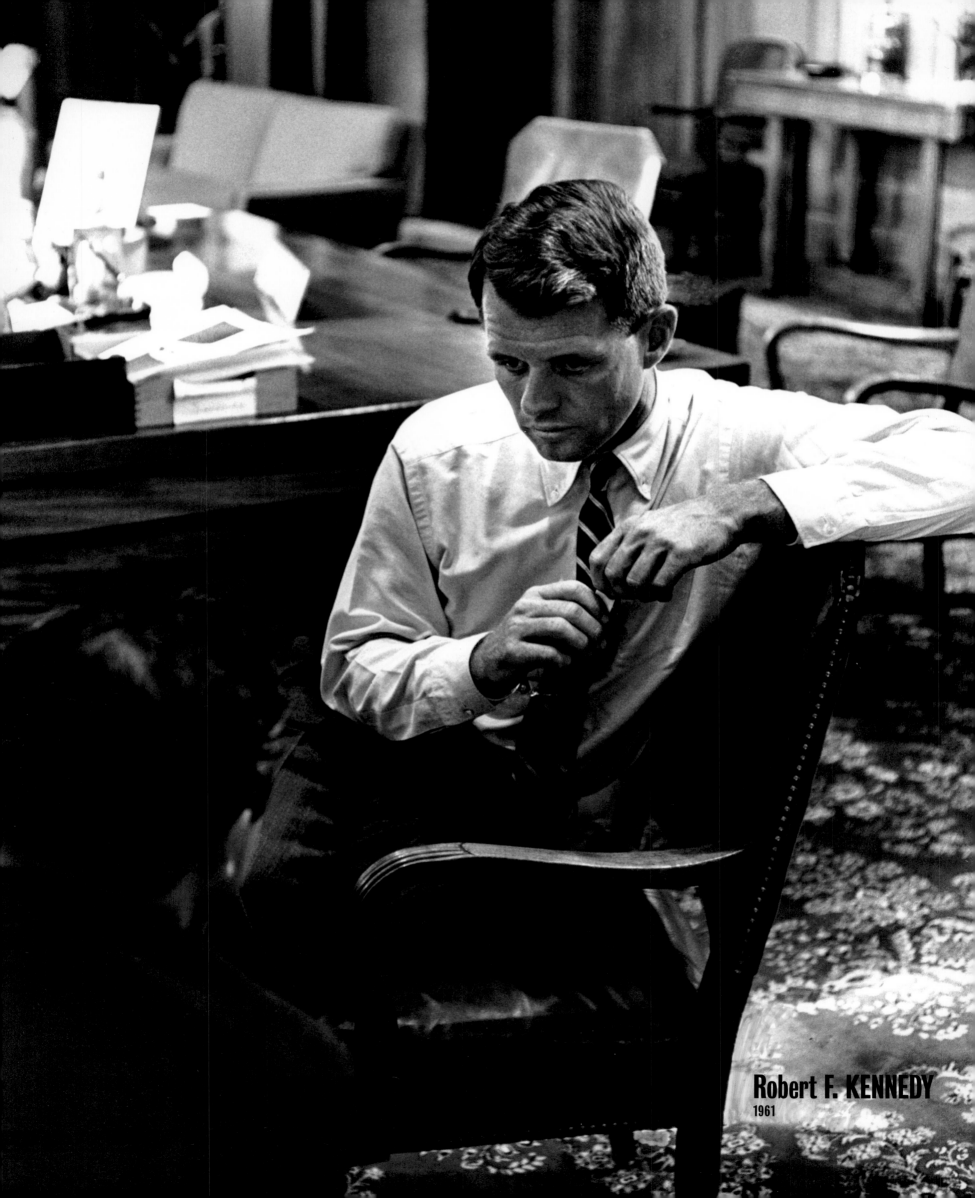

Robert F. KENNEDY
1961

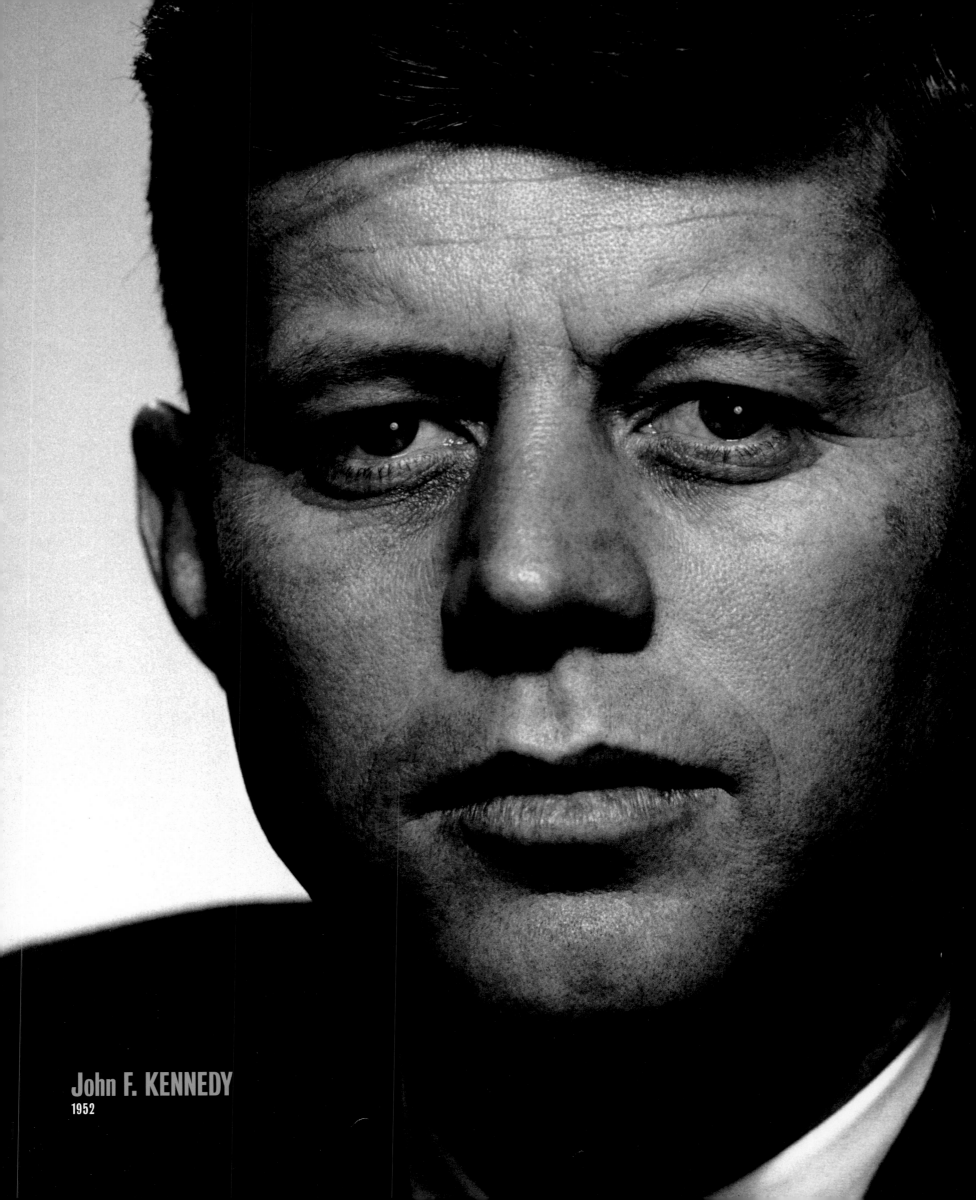

John F. KENNEDY
1952

L

LE CORBUSIER
1935

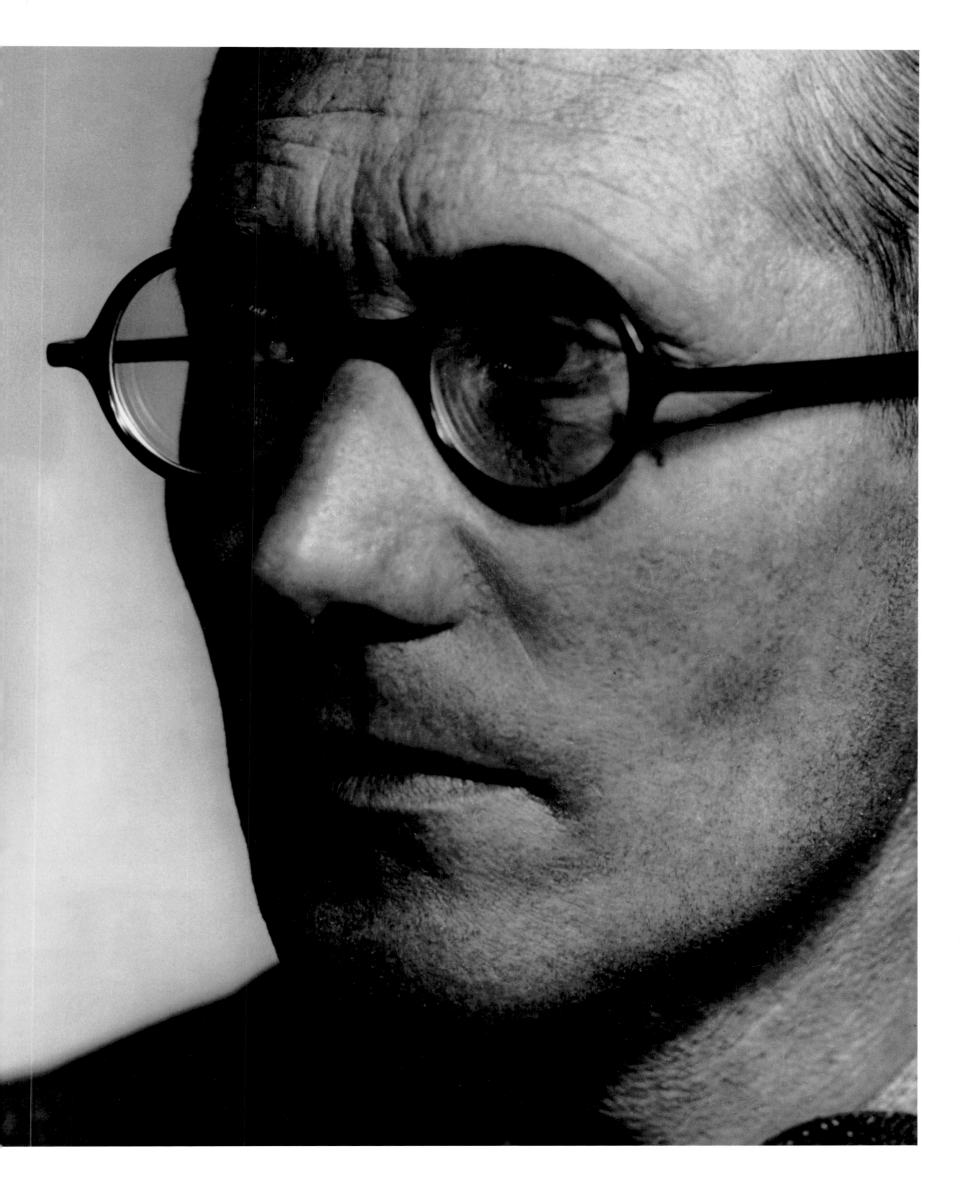

Vivien LEIGH & LAURENCE Olivier
1951

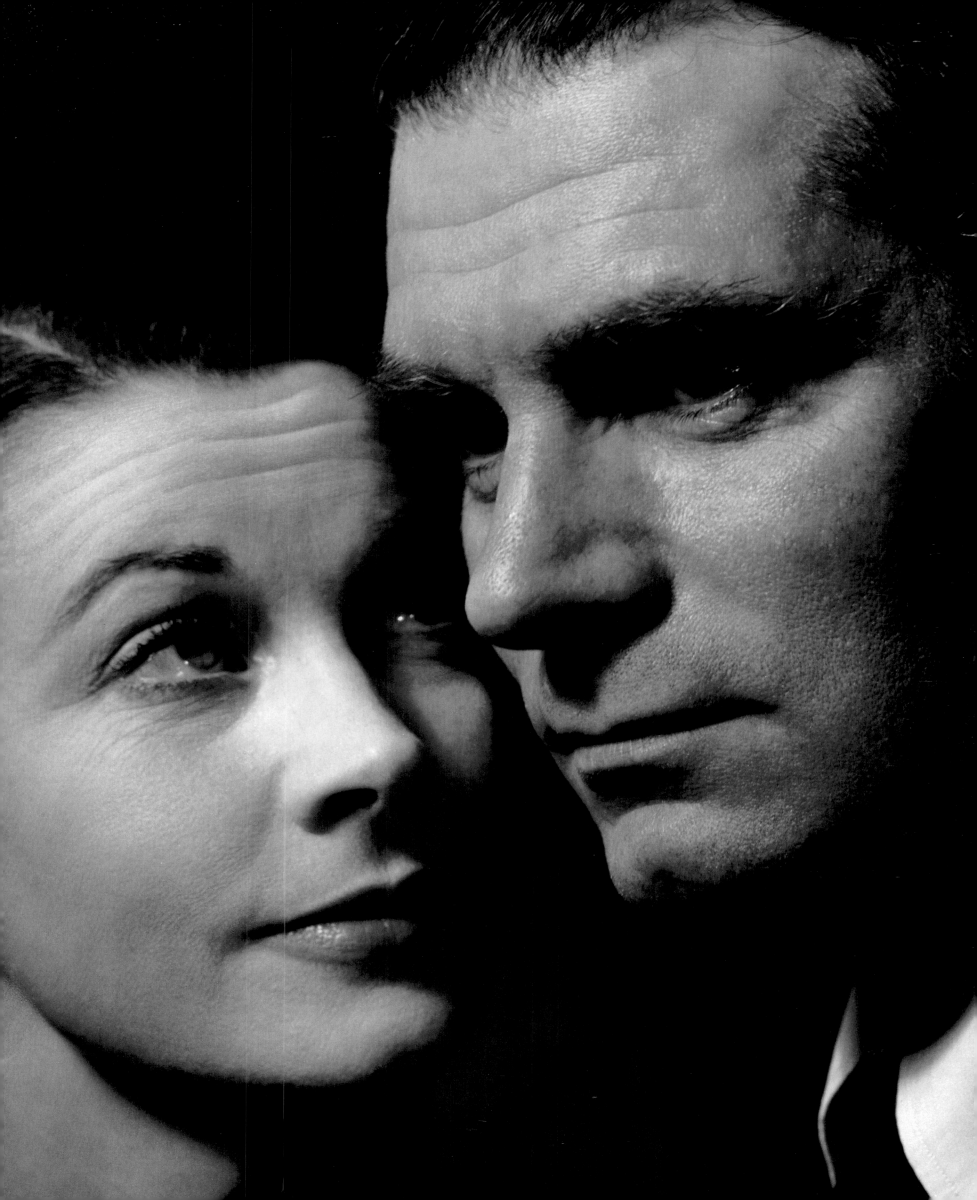

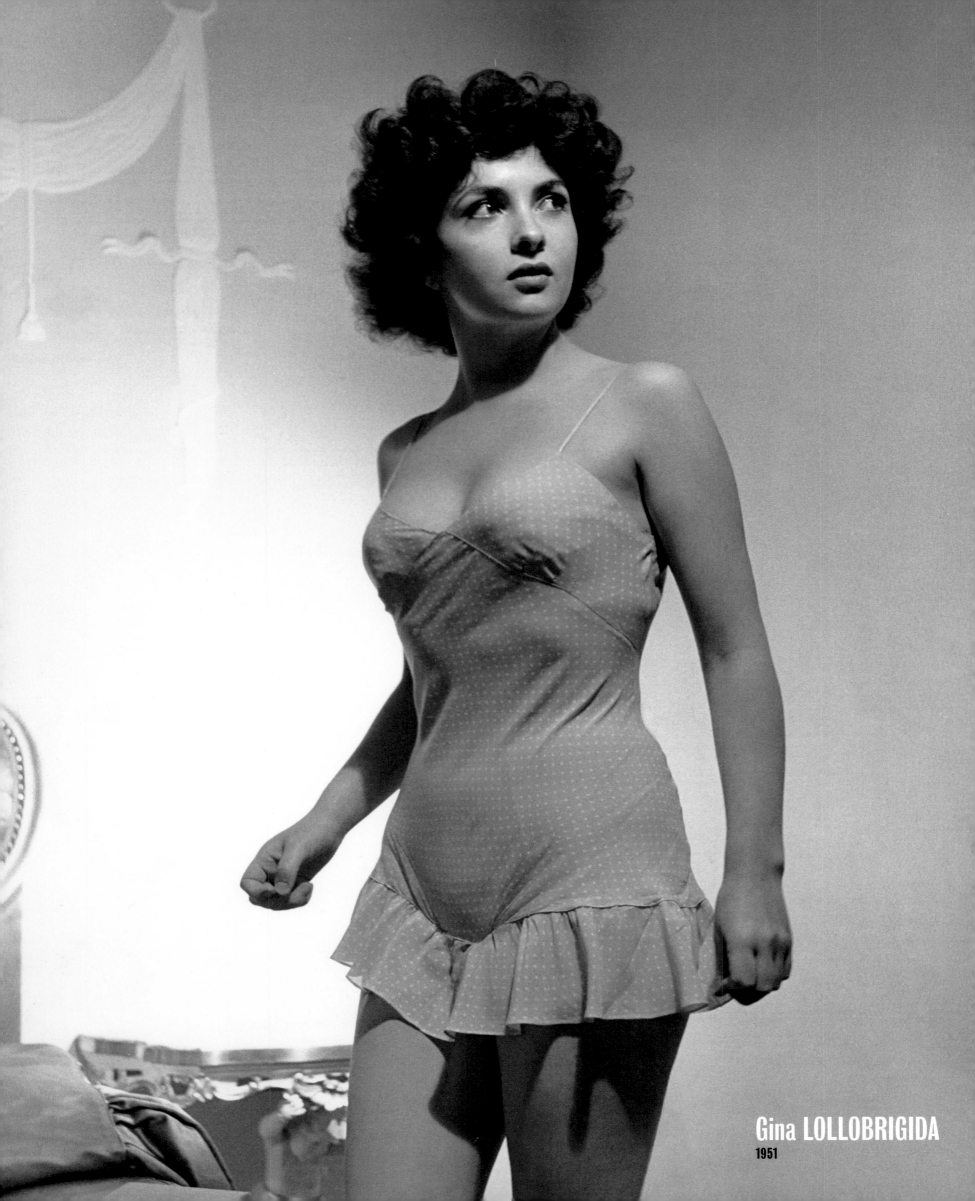

Gina **LOLLOBRIGIDA**

1951

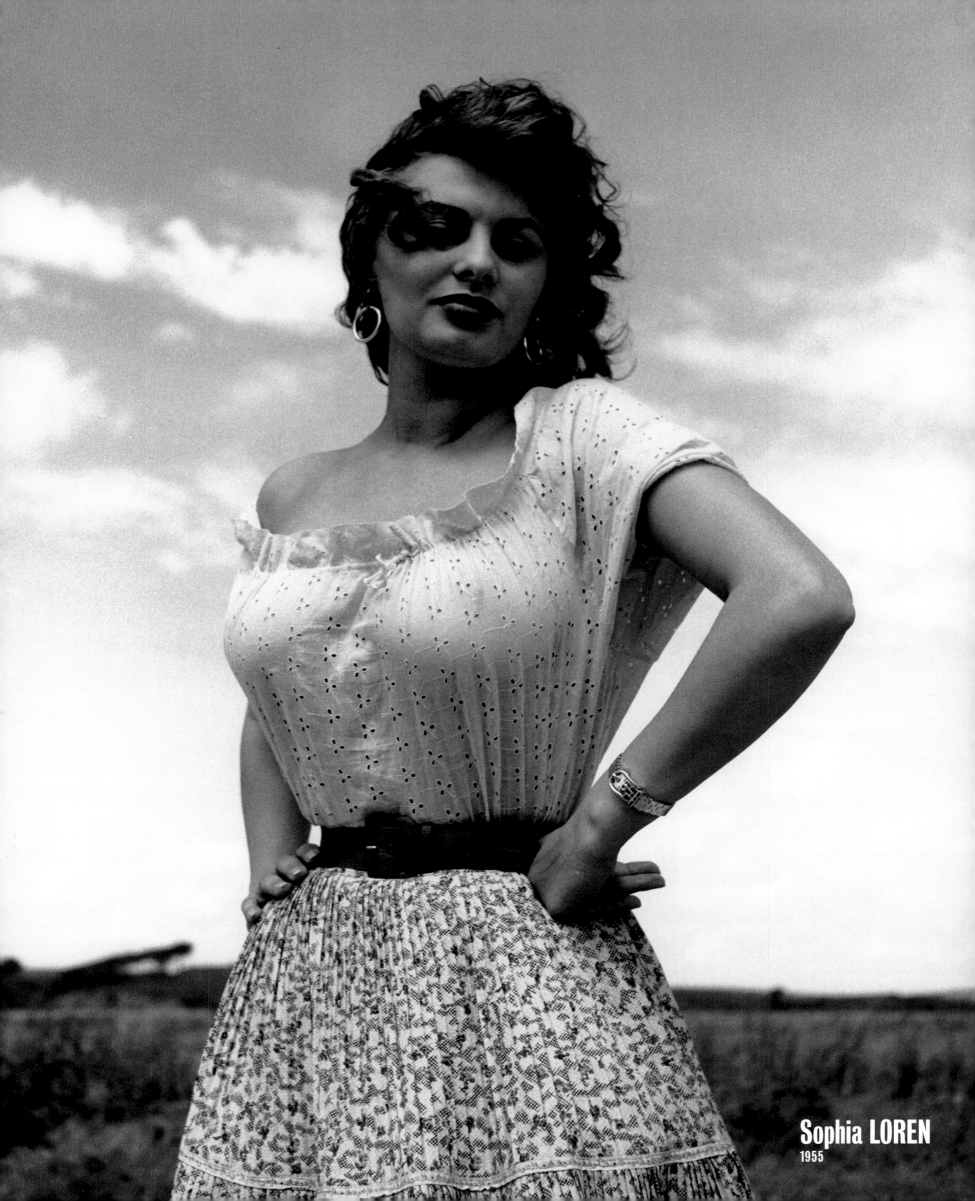

Sophia LOREN
1955

M

MARILYN Monroe
1952

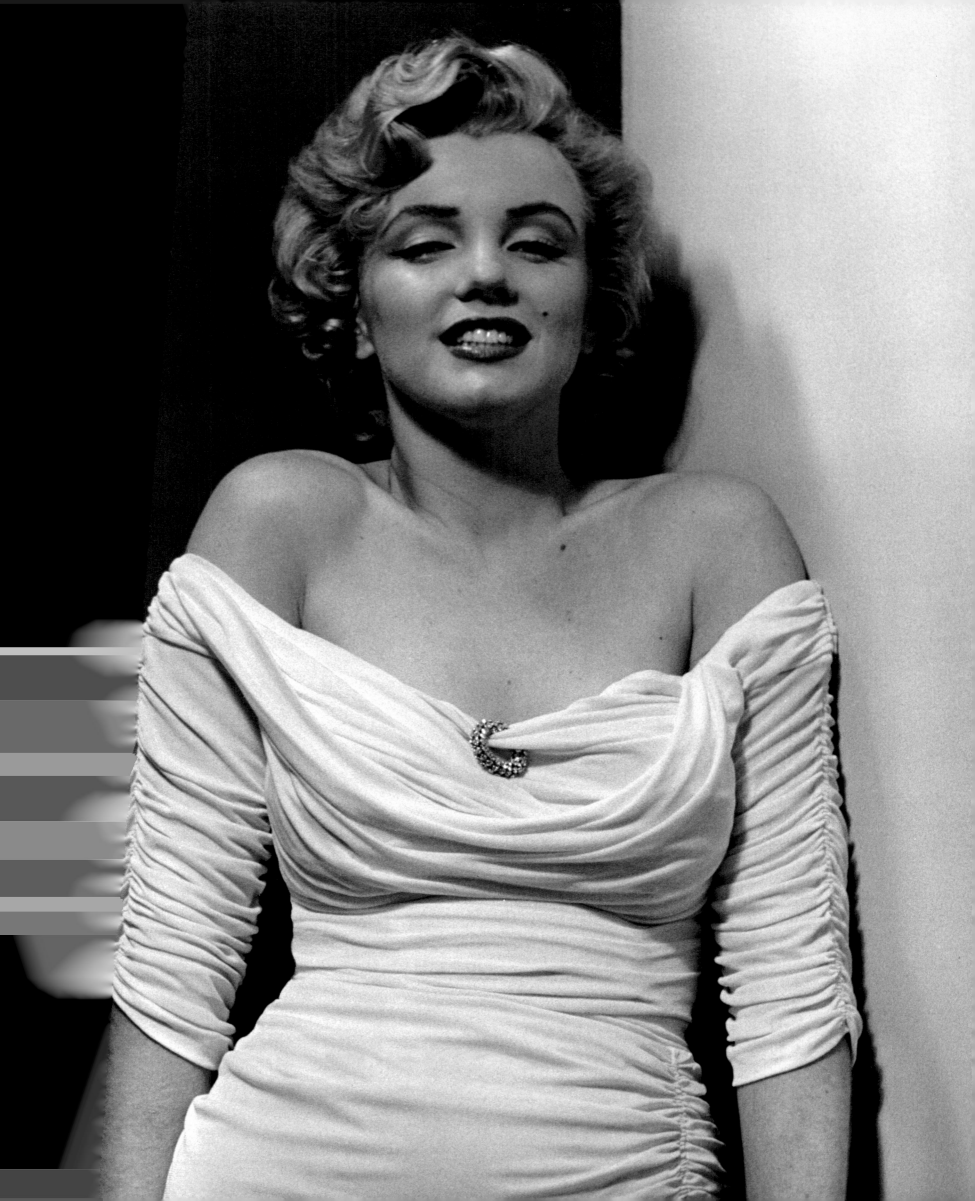

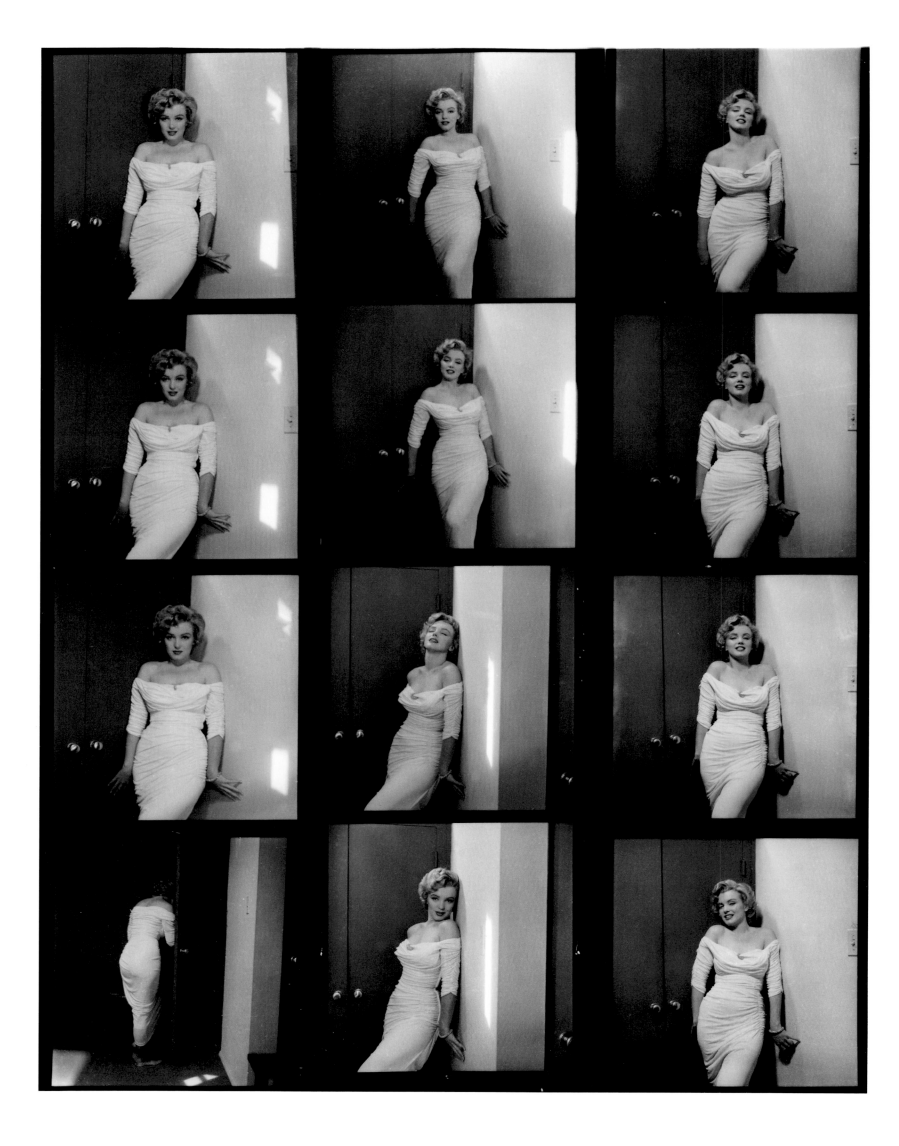

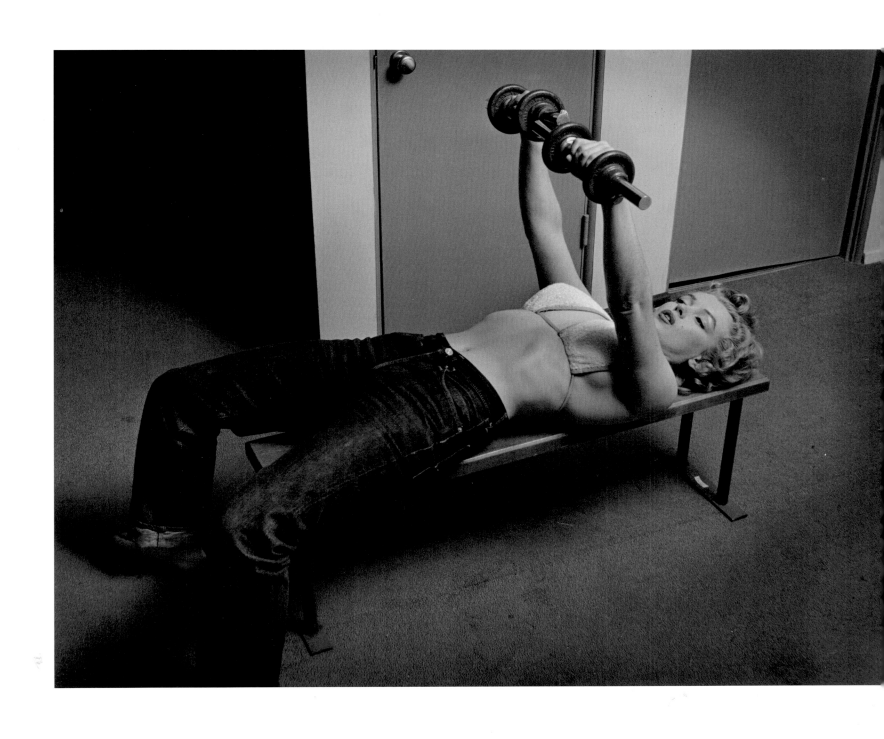

MARILYN Monroe
1959

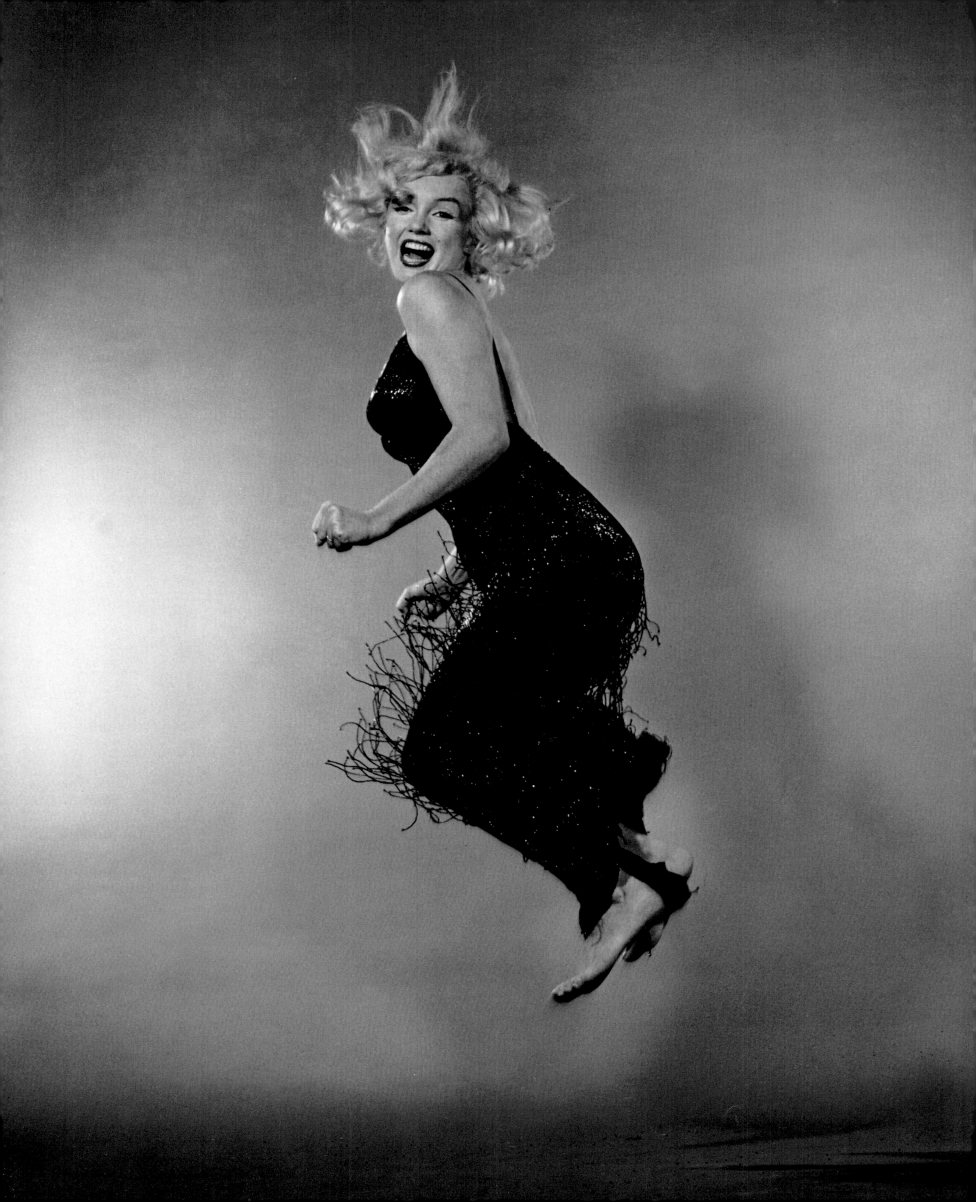

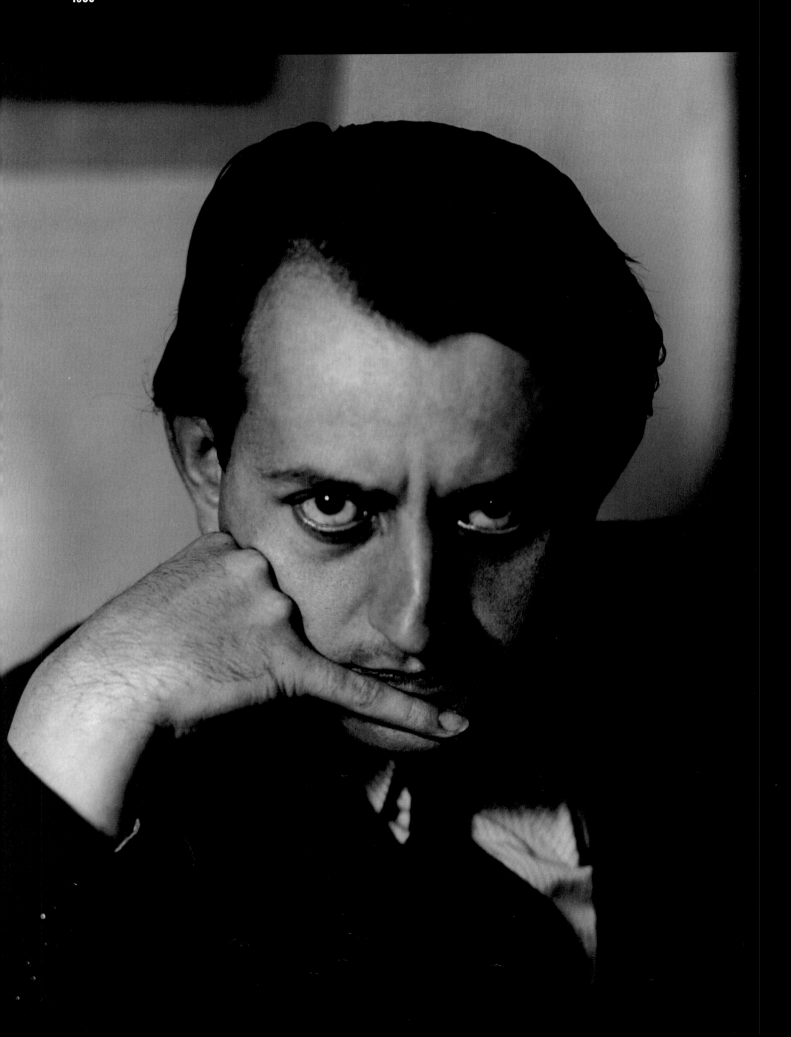

André MALRAUX
1935

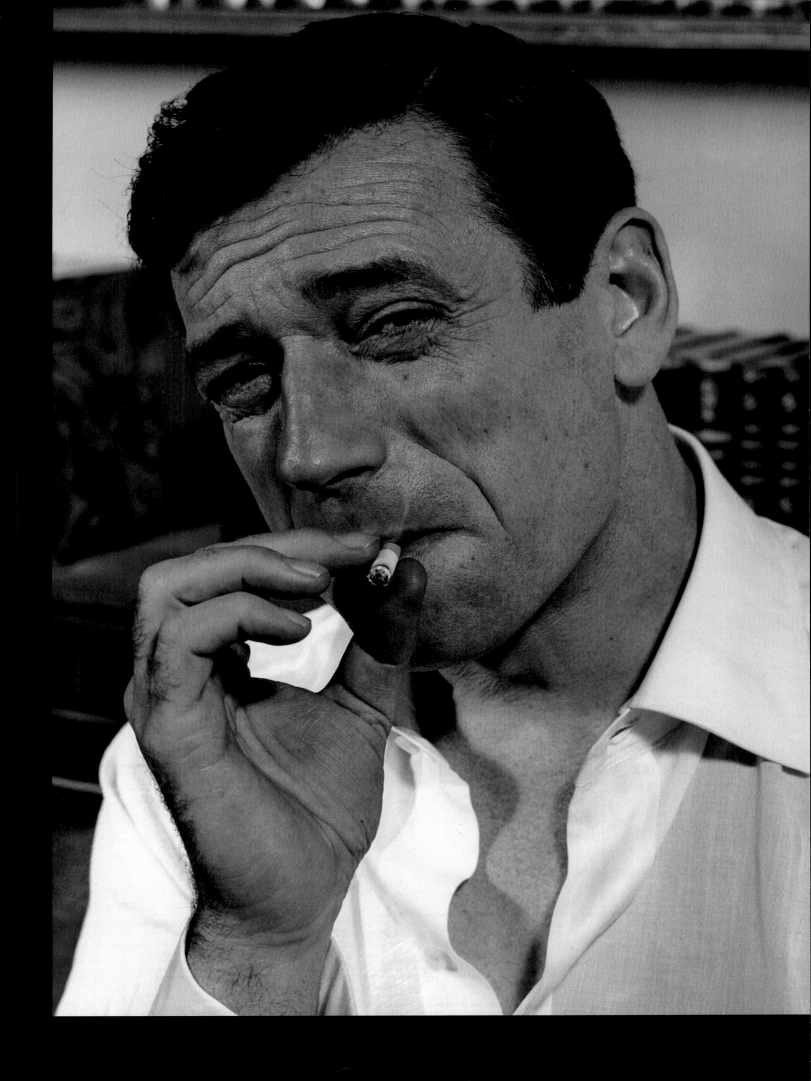

Yves MONTAND
1960

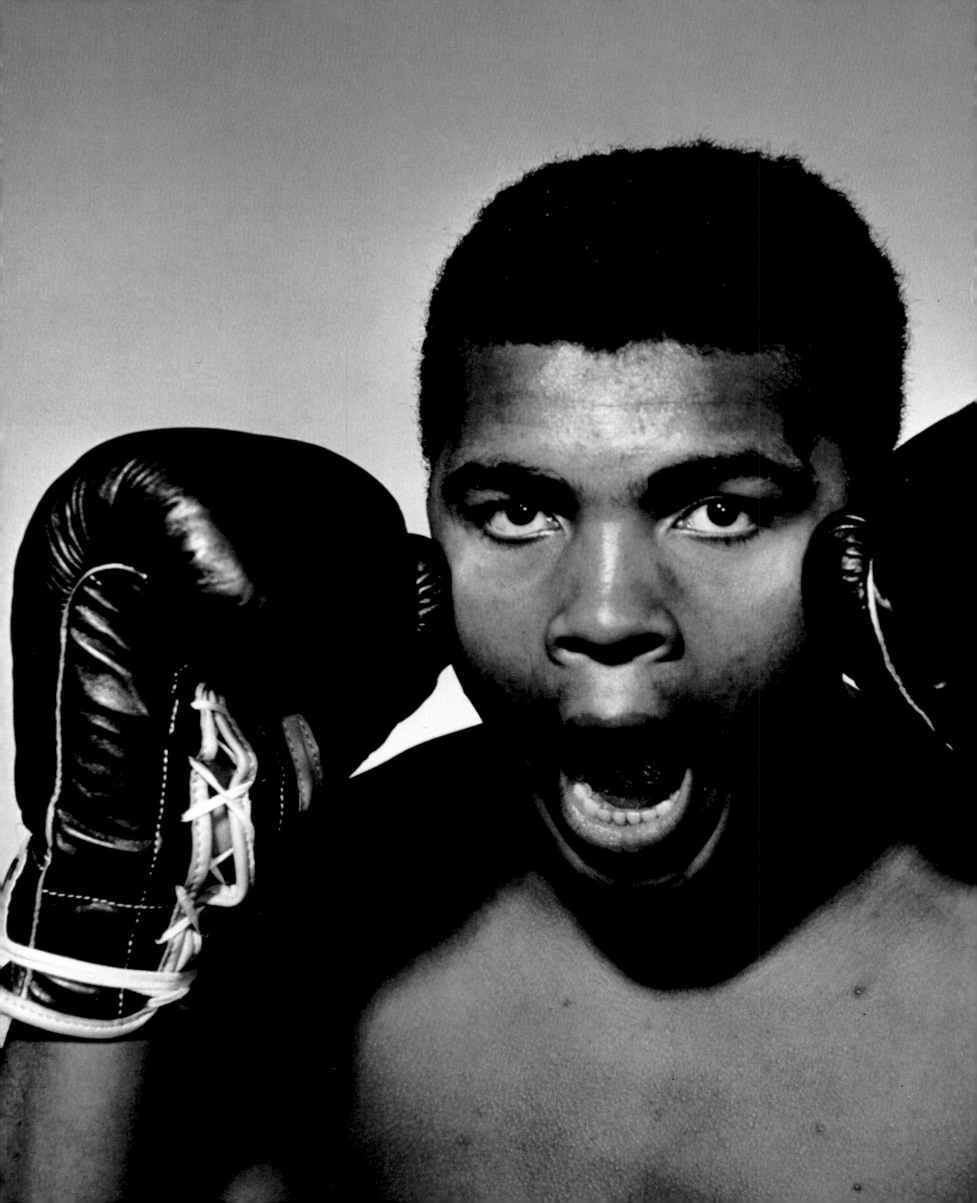

MUHA
1963

I was already an ardent admirer of Anna
Magnani when I saw the movie *Bellissima* in
Italy. It was a cheap and corny movie, made
only for domestic consumption, but it gave
me final proof that Magnani was the greatest
dramatic actress I had ever seen. There,
surrounded by overacting actors, was a full-
blooded human being, not acting but living
her part with incredible intensity and vitality.
I had never seen a greater range of emotions,
starting with paroxysms of exuberant joy and
ending with depths of unbearable grief.

 Therefore I was delighted when,
during a visit to Rome, I was given the
assignment to photograph her. Accompanied
by my wife, Yvonne—who again played the
part of my assistant—and carrying my
equipment and the biggest box of Perugina
chocolates I could find, I arrived at an old
Roman palazzo. Anna Magnani lived on the
third floor. I did not want Magnani to pose,
and I started to photograph her while she
was talking. Soon she opened up even more
and spoke about her son, her only child,
a beautiful and gifted boy who was
hopelessly crippled by polio. Magnani had
tried every treatment for him, but nothing
helped; he was in a special sanitorium in
Switzerland. What I was getting now were
not pictures of an actress acting but of a
woman telling about her own personal
tragedy.

 On parting, I realized that not even once
had I tried to make her look beautiful in my
photographs. All the women I had ever
photographed—glamorous actresses or
brainy writers—all had asked me to make
them look as beautiful as possible. I did not
want Magnani to be disappointed, and I
warned her, "My lens is very sharp; it will
show all the lines in your face."

 "Don't hide them," she replied. "I suffered
too much to get them."

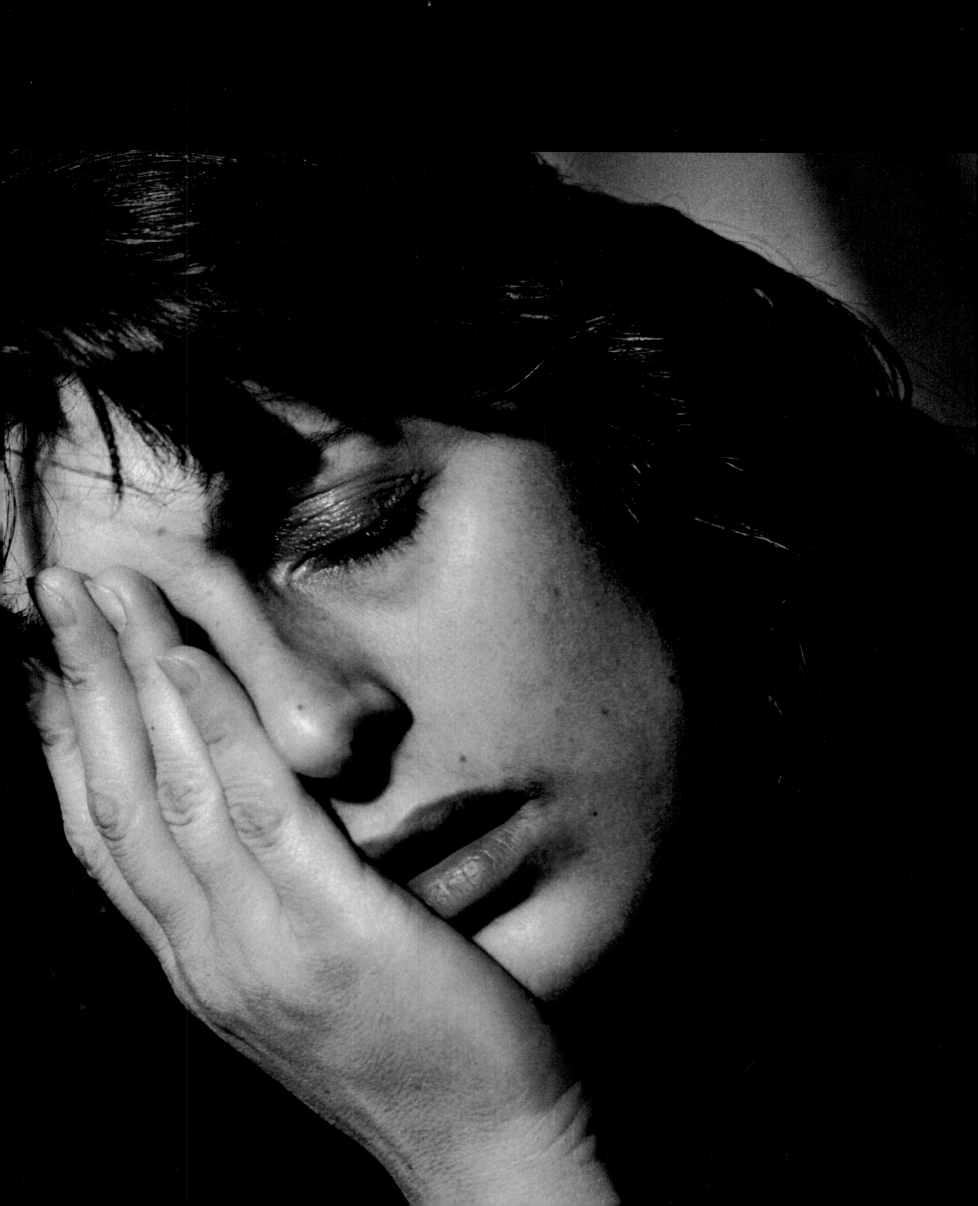

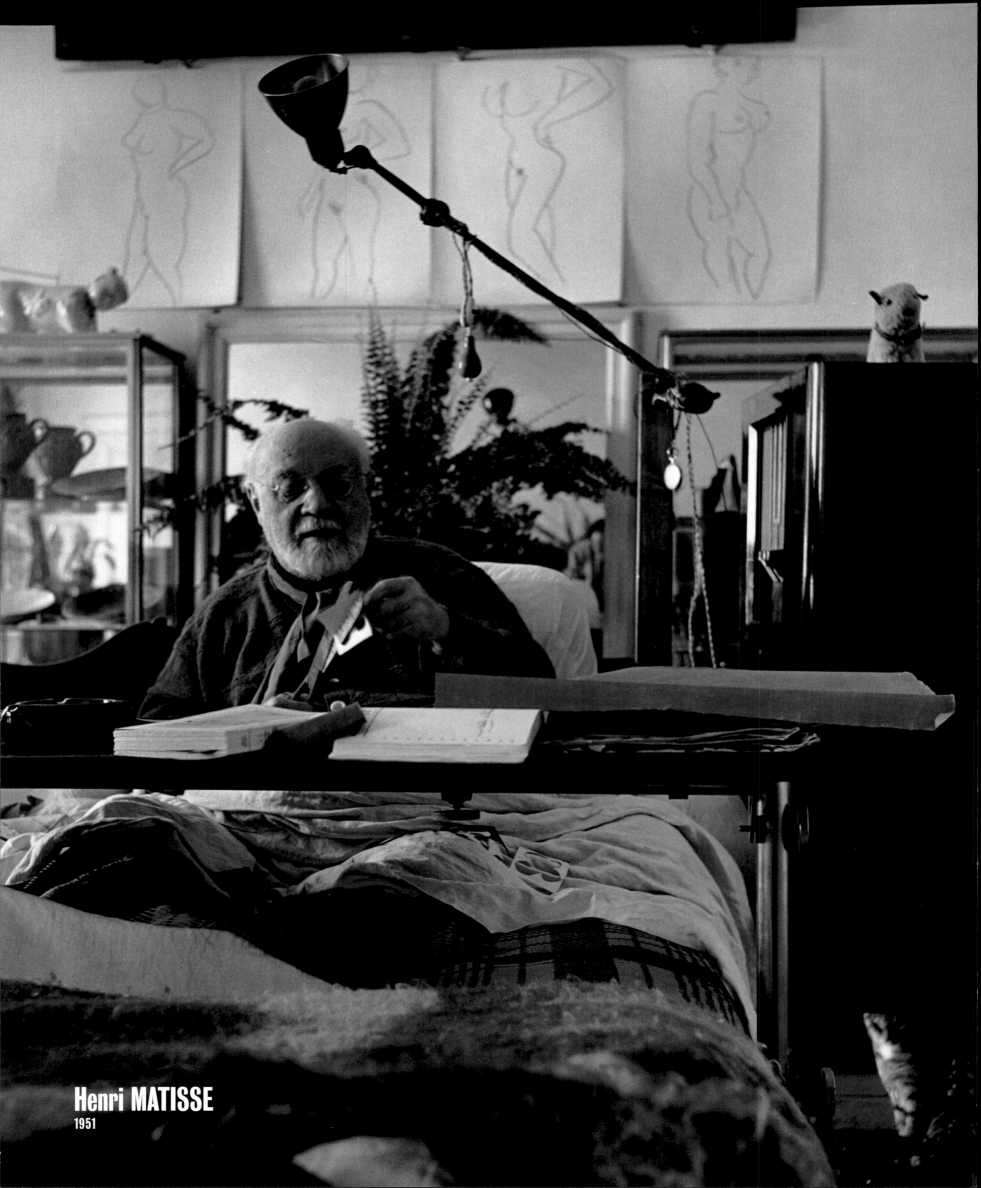

Henri MATISSE
1951

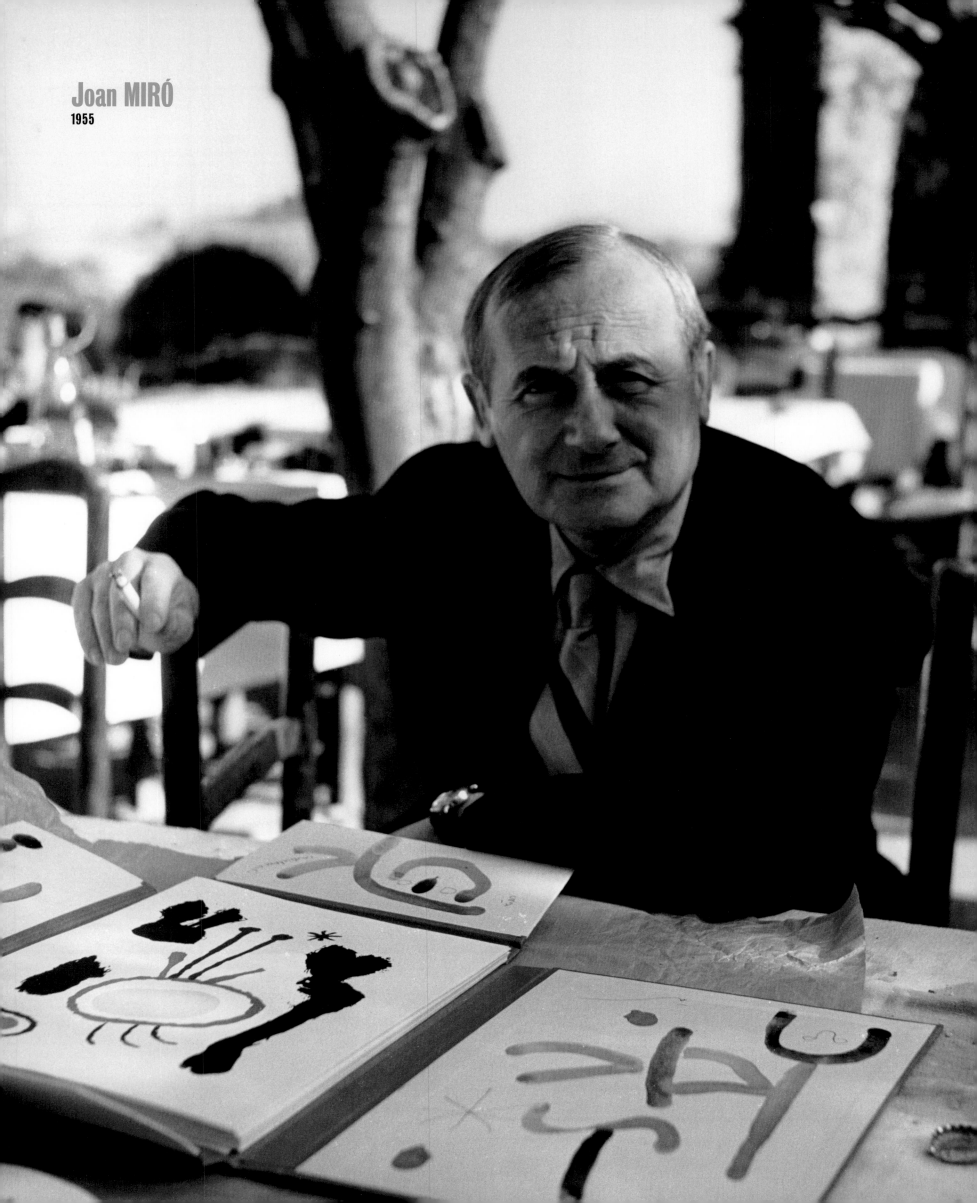

Joan MIRÓ
1955

Mary MARTIN
1950

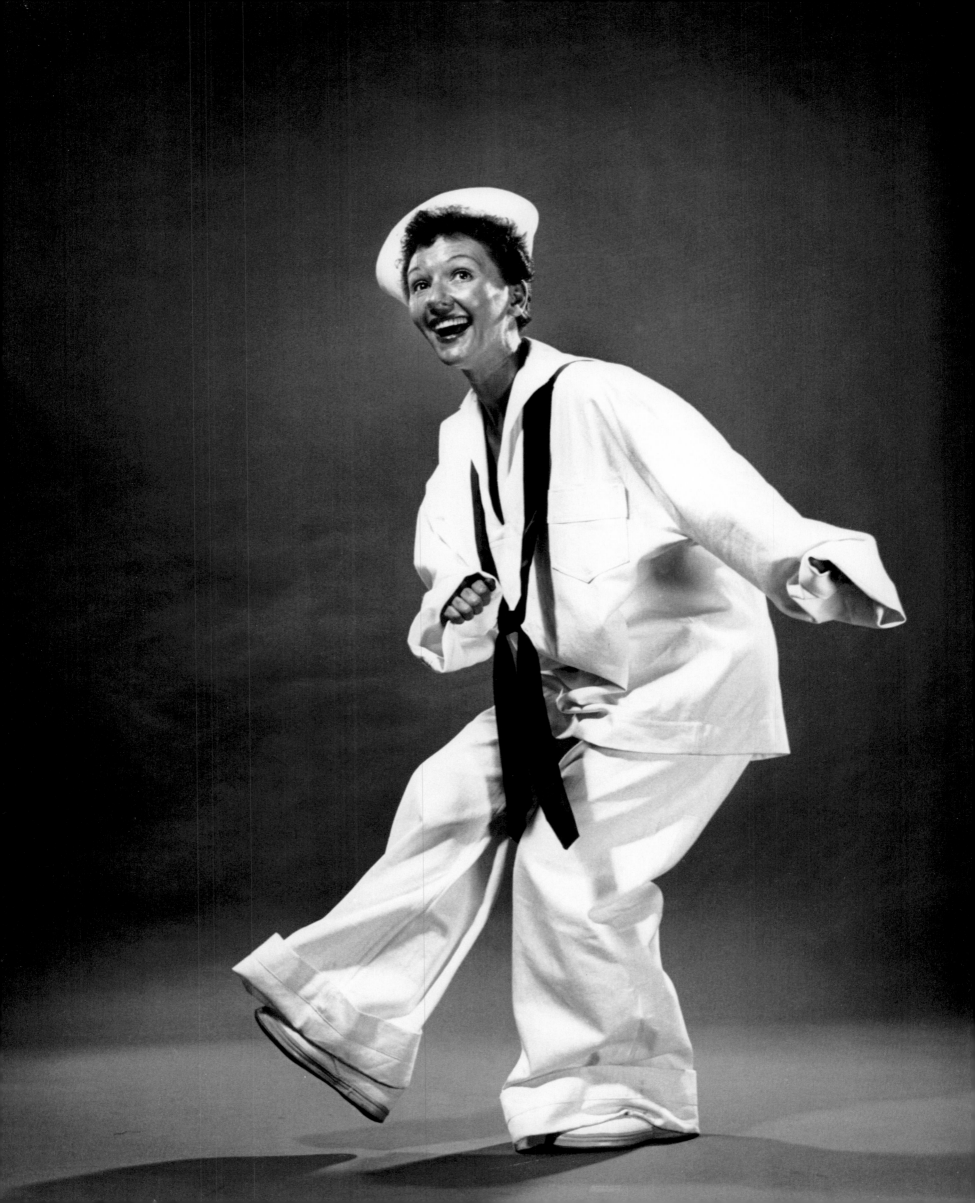

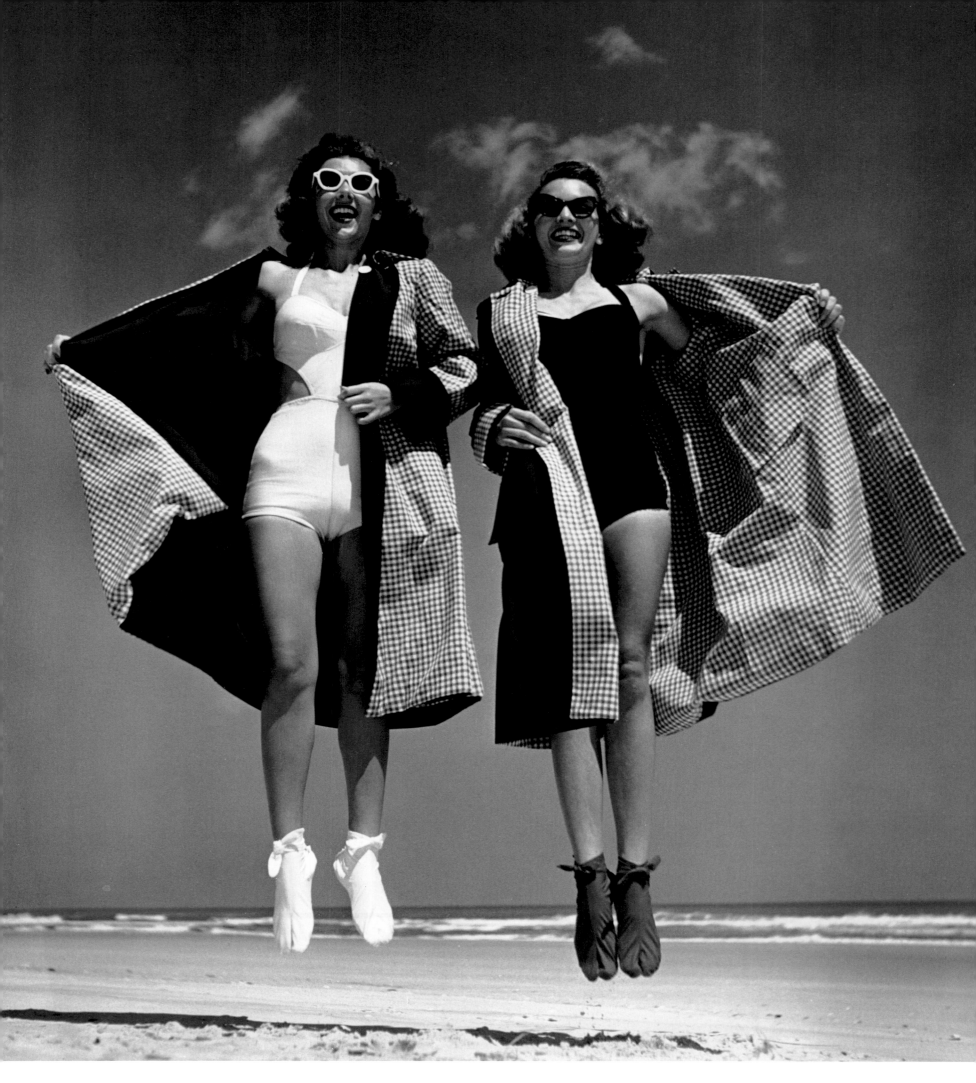

MOST beautiful bathing suit Daytona Beach Bermuda
 1946 1946

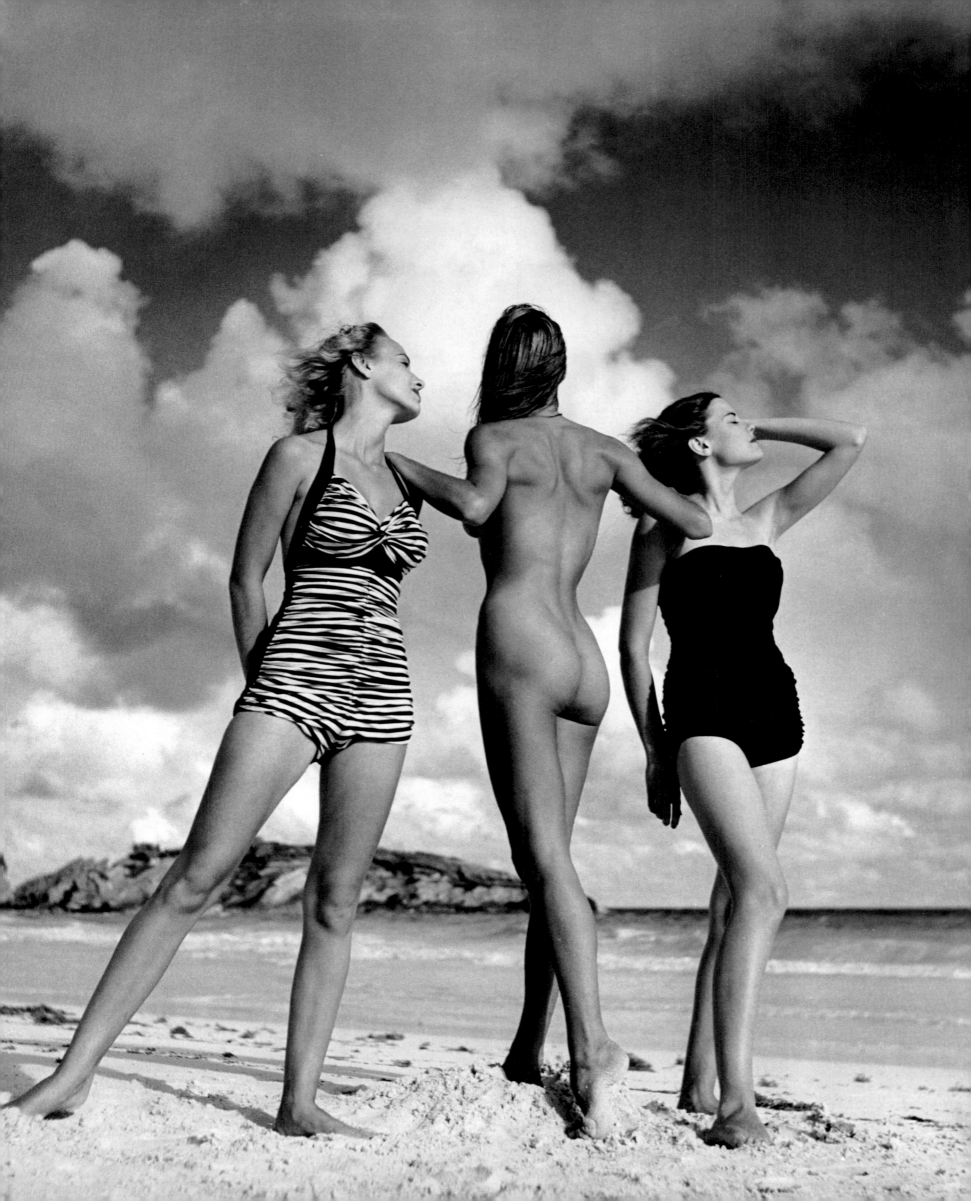

Vladimir NABOKOV
1966

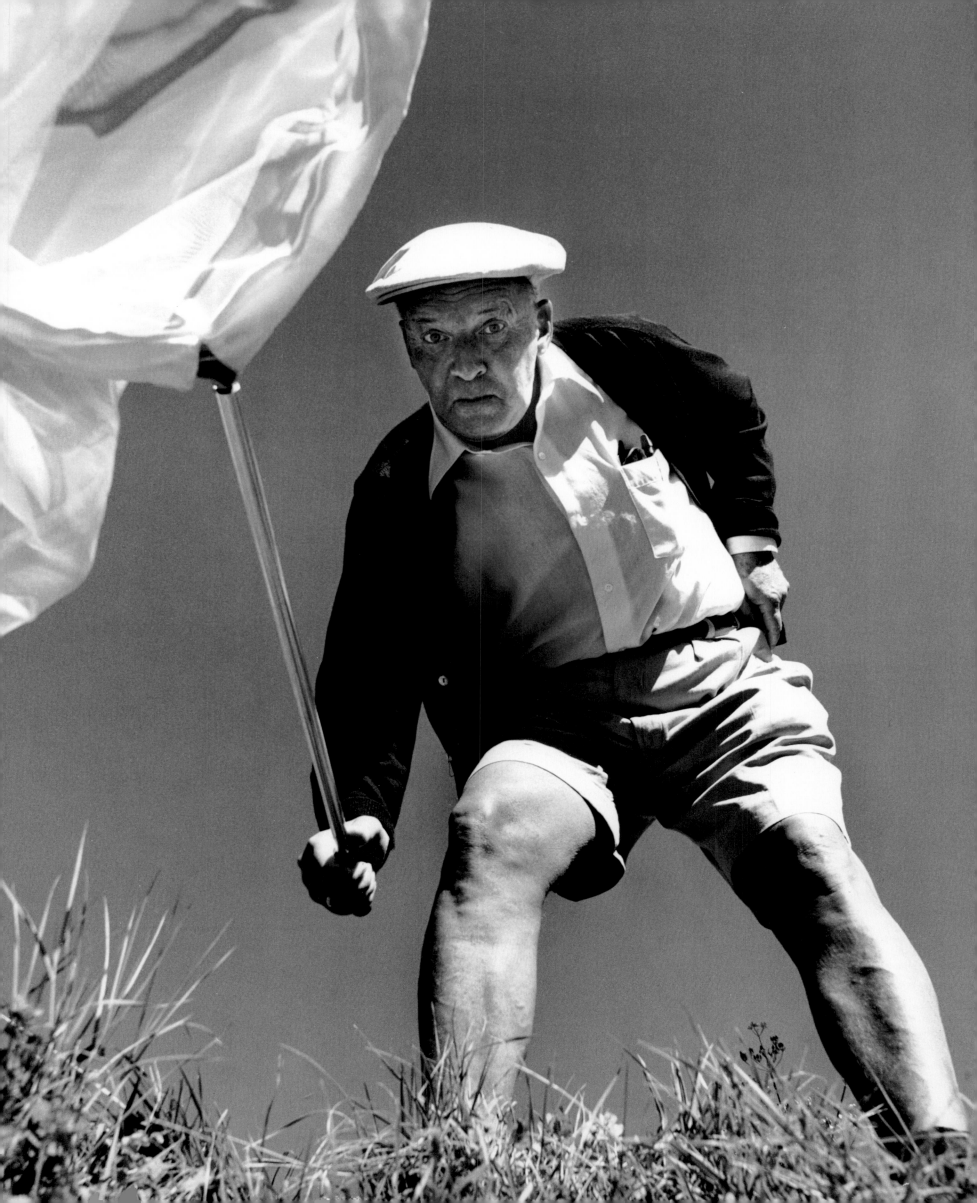

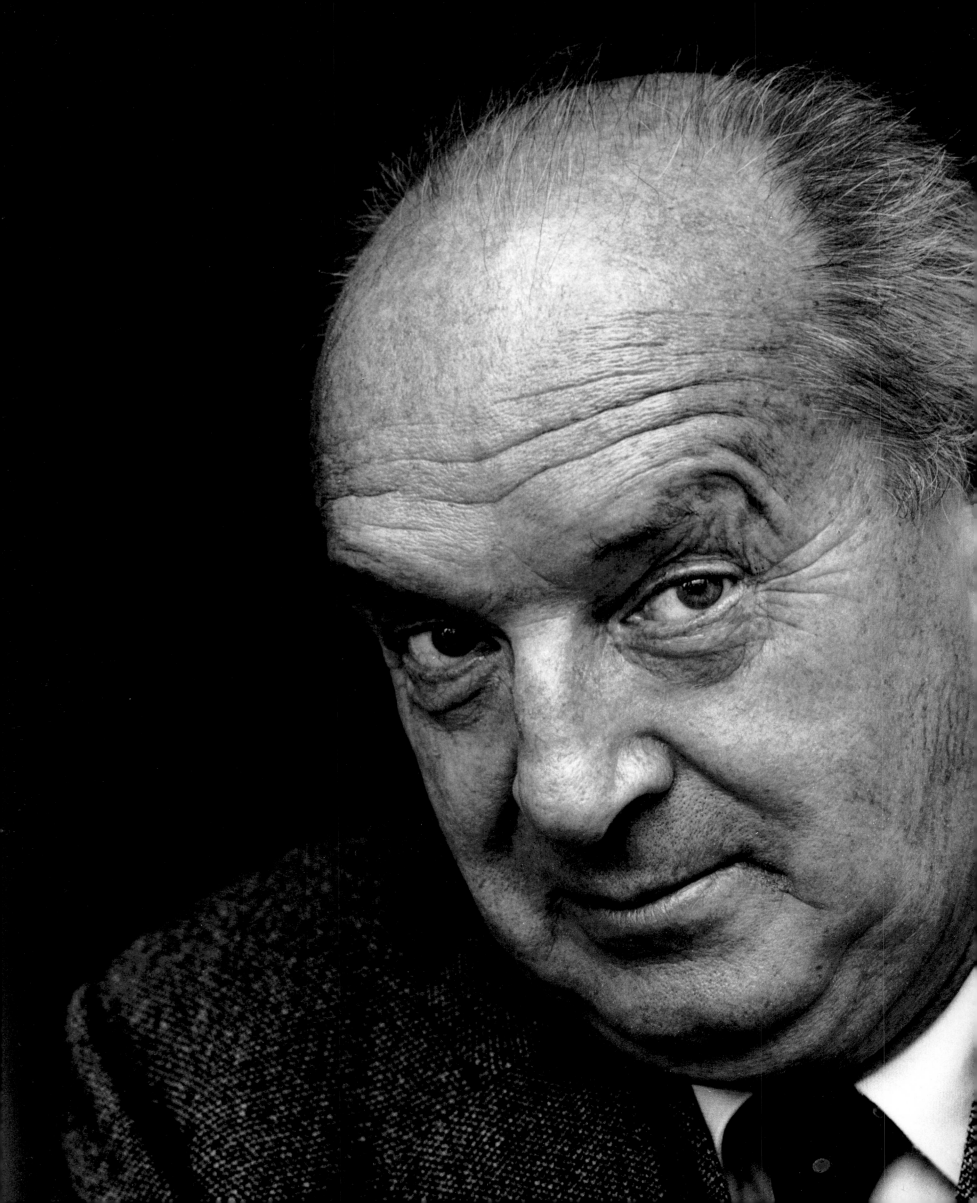

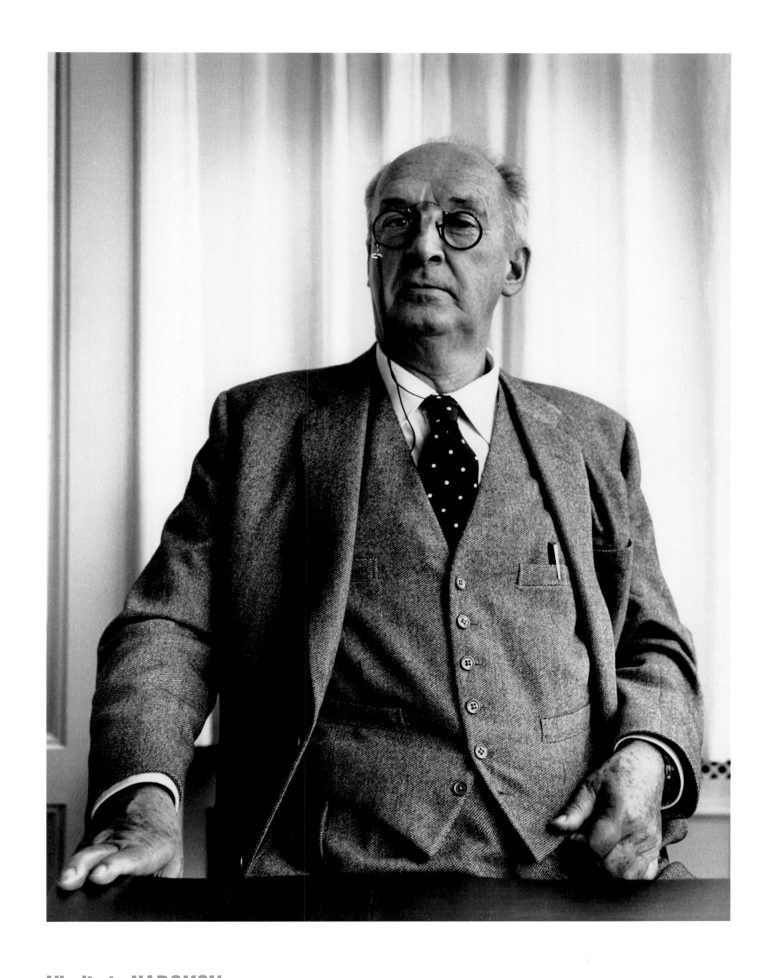

Vladimir NABOKOV
1968

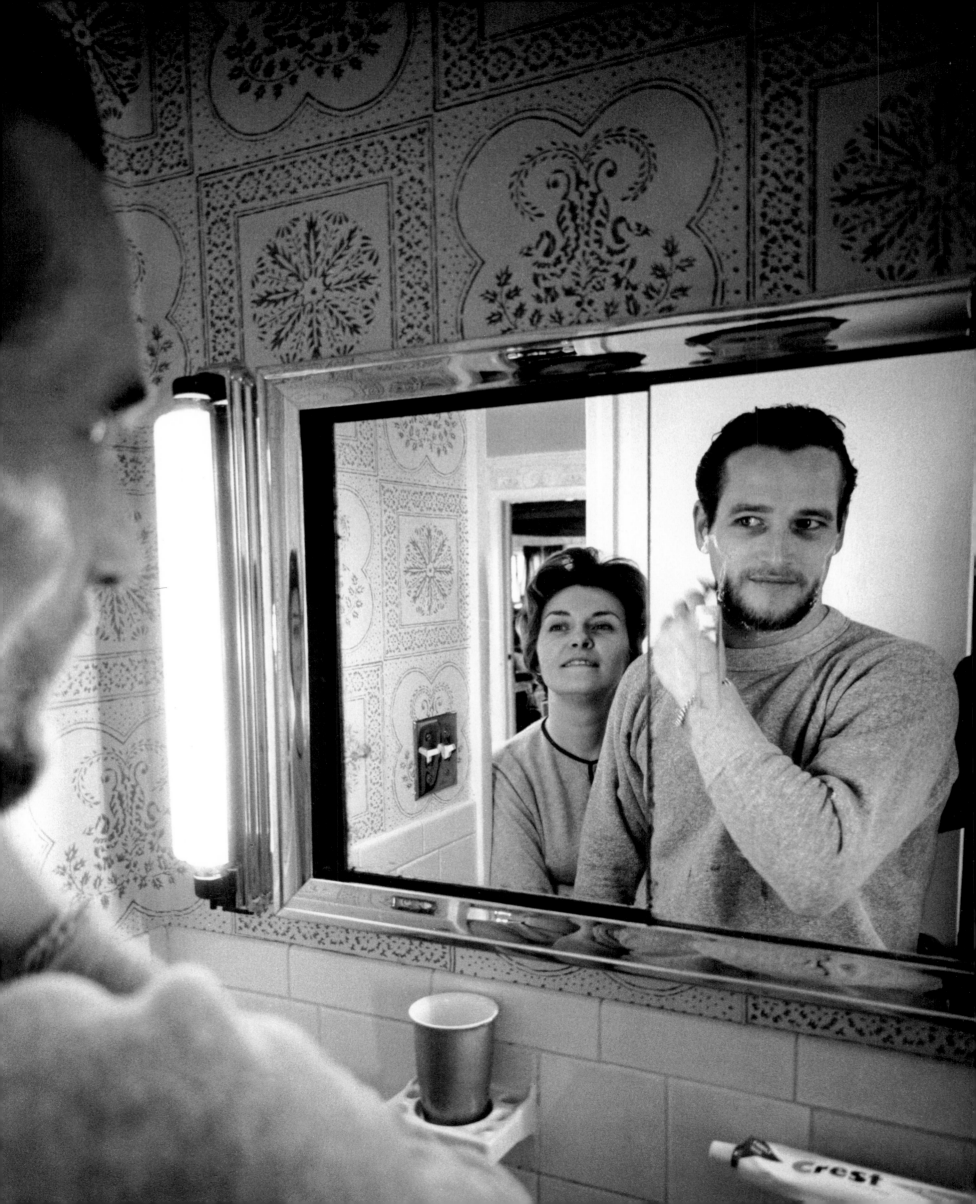

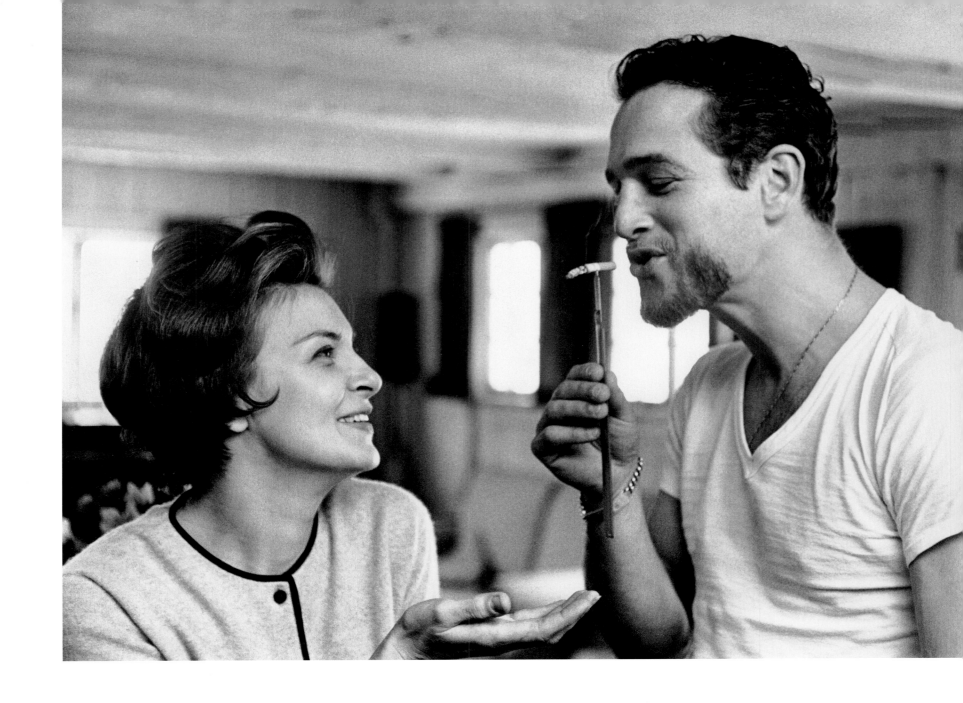

Paul NEWMAN & Joanne Woodward
1963

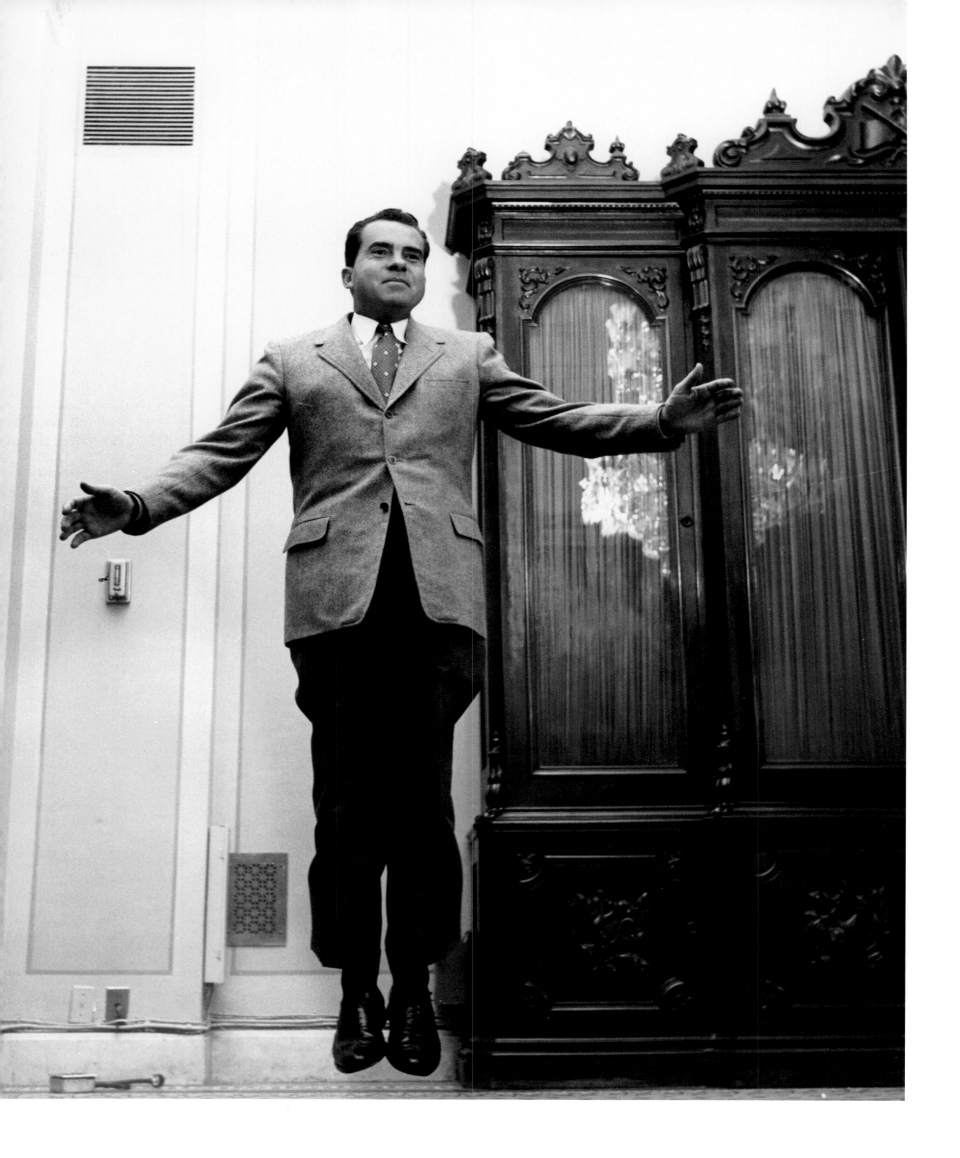

Richard
NIXON
1955, 1966

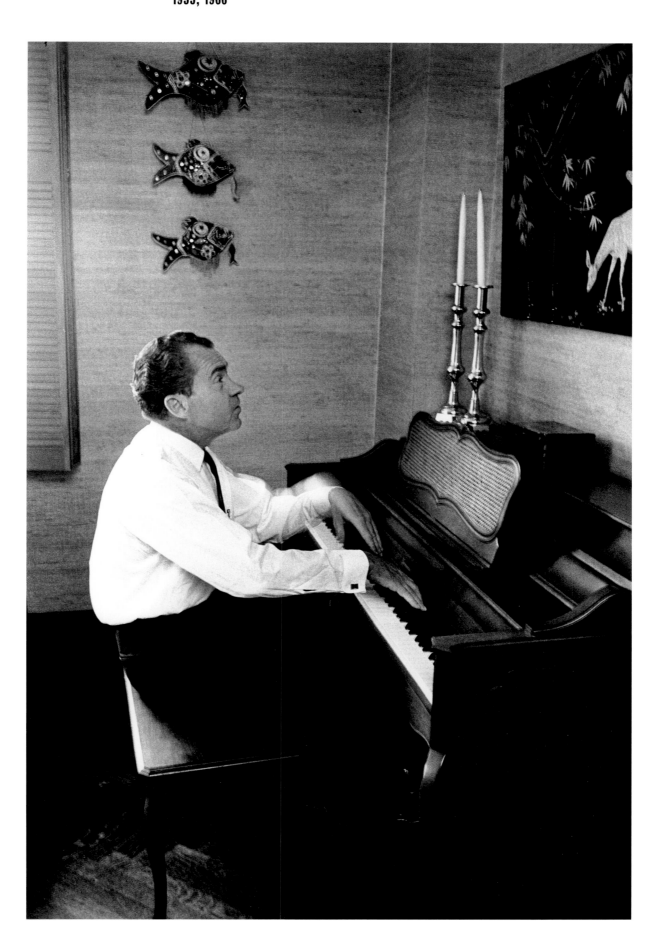

Georgia O'KEEFFE
1967

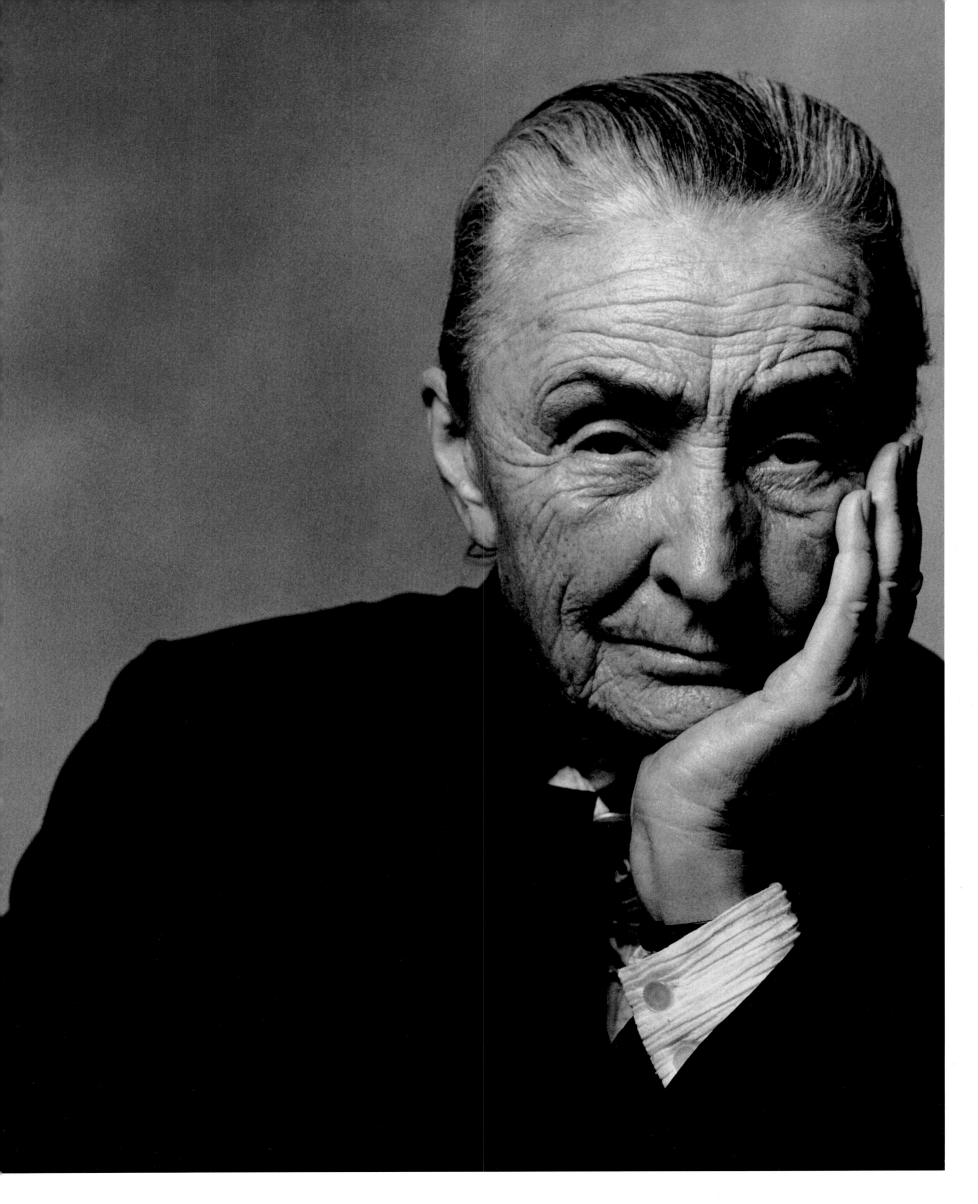

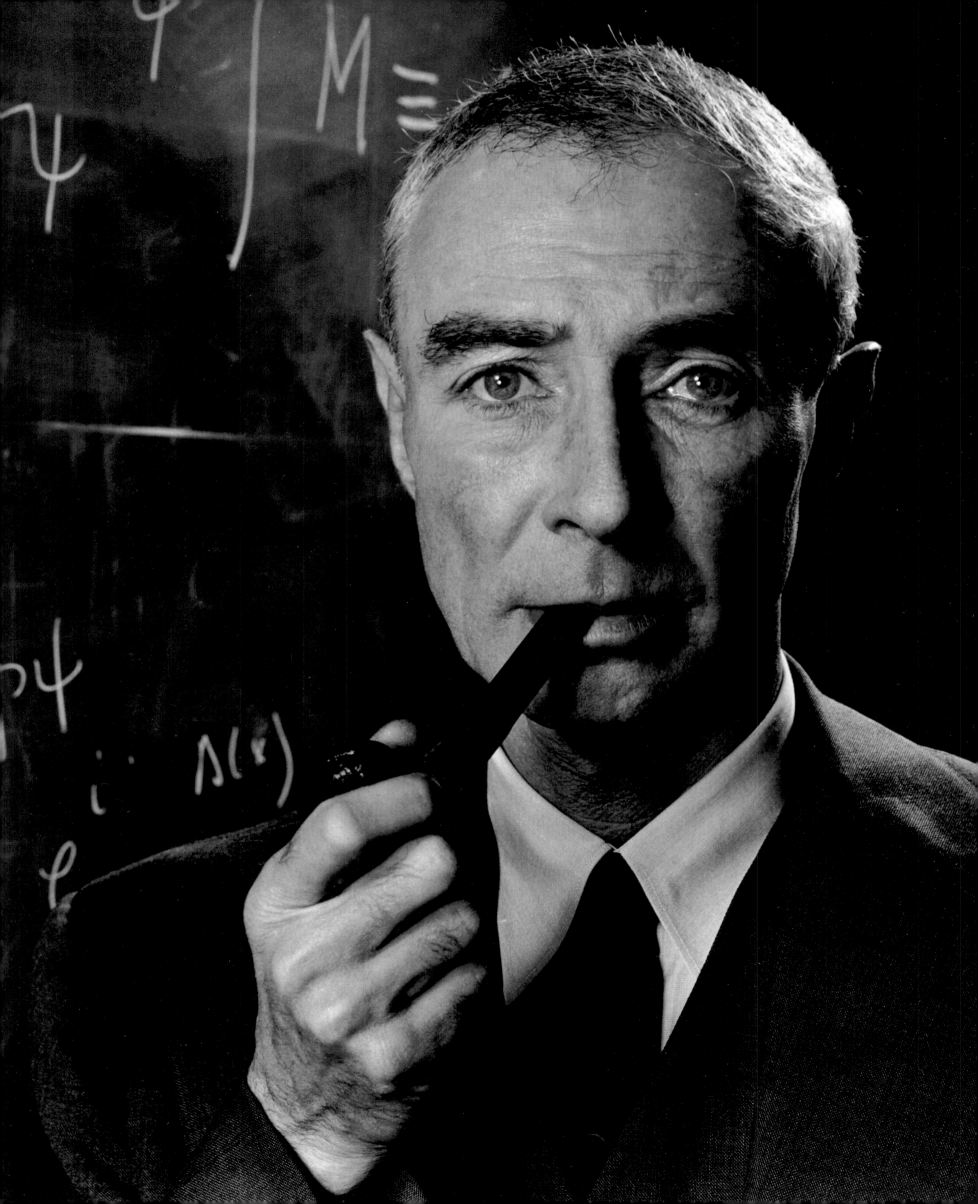

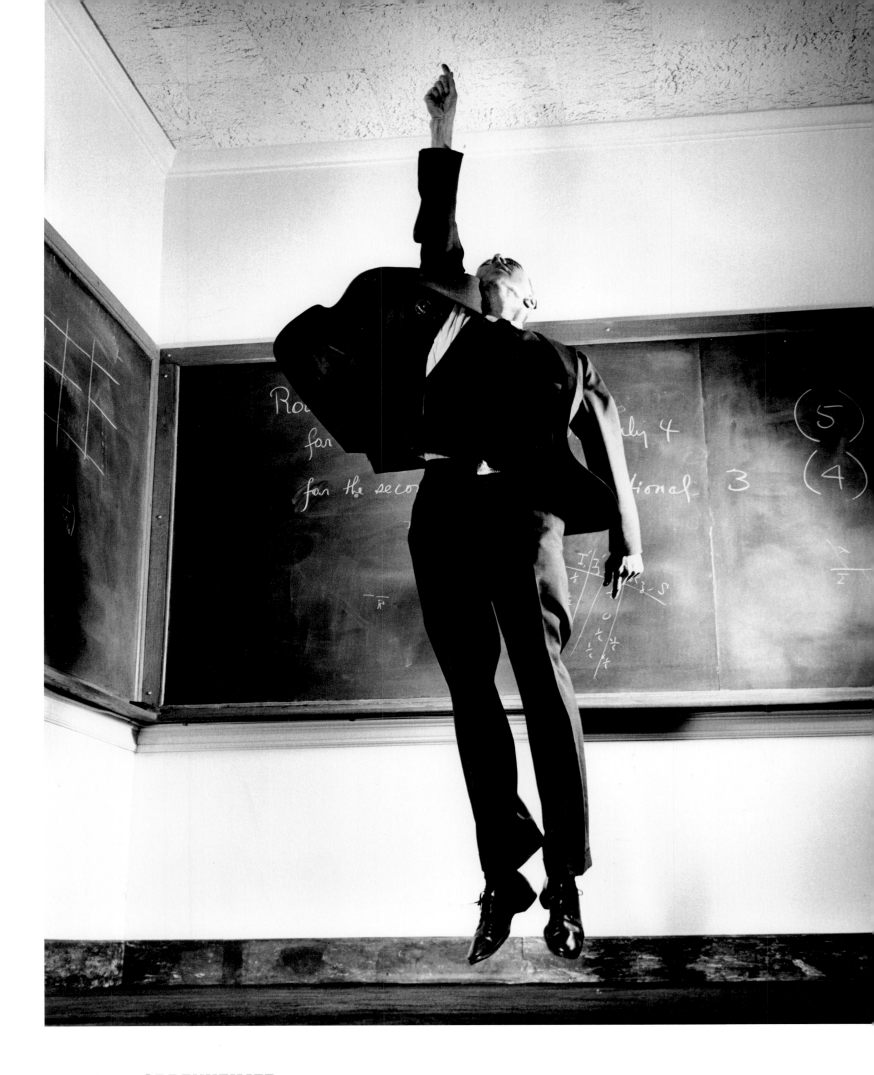

J. Robert OPPENHEIMER
1958

Emily POST
1946

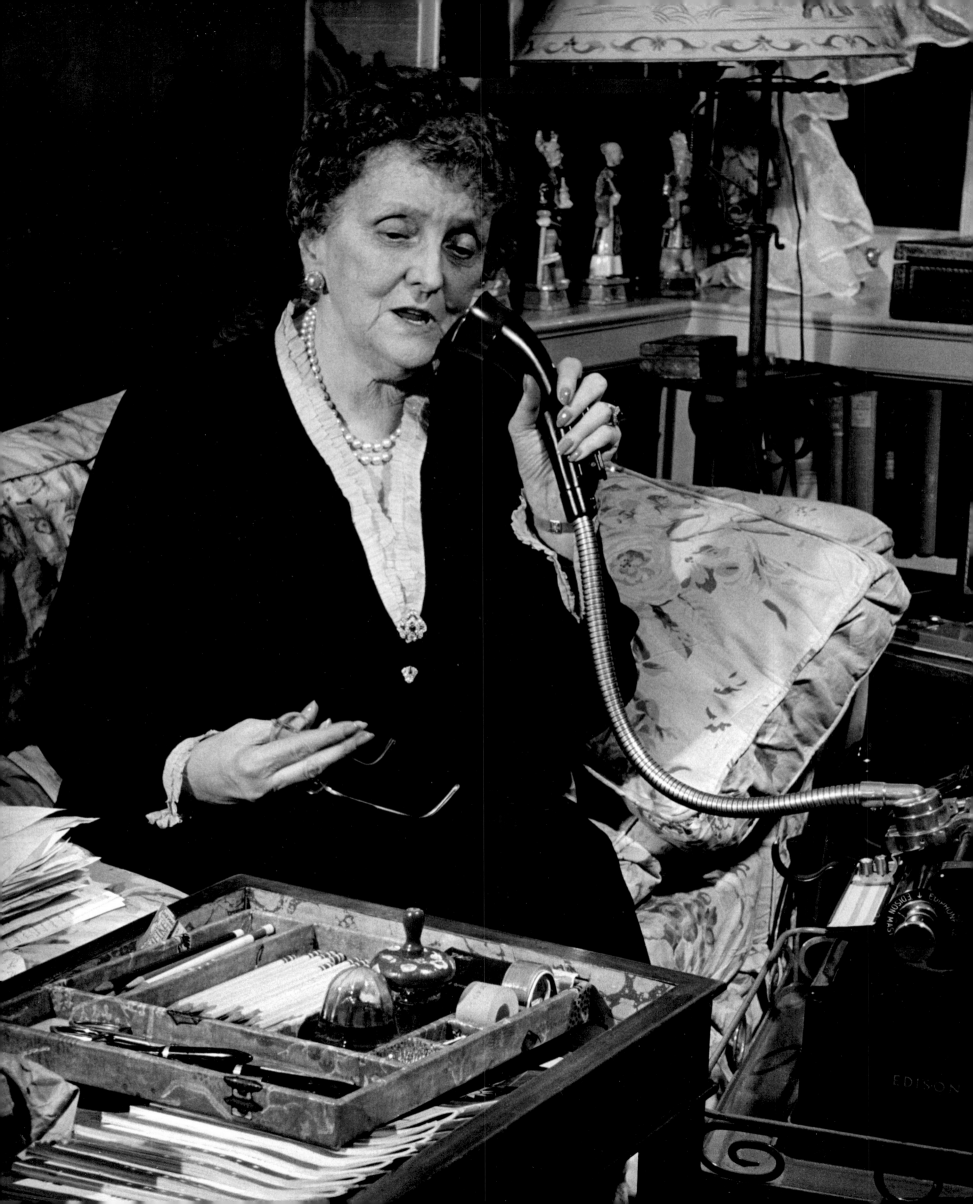

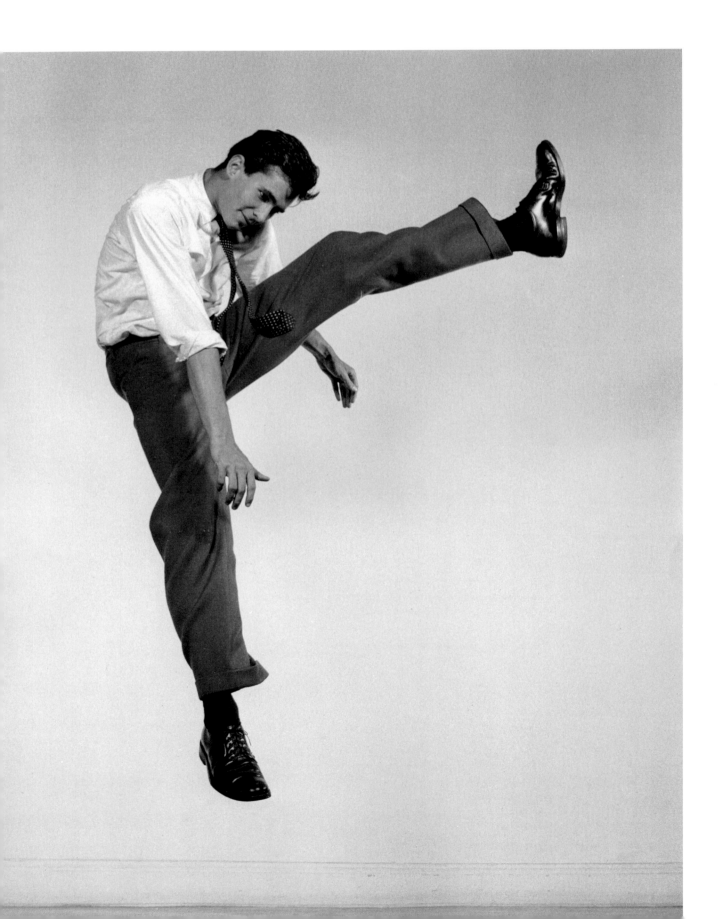

Anthony PERKINS
1956

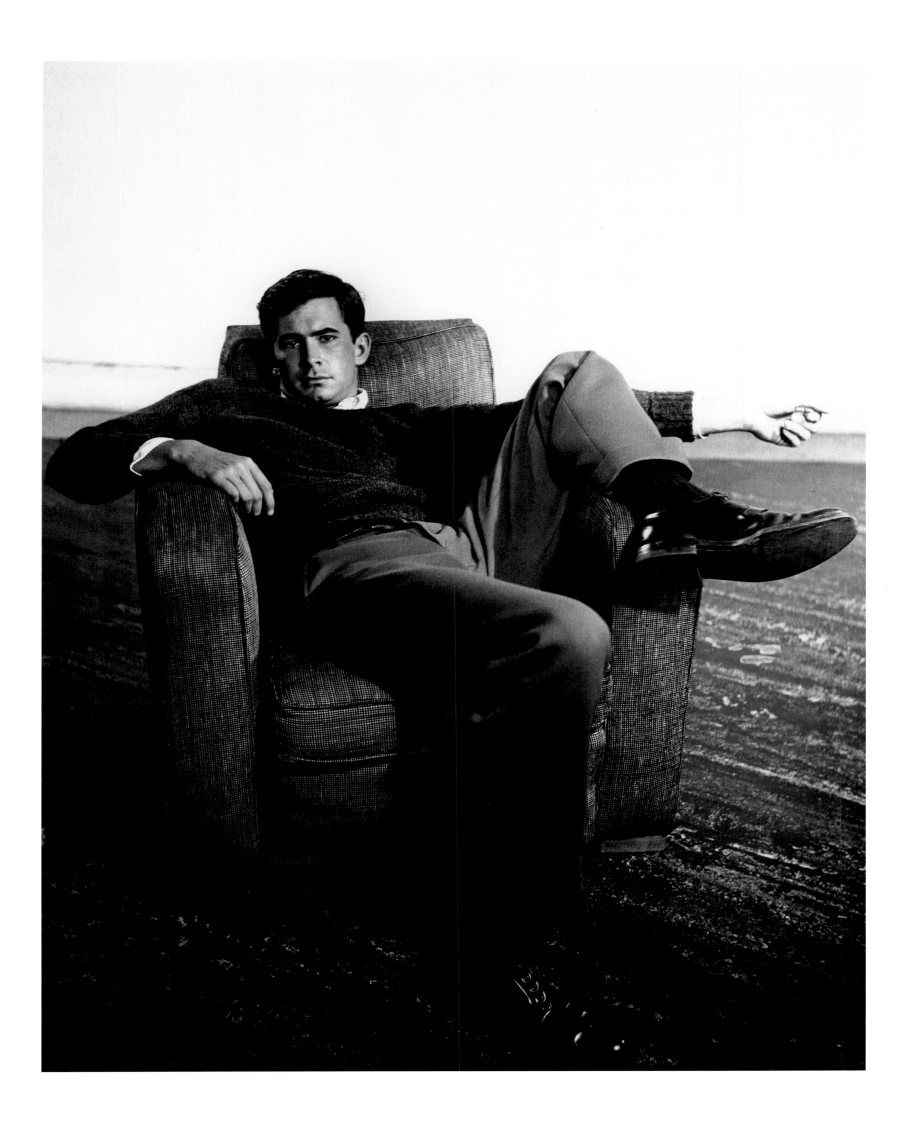

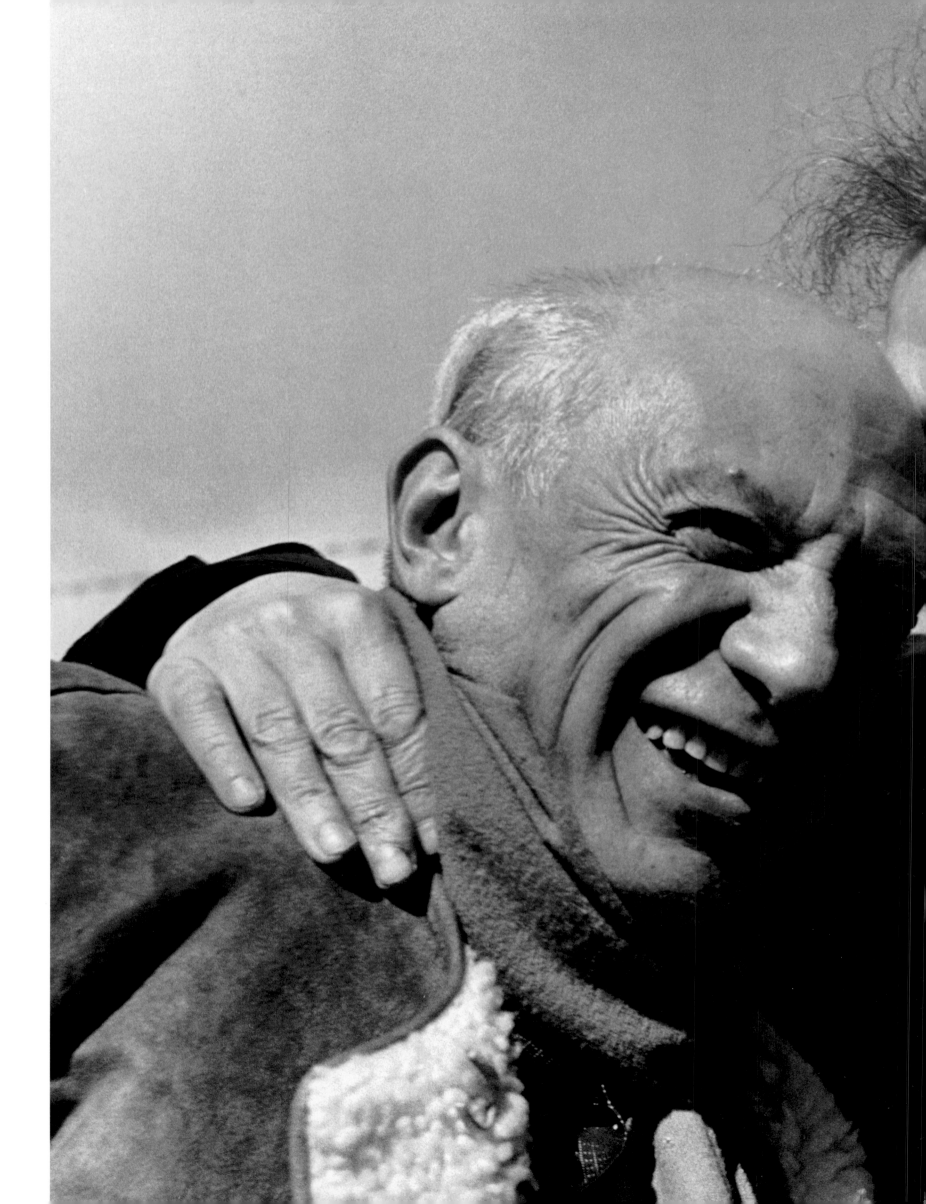

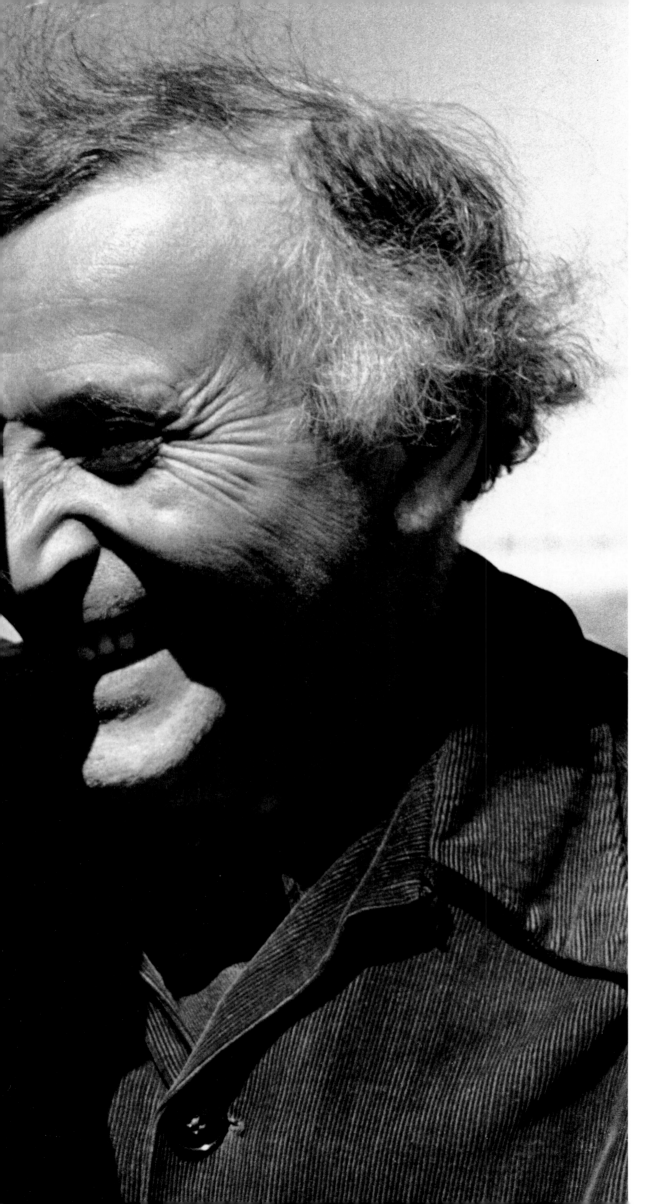

PICASSO
& Chagall
1955

QUOTATION

"This fascination with
the human face has
never left me….
Every face I see seems
to hide—and sometimes,
fleetingly, to reveal—
the mystery of another
human being. Capturing
this revelation became
the goal and passion
of my life."

R

Bertrand **RUSSELL**
1958

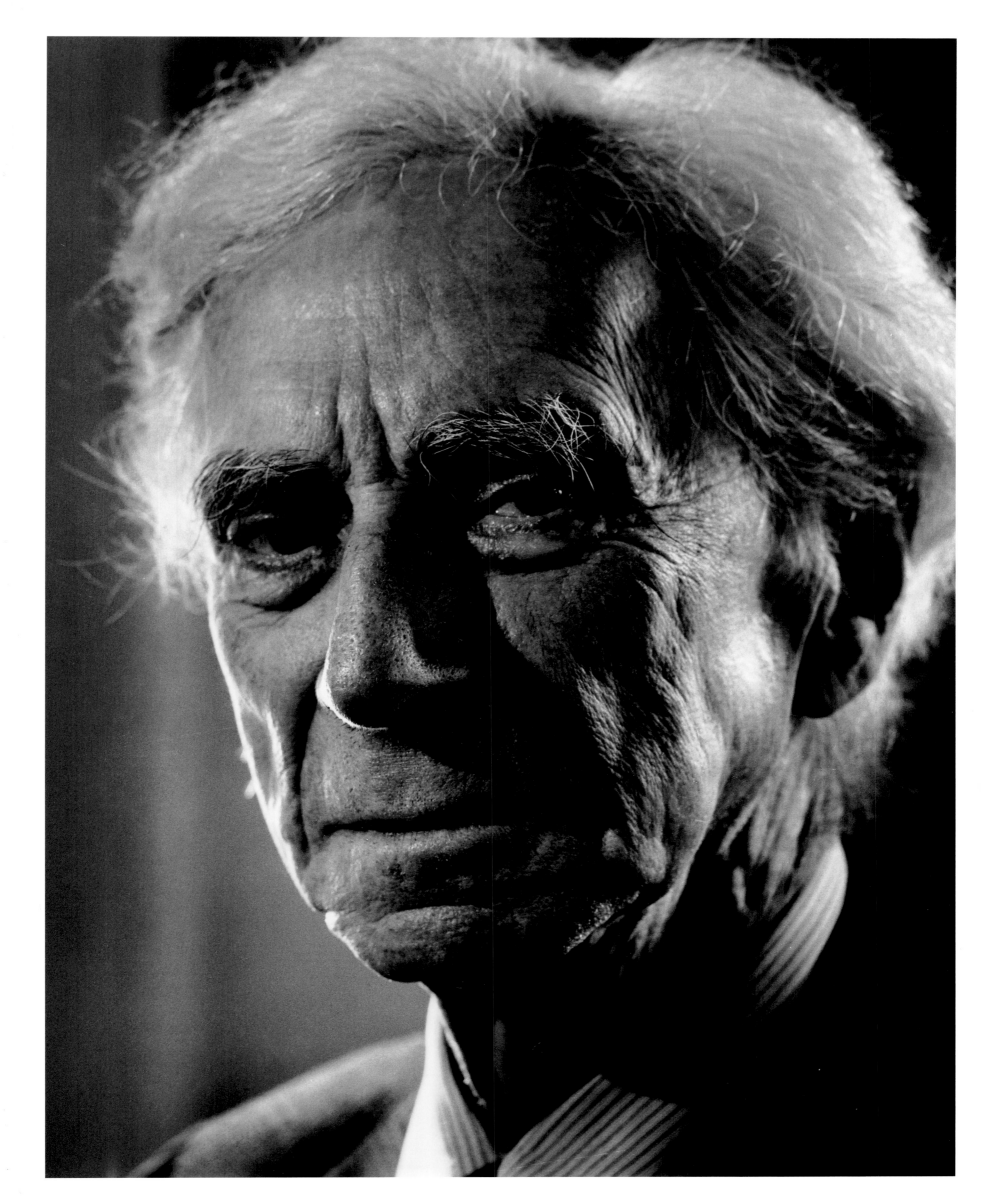

Tony RANDALL
1965

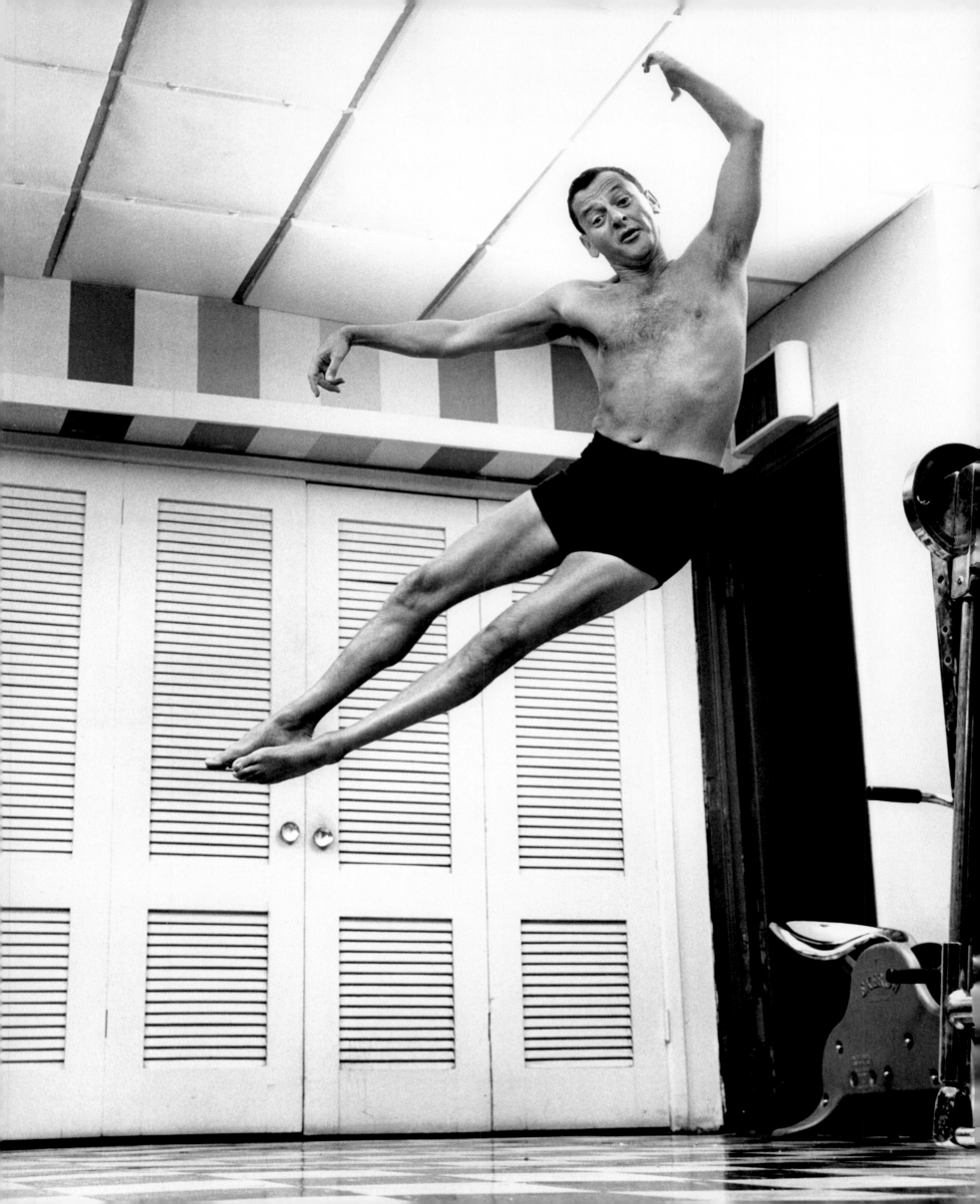

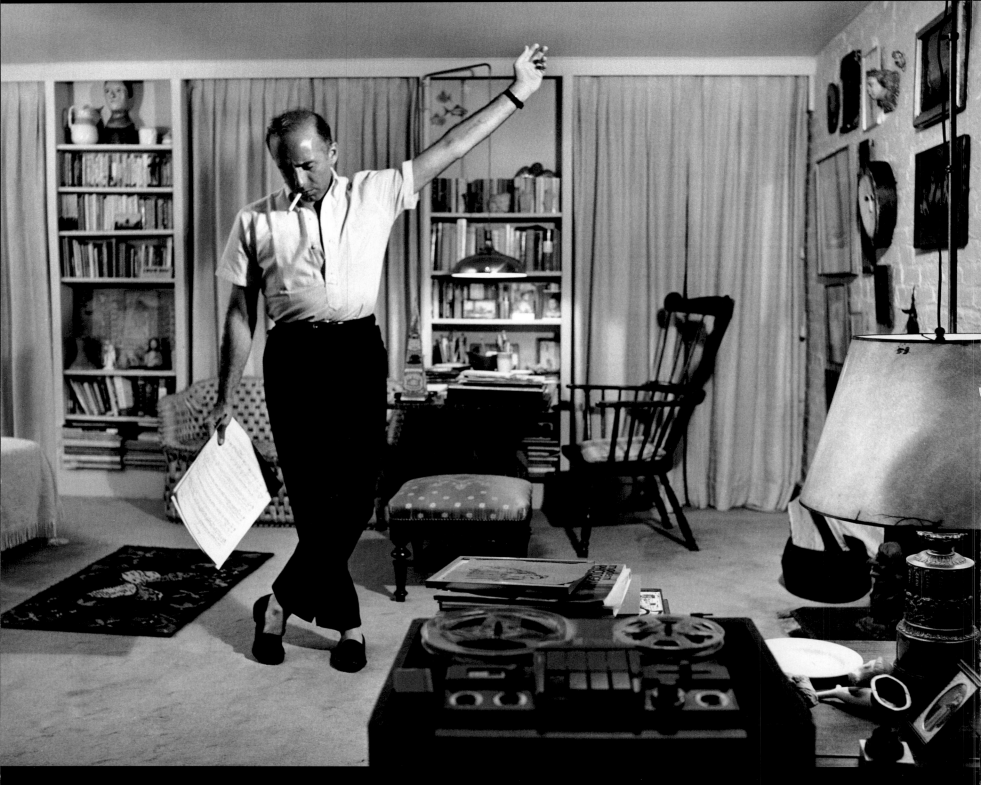

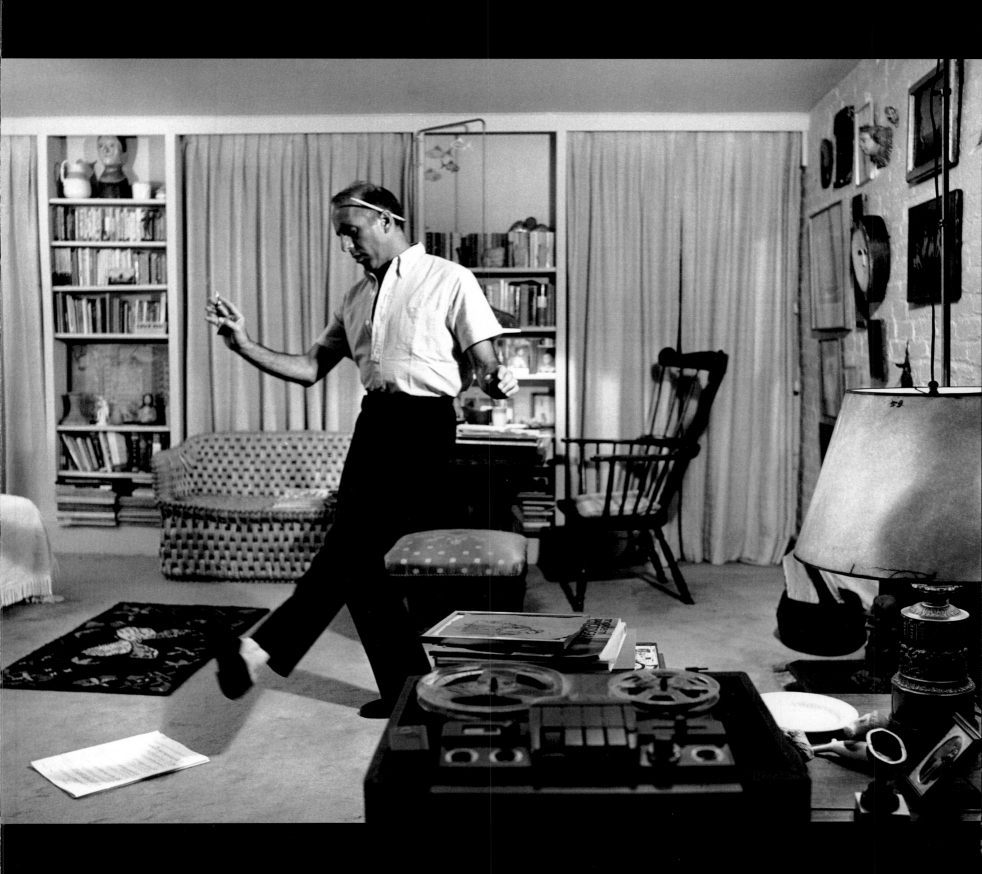

Jerome ROBBINS
1959

S

Barbra STREISAND 1965

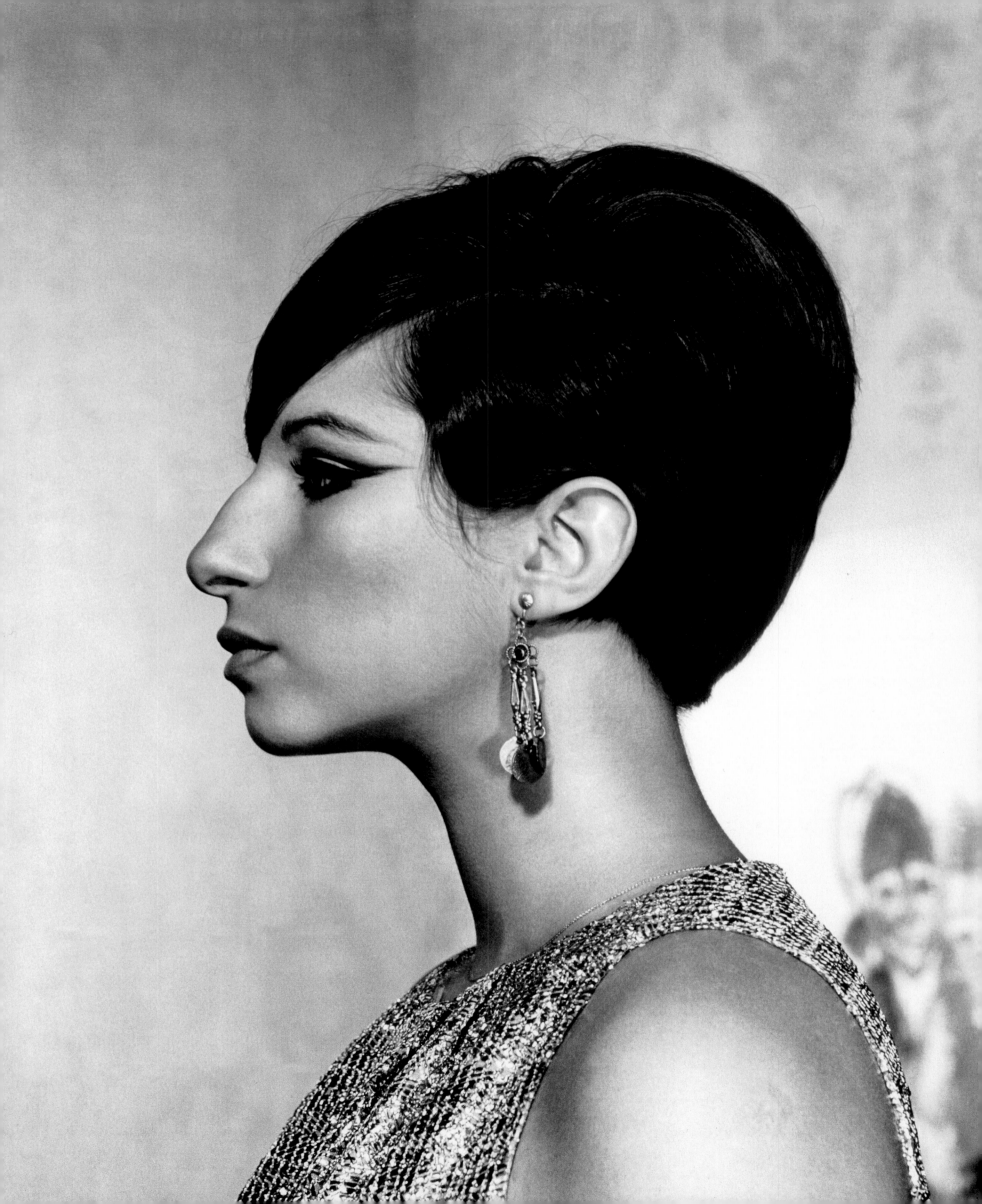

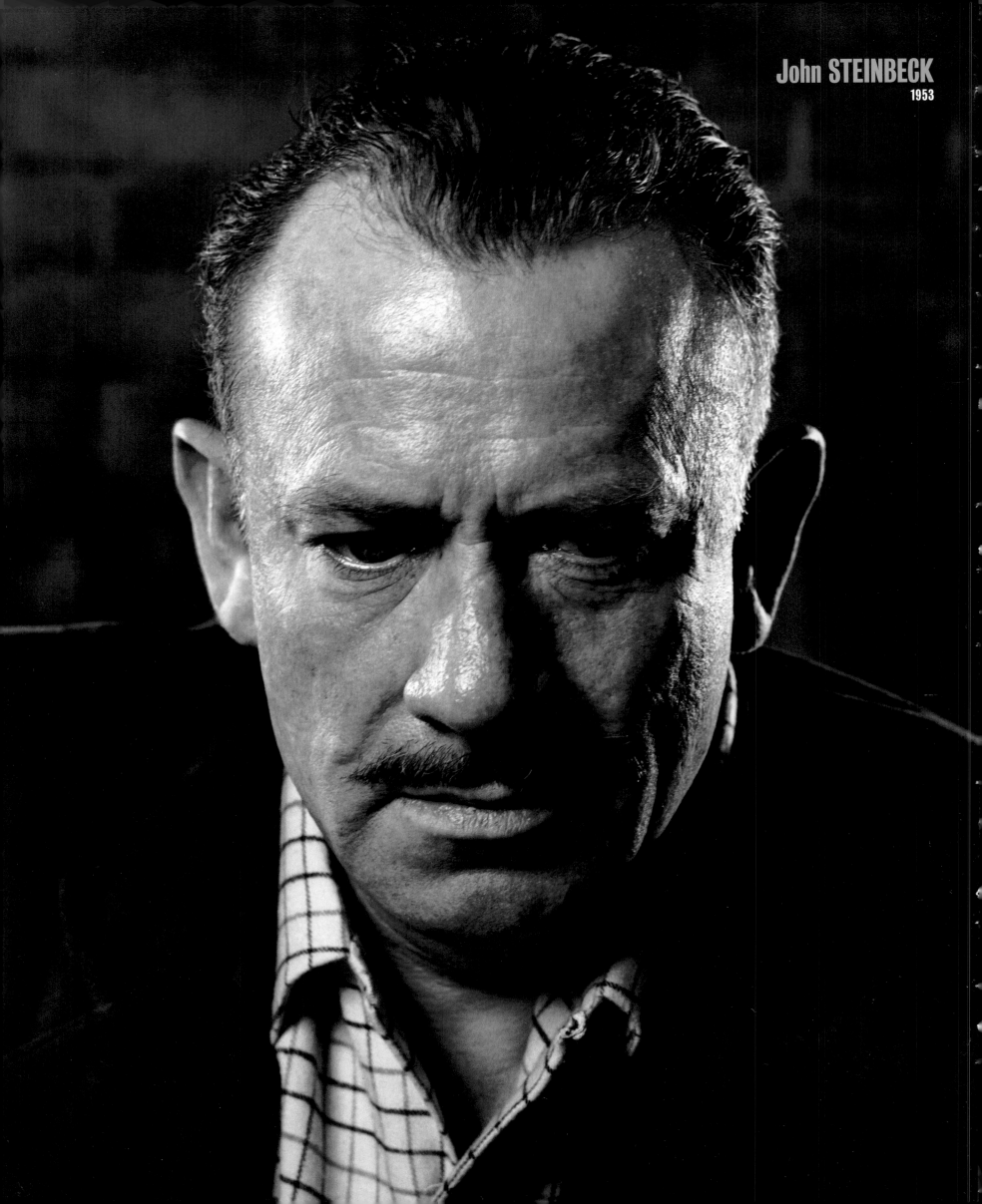

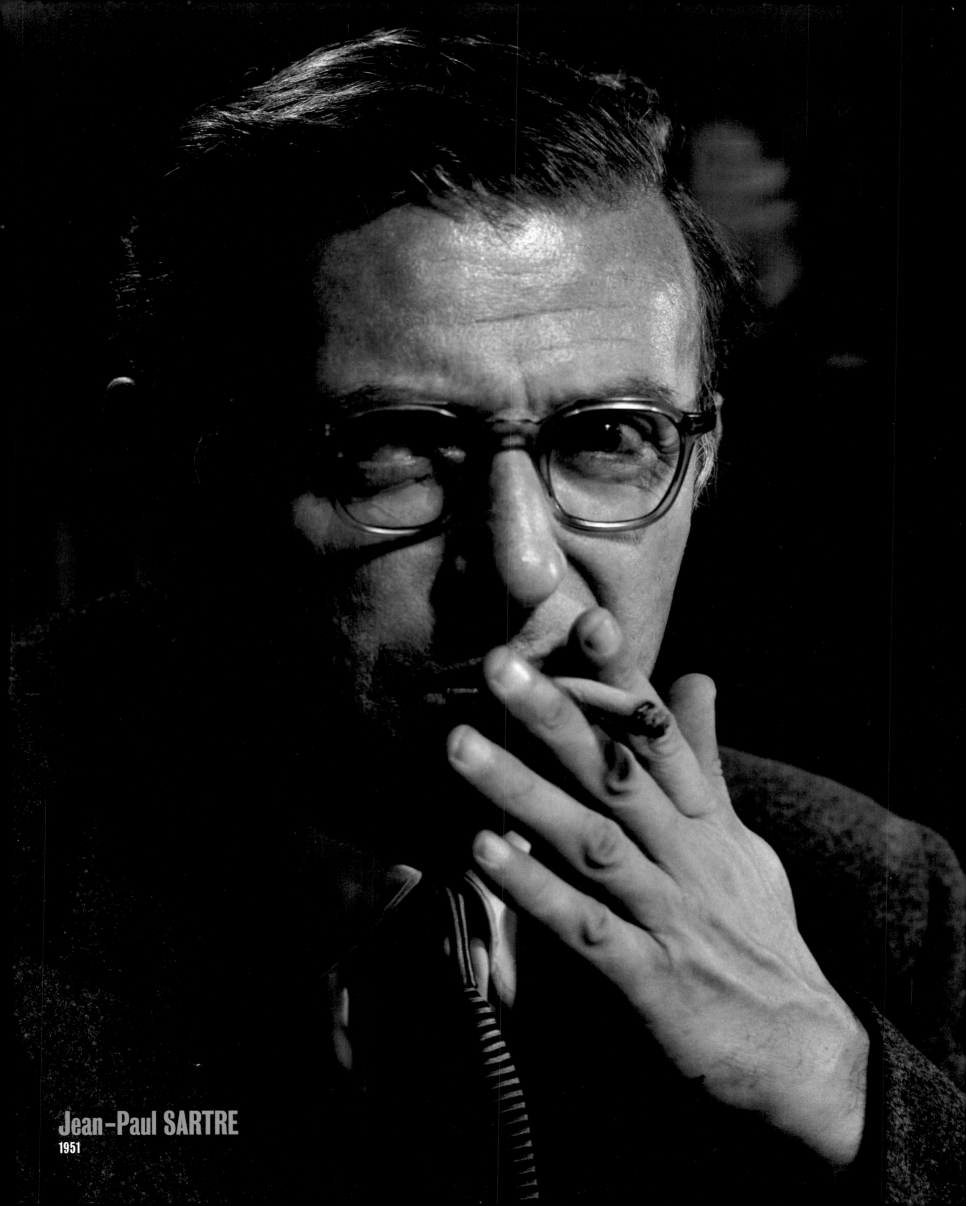

Jean-Paul SARTRE
1951

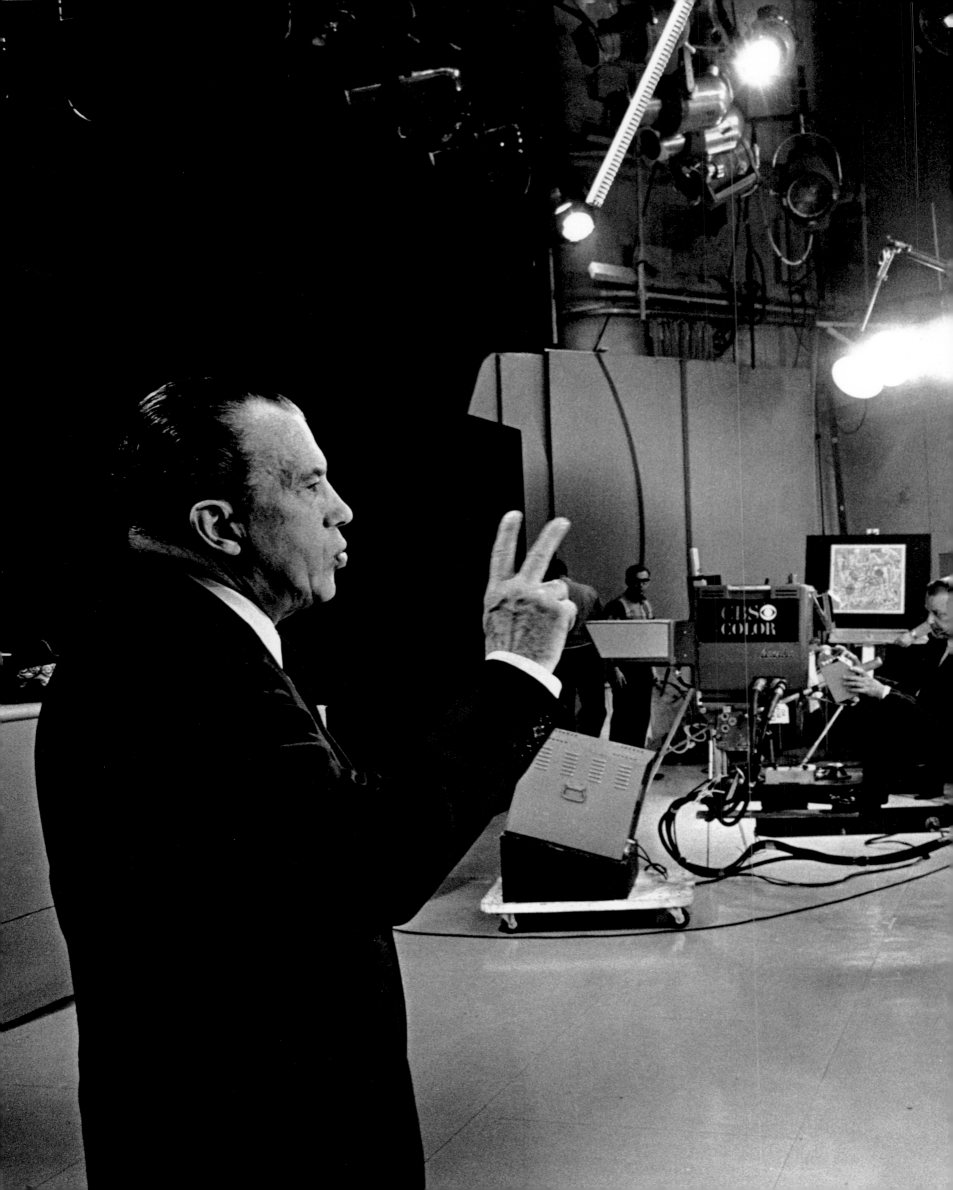

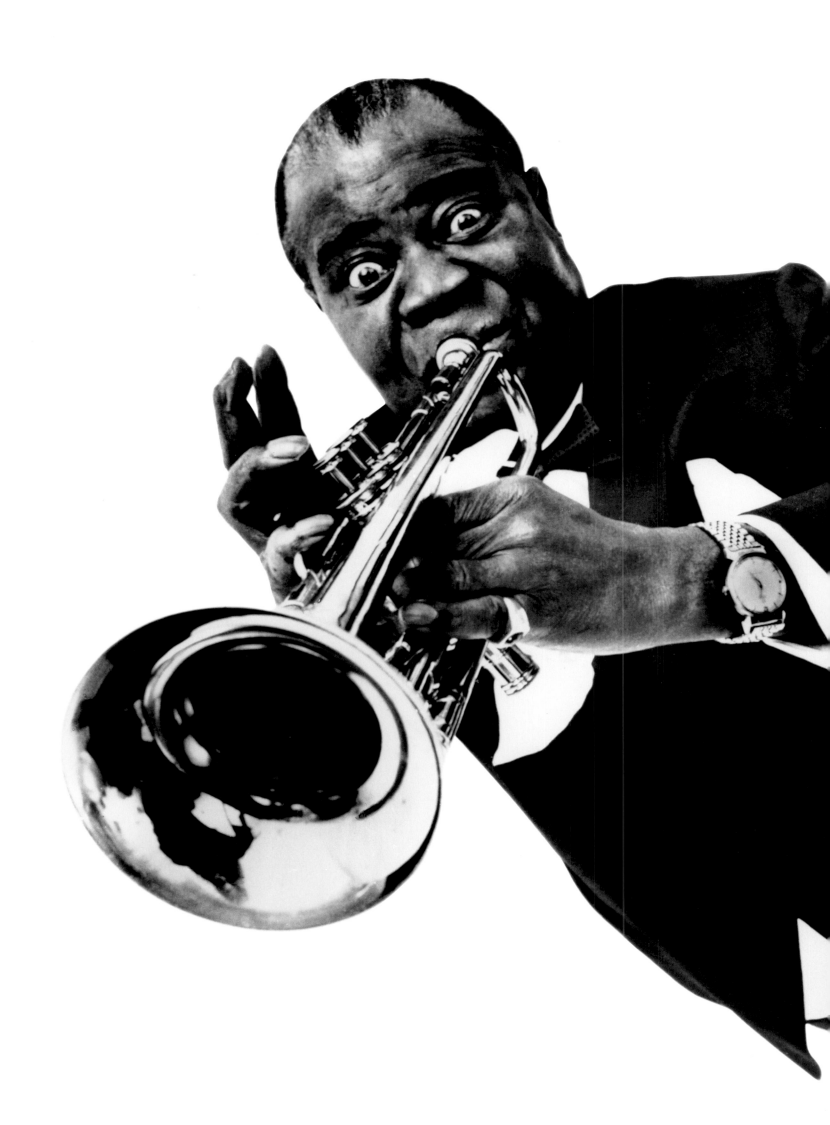

Louis Armstrong
(SATCHMO)

1966

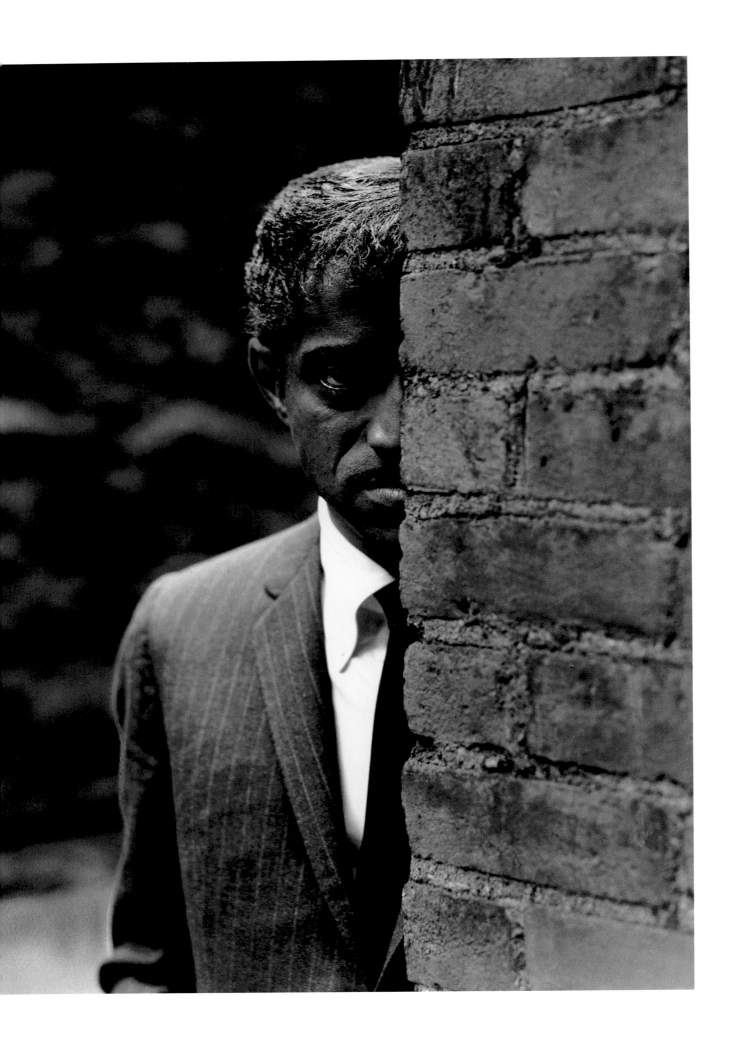

SAMMY Davis, Jr.
1955

Frank SINATRA
1944

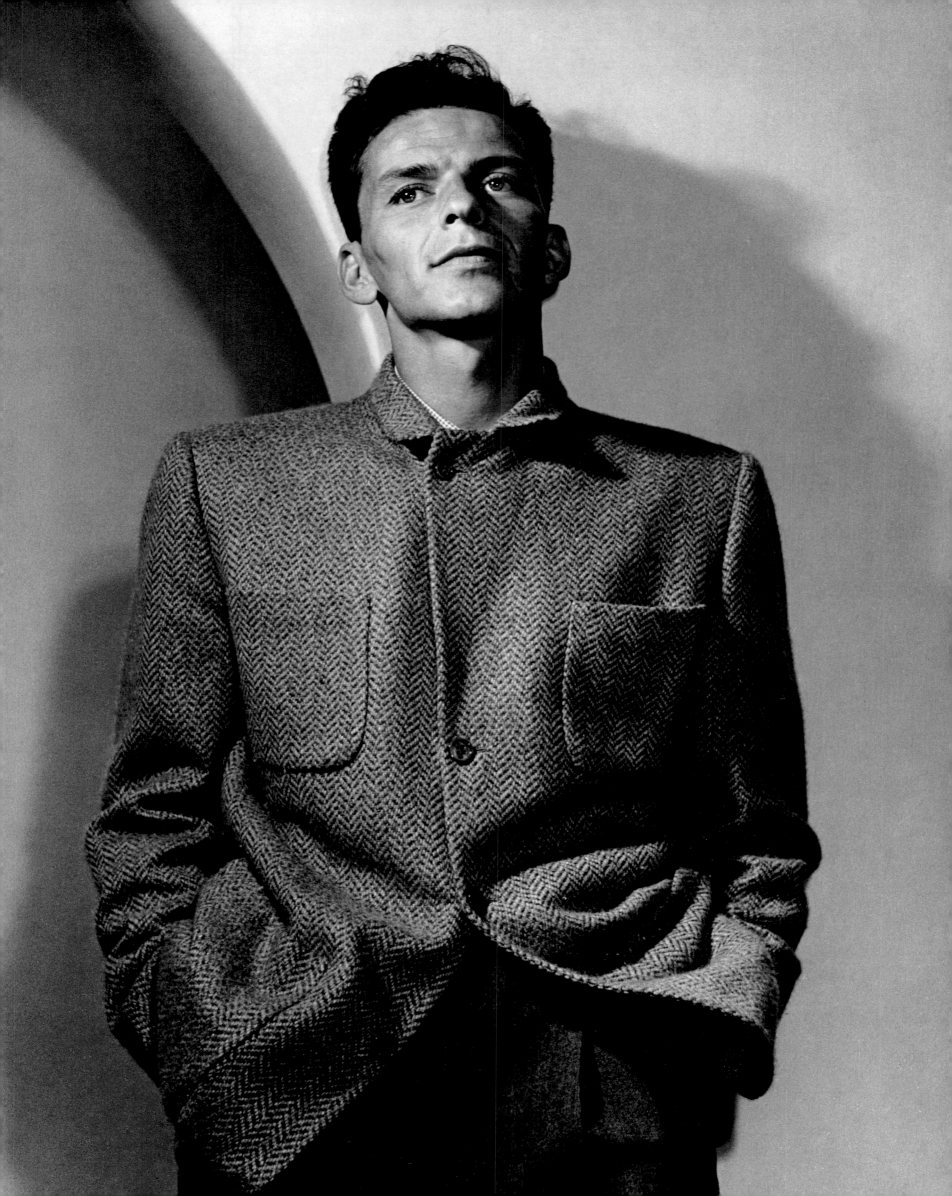

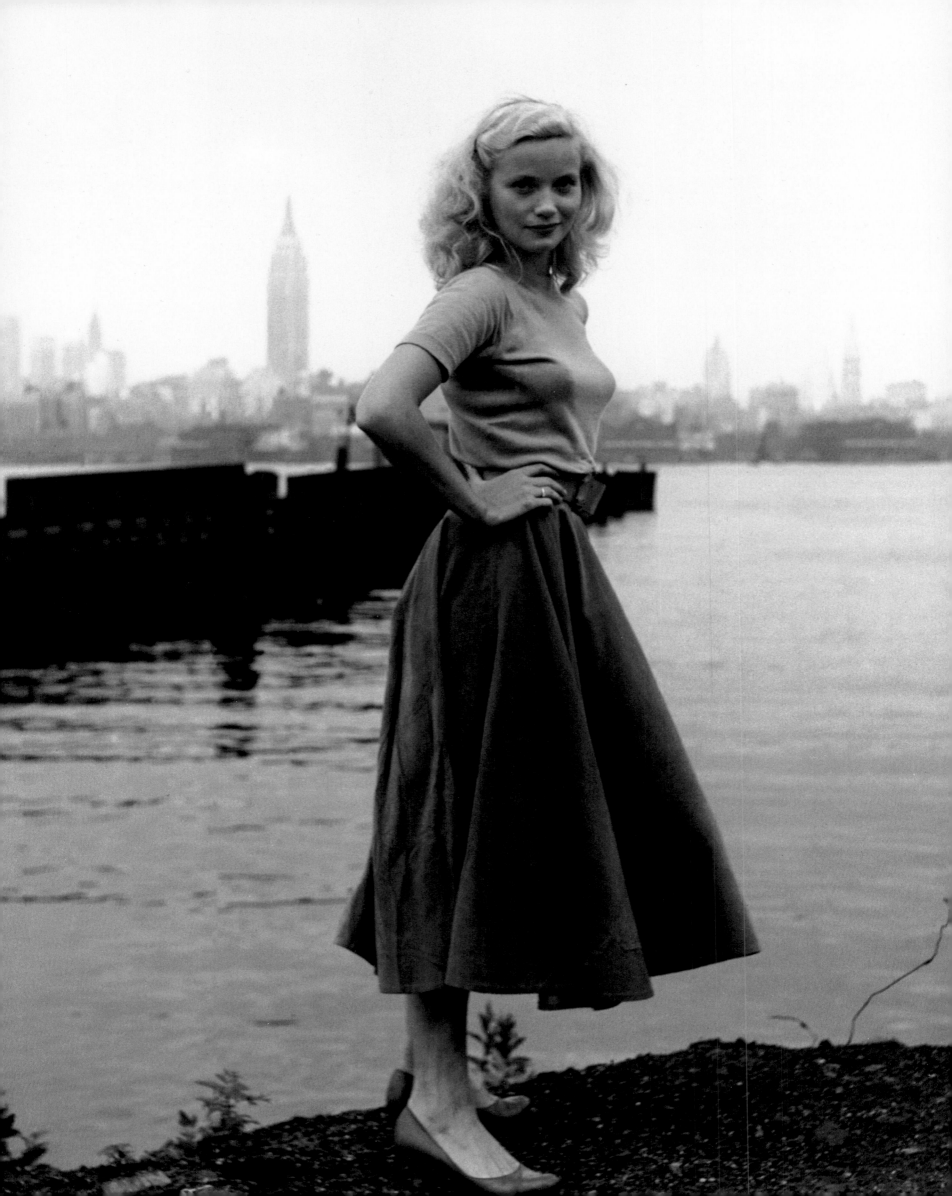

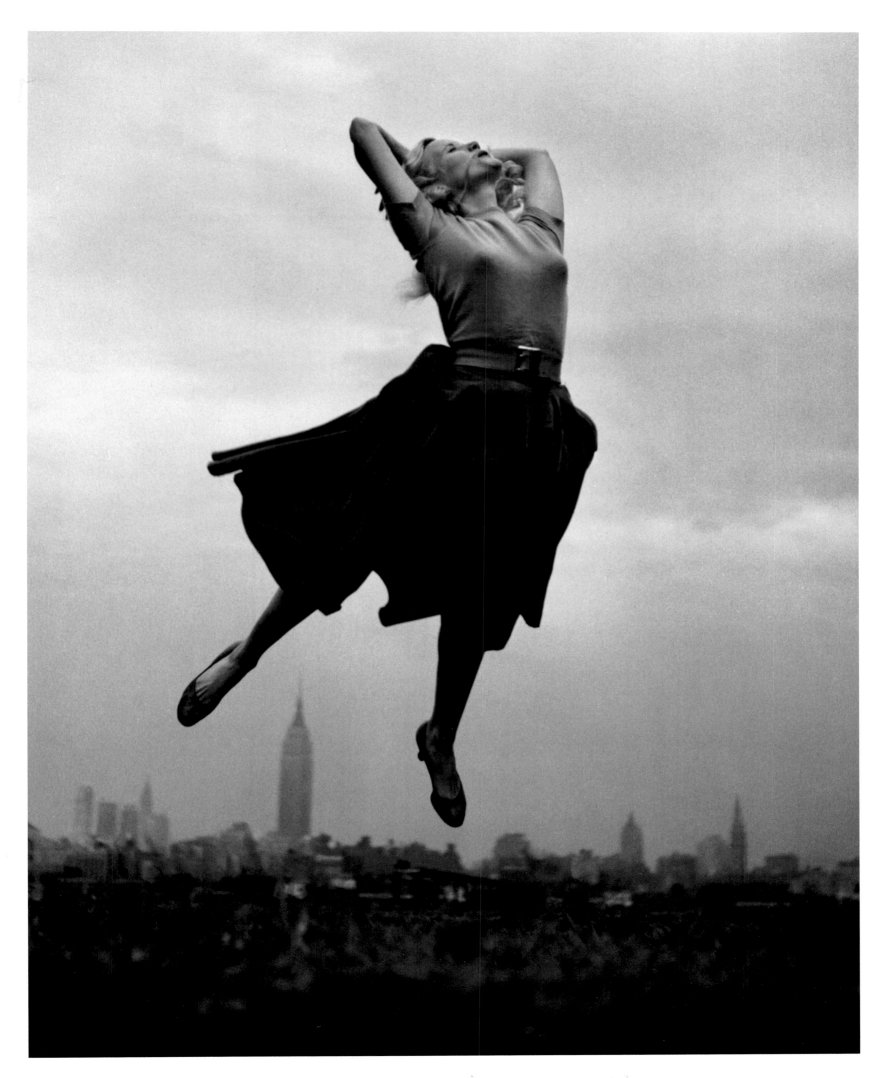

Eva Marie SAINT
1954

T

Elizabeth TAYLOR
1948

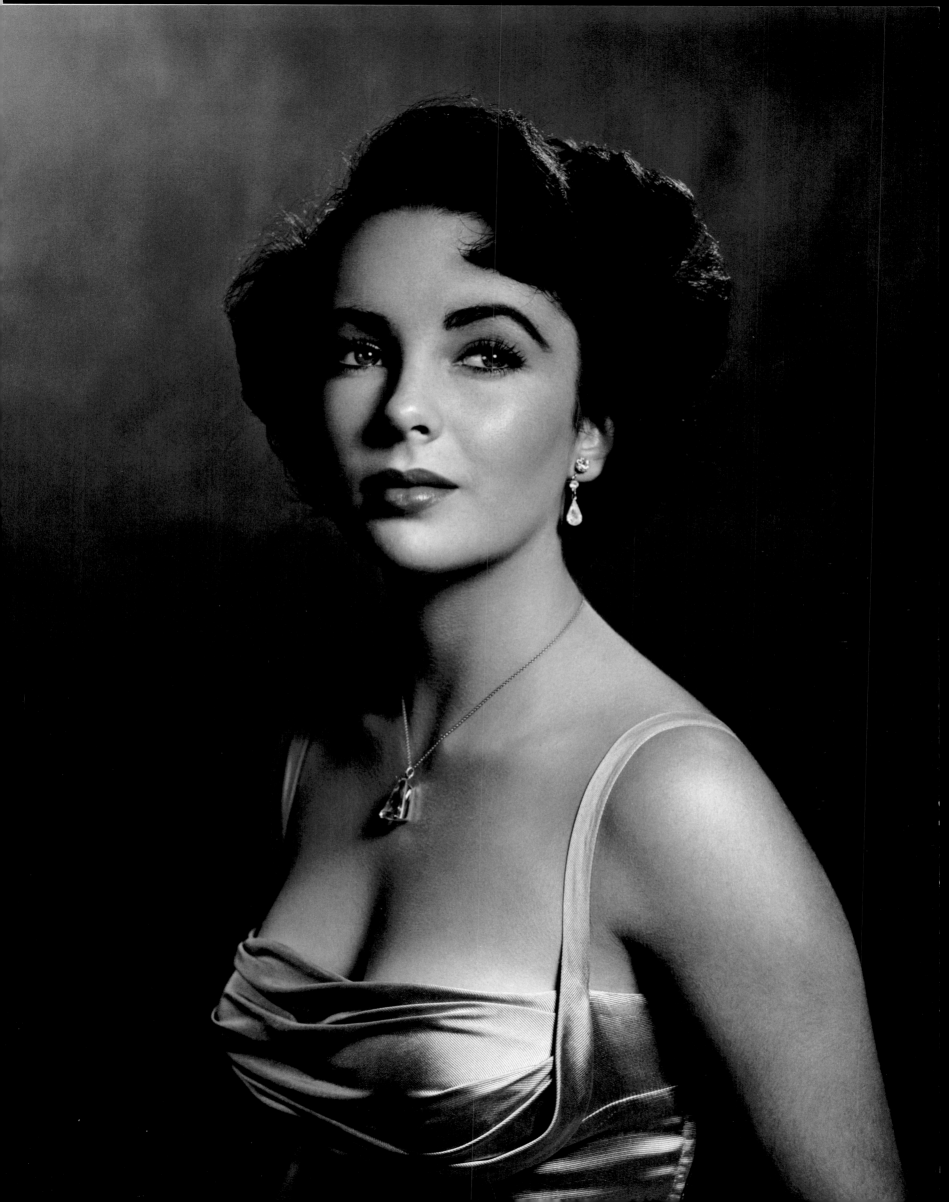

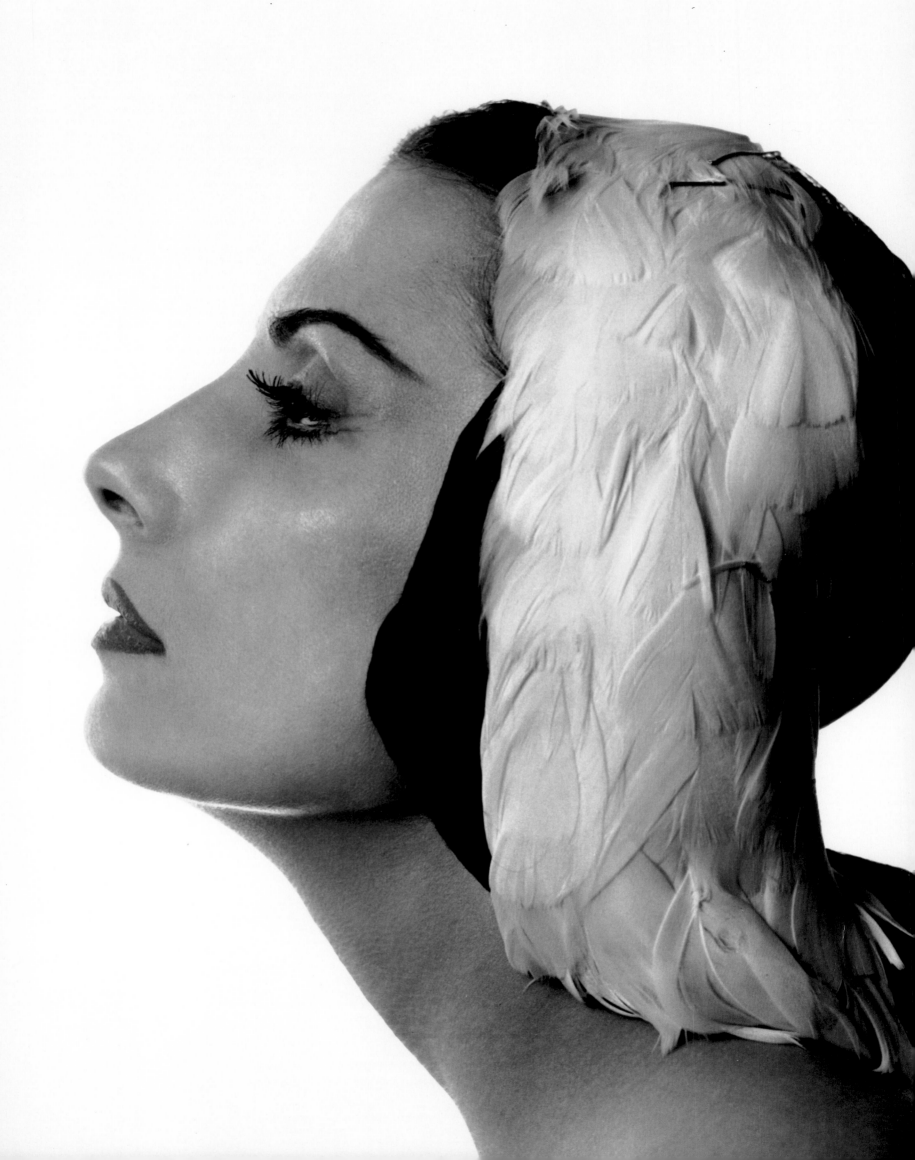

Tamara **TOUMANOVA**
1956

Sharon TATE
1966

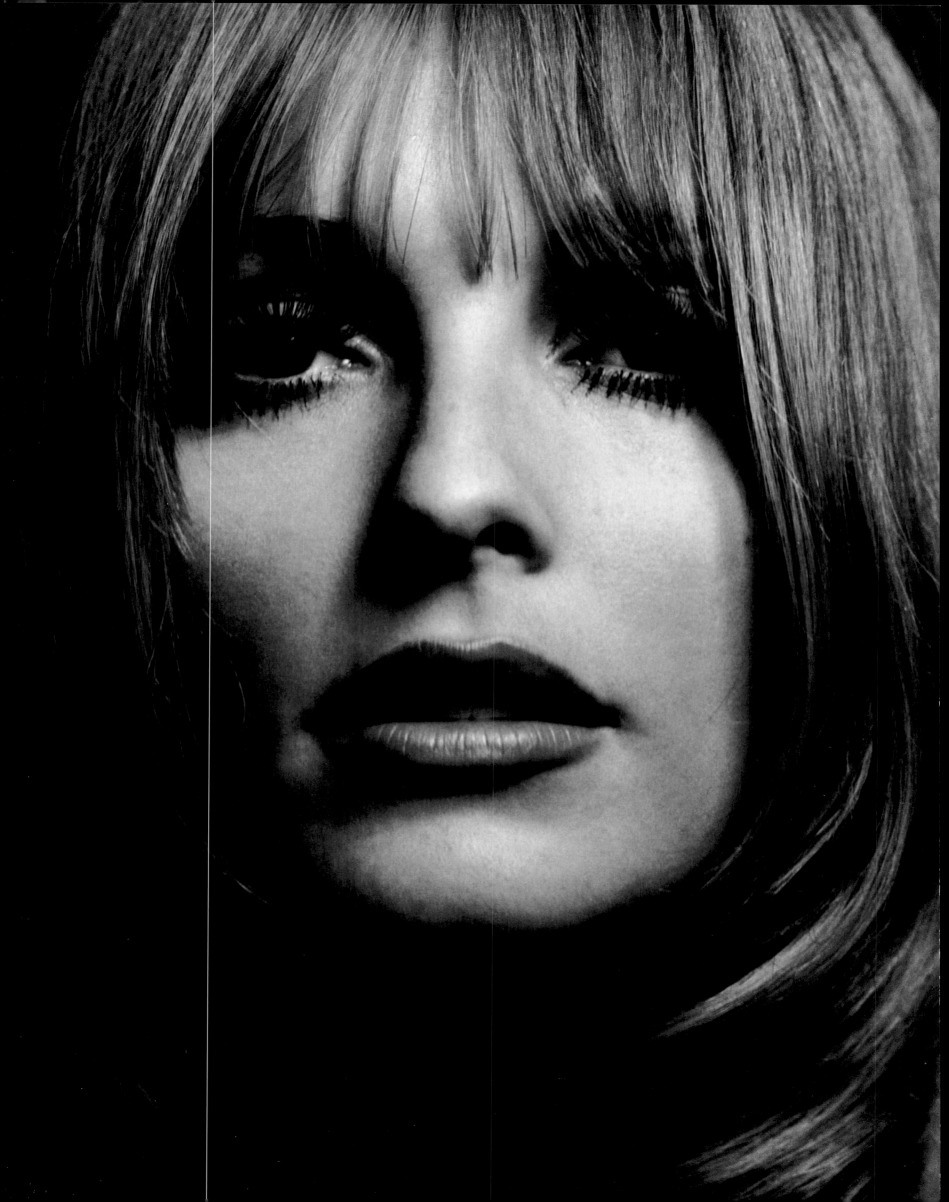

Peter USTINOV
1955

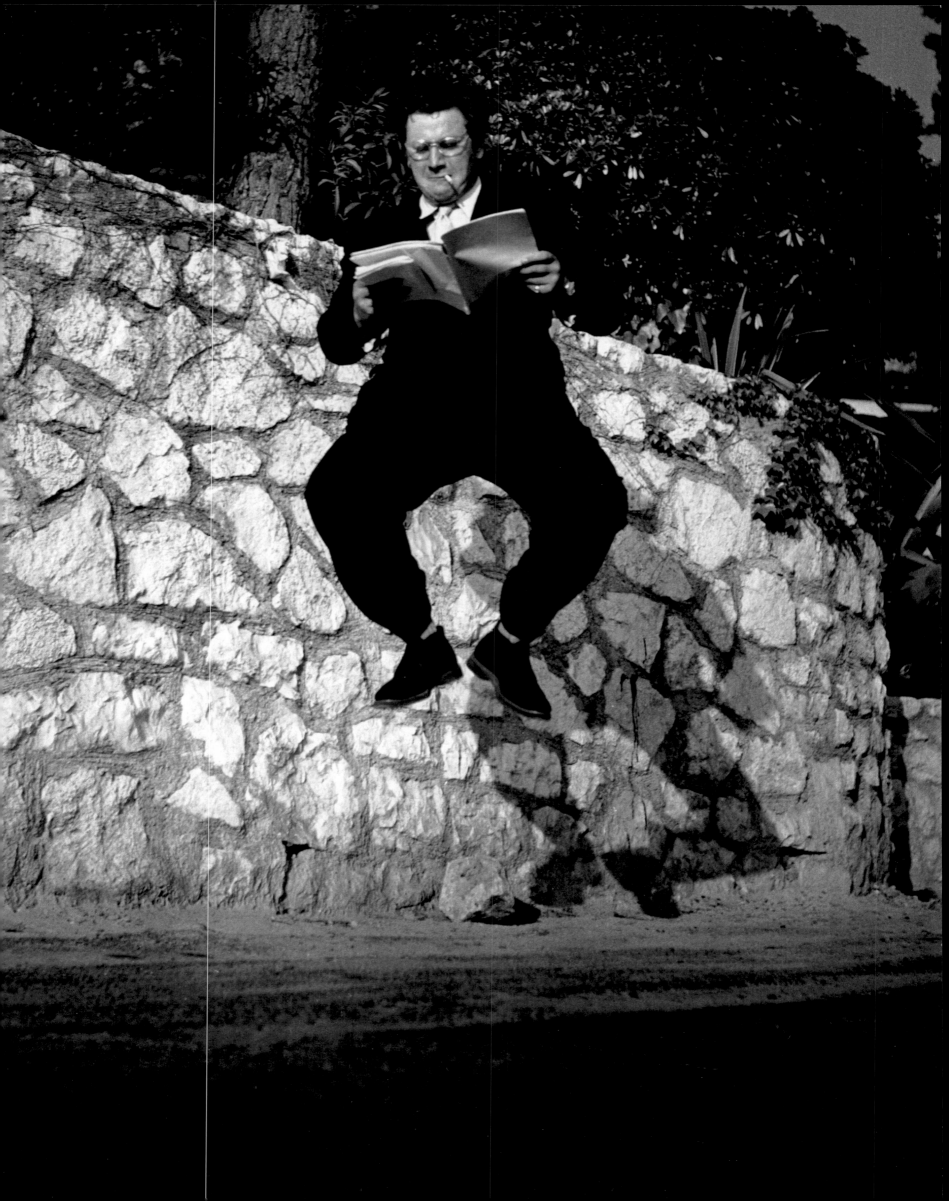

Edward VILLELLA
1961

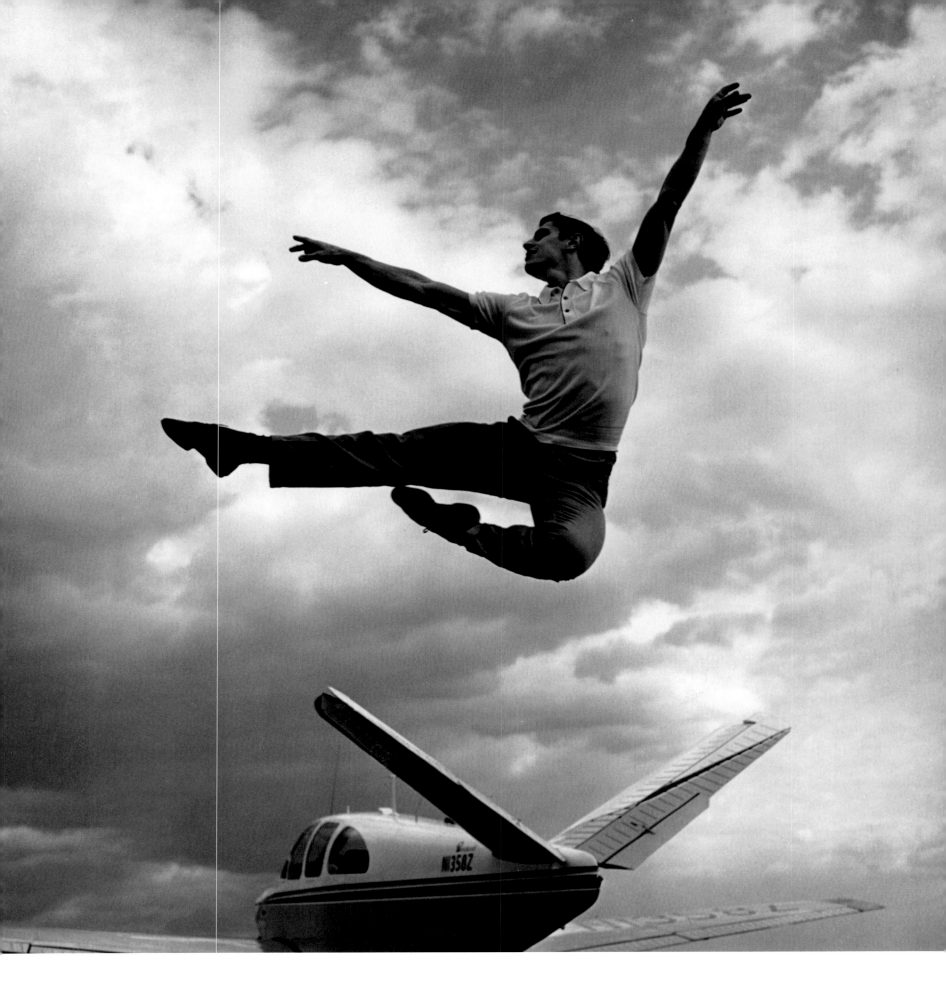

WINDSOR

Duke & Duchess of 1956

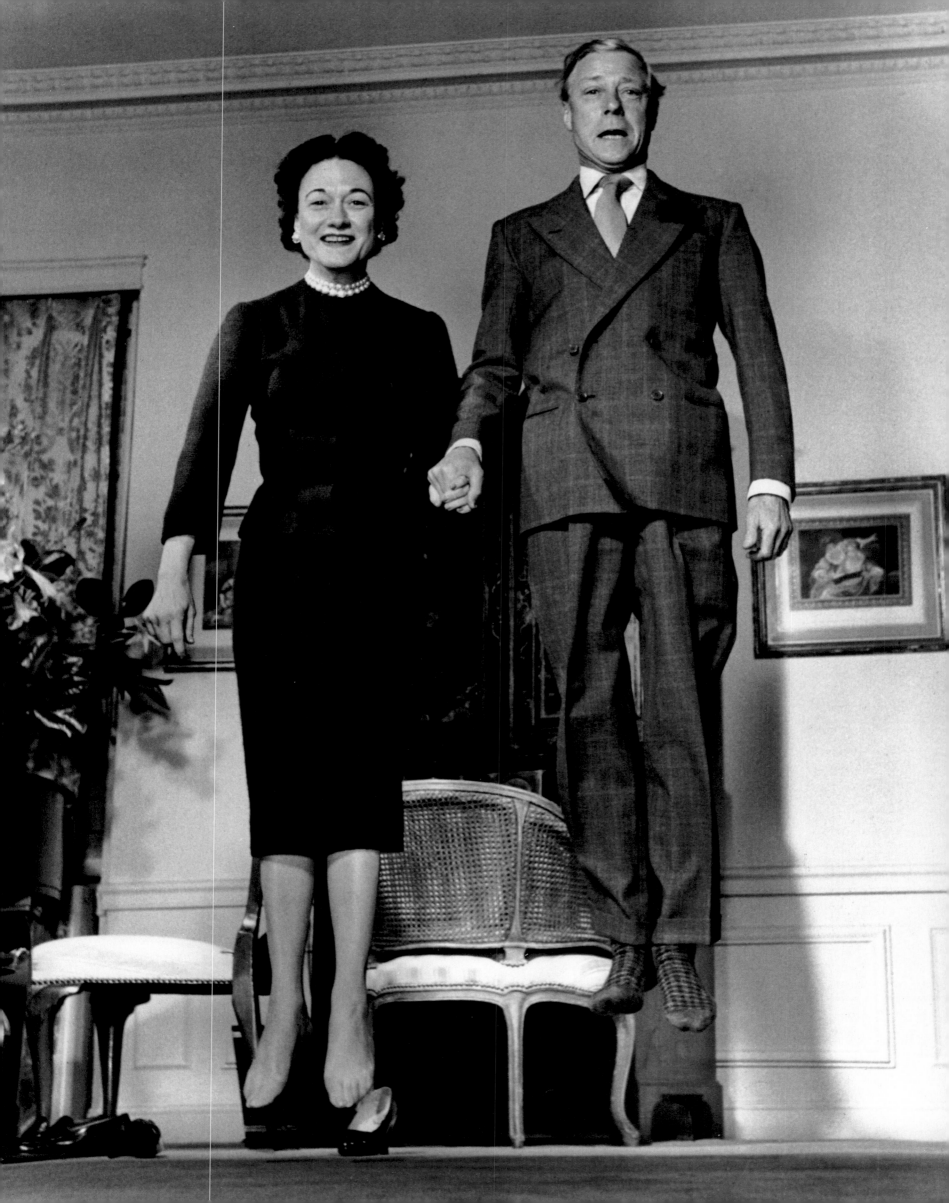

Oskar WERNER
1966

WEEGEE
1961

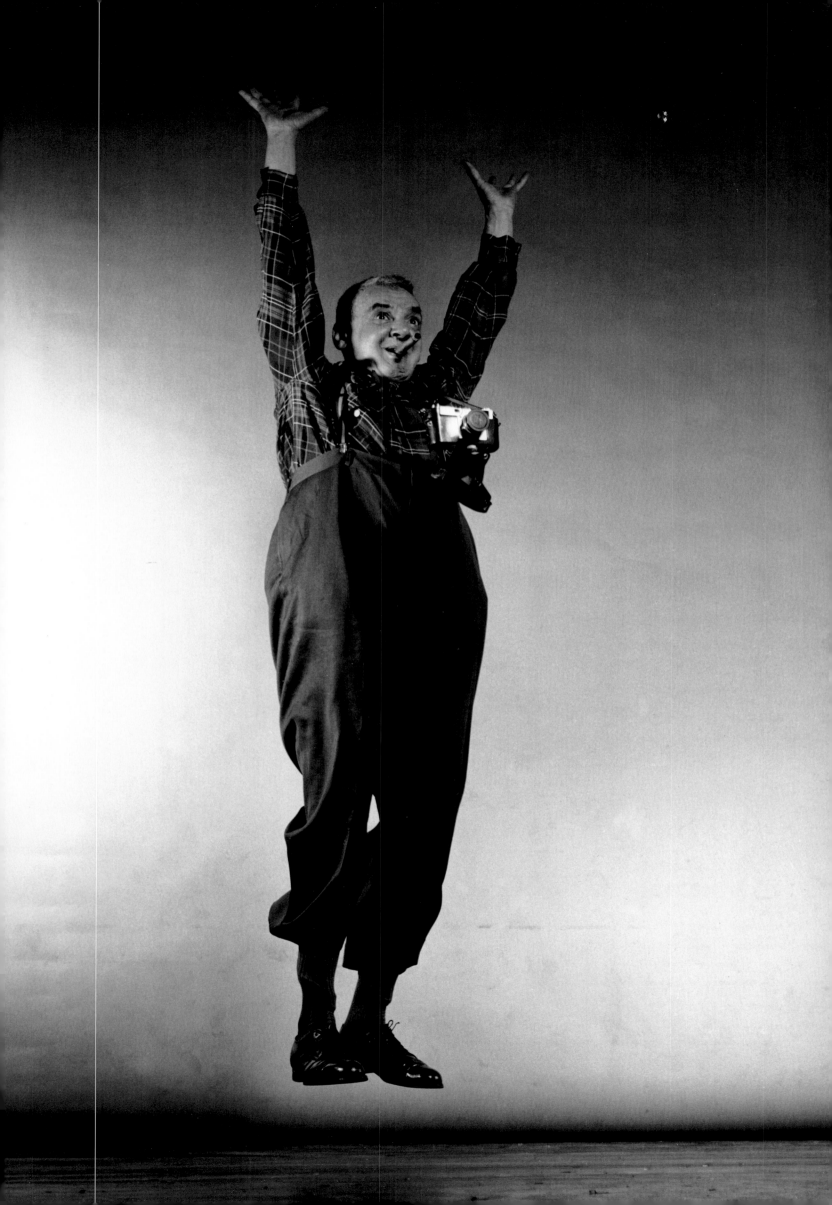

Andy **WARHOL**
1968

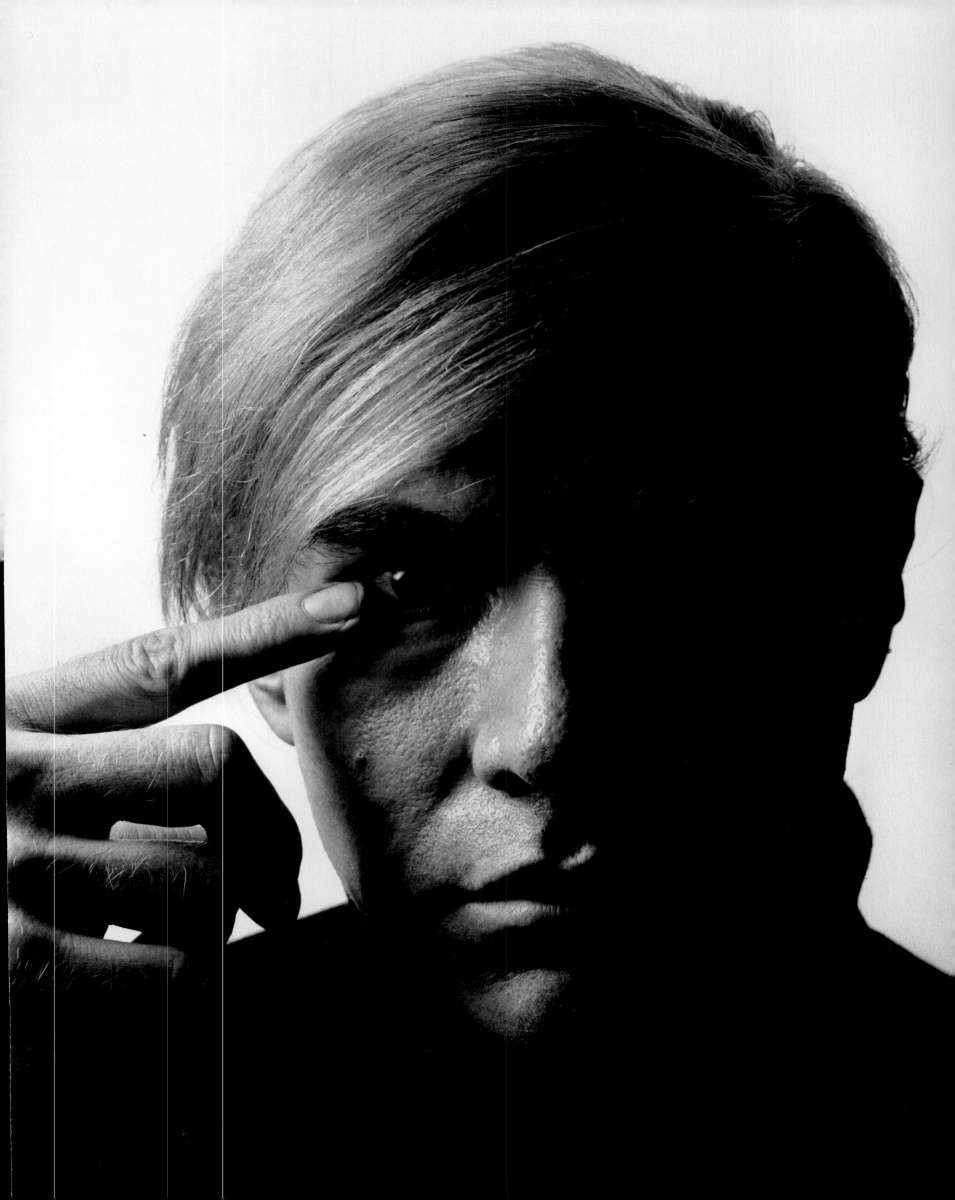

XYZ Aquacade
1953

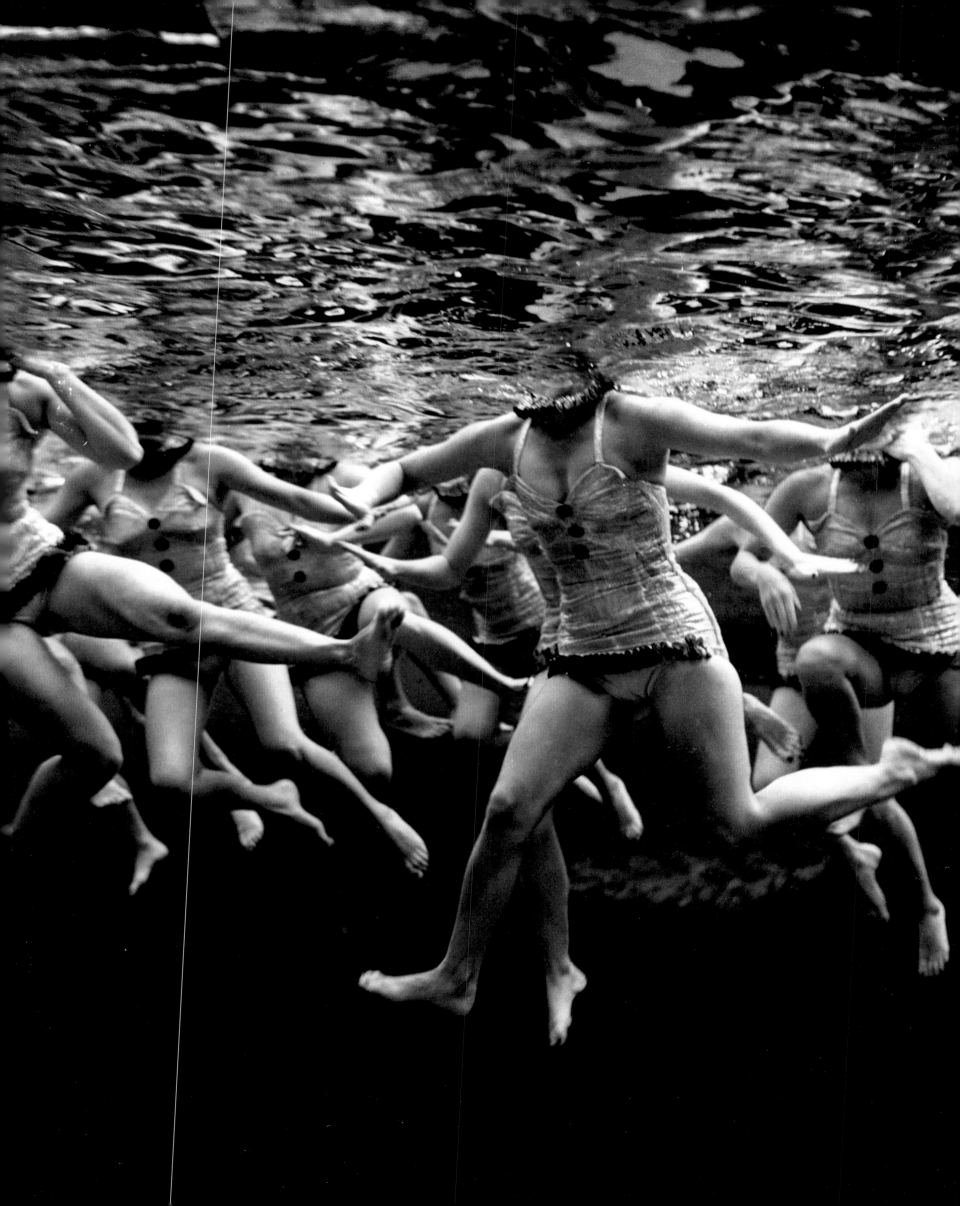

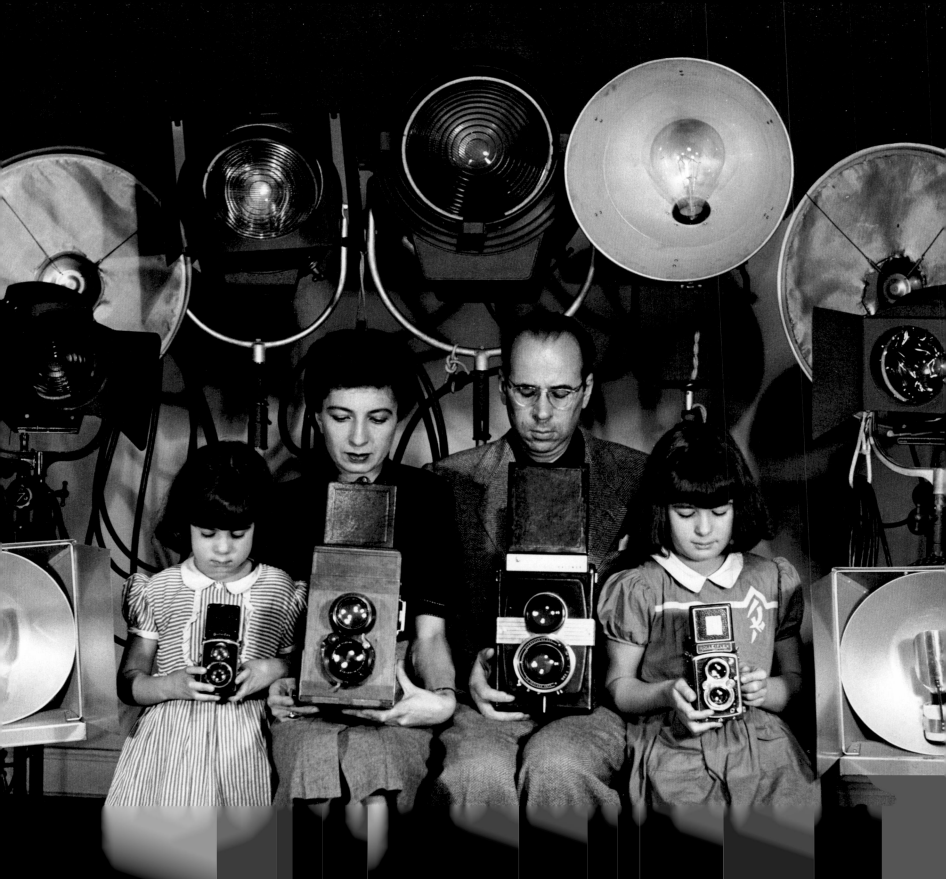

Chronology

1906
Philippe Halsman born May 2 in Riga, Latvia, the son of Max Halsman, a dentist, and Ita Grintuch, principal of a grammar school.

1910
Birth of sister, Liouba

1921
Discovers his father's old view camera and begins photographing family and friends. PH experiences his first "miracle" as he develops the glass plates in the bathroom sink.

1924
Graduates high school first in his class, having studied Greek, Latin, French, German, and Russian. Enrolls at university in Dresden, Germany, to study electrical engineering.

1928-30
Innsbruck, Austria

1930
Travels to Paris to visit Liouba and her fiancé, René Golschmann.

1930-40
Continues to live and work in Paris as a photographer. His work appears in *Vogue, VU,* and *Voilà,* and he opens a portrait studio and darkroom at 22 Rue Delambre in Montparnasse. Makes portraits of André Malraux, Paul Valéry, Jean Painlevé, Marc Chagall, André Gide, Jean Giraudoux, Le Corbusier.

1934
Maria Eisner, founder of Alliance Photo (who later helps organize Magnum Photos), introduces PH to Yvonne Moser, a young photographer who goes to work as his apprentice.

1936
Designs a 9 x 12 cm twin-lens reflex camera and has it built by a cabinetmaker whose grandfather (Alphonse Giroux) built the first camera for Daguerre.

First major exhibit: Galerie de la Pléiade, 73 Boulevard Saint-Michel

1937
Marries Yvonne Moser, now an established children's photographer and on staff at *Votre Bonheur,* a small weekly. They move into a larger studio at 350 Rue St. Honoré.

1939
Birth of first daughter, Irène, in Paris

Exhibition poster, Paris, 1936

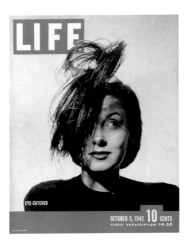
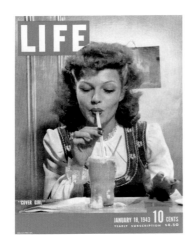
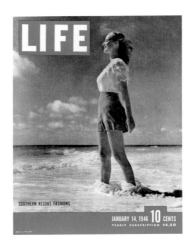
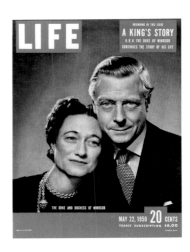

1940

MAY: Yvonne and infant Irène, along with Philippe's mother, Ita, his sister, Liouba, and her two young daughters, leave Bordeaux for the United States on a freighter just before the fall of France.

NOVEMBER: PH, who holds a Latvian passport, finally obtains an emergency visa to the United States through the intervention of Albert Einstein. With the help of the Emergency Rescue Committee, he arrives in New York City on a refugee ship from Lisbon, carrying with him one suitcase with his camera and a dozen prints.

1941

Birth of second daughter, Jane, in New York

Meets Salvador Dali; their thirty-year collaboration begins.

1941–42

Accepts fashion and magazine assignments from Black Star agency in New York.

"Victory Red" campaign for Elizabeth Arden

1942

First *LIFE* cover (10/5/42)

Yvonne continues what has become her life's work alongside Philippe as photographic and darkroom assistant.

1943

Moves to an artists' studio building on West Sixty-seventh Street in Manhattan, where he lives and works for the rest of his life.

Liouba becomes the studio's full-time secretary; she continues in this role until 1973, when she and René retire to the Virginia countryside.

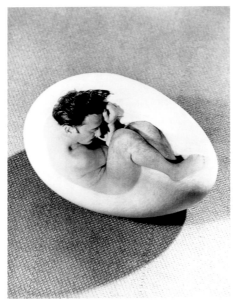

Dali, 1941

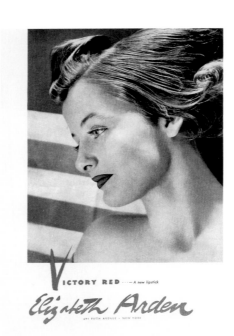

"Victory Red" advertisement
(Connie Ford), 1941

1944

Travels to California and photographs his first Hollywood assignments for *LIFE,* including Bogart, Bacall, Sinatra, Ingrid Bergman, Bette Davis, Judy Garland.

Produces seven *LIFE* covers this year, including a major cover story on American fashion designers.

1945

Elected the first president of the American Society of Magazine Photographers (ASMP).

Azzielean Roberts, a young woman from Texas, joins the studio as housekeeper and permanent girl Friday.

1946

Extensive photographic coverage of Martha Graham and her dance company in performance

1947

Photographs Albert Einstein in Princeton.

Designs an improved version of his twin-lens reflex camera in 4 x 5 format. Three prototypes, known as the Halsman-Fairchild, are manufactured. PH continues to use this camera for portraits throughout his career.

Medea, directed by John Gielgud, is the first of thirty-seven Broadway plays and musicals PH is assigned to photograph for *LIFE* over the next twenty-two years.

1948

Becomes a U.S. citizen.

Makes the photograph *Dali Atomicus.*

Travels throughout the Southwest on multiple assignments. Photographs Georgia O'Keeffe in Abiquiu.

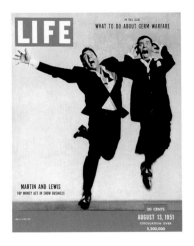

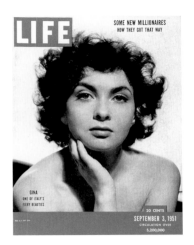

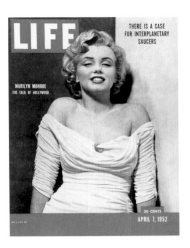

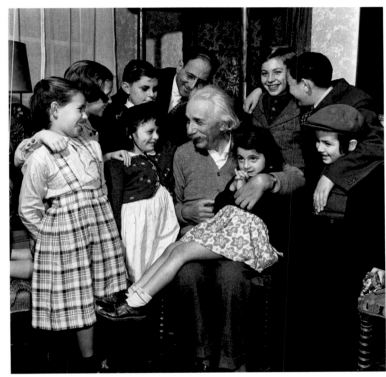

Einstein's seventieth
birthday party, 1949

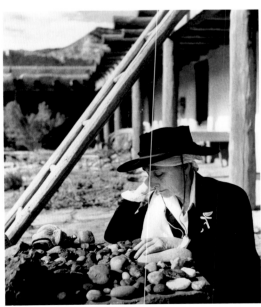

Georgia O'Keeffe,
1948

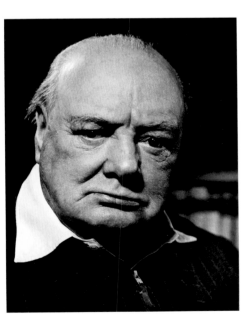

Winston Churchill,
1951

1949

Publishes *The Frenchman* (Simon &
Schuster), a book of photographs of
Fernandel, the French film star. It becomes
a *New York Times* bestseller.

Attends Einstein's seventieth birthday
celebration; photographs Einstein with
refugee children.

1950

Death of Ita, PH's mother, who had been
living nearby with Liouba and her family

1951

Fiftieth *LIFE* cover: Gina Lollobrigida
(9/3/51)

Returns to Europe for the first time;
photographs Chagall, Churchill, Matisse,
Sartre, Bardot, Magnani, and others.

David Seymour ("Chim"), one of the
founders of Magnum, asks PH to become a
contributing member of the legendary photo
agency. PH agrees to let Magnum distribute
his work in Europe.

1952

Marilyn Monroe *LIFE* cover (4/7/52)

1953

Publishes *Piccoli, A Fairy Tale* (Simon &
Schuster), which he had written earlier for
his daughters. *LIFE* runs an excerpt in its
12/7/53 issue.

Portrait of Winston Churchill appears on
cover of *LIFE* (11/2/53) as well as on the
jacket of Churchill's war memoirs, volume V.
Many PH portraits appeared on book
covers throughout his career.

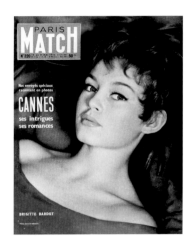
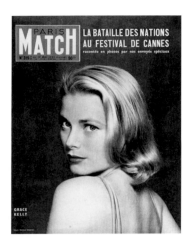

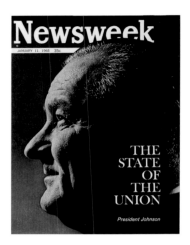

1954

Publishes *Dali's Mustache* (Simon & Schuster): thirty surreal images of his artist friend.

1955

Seventy-fifth *LIFE* cover: Audrey Hepburn (7/18/55)

1956

Sent around the world by *LIFE* to select and photograph the most beautiful women in seventeen countries.

1958

Chosen one of the "World's Ten Greatest Photographers" in an international poll conducted by *Popular Photography*.

1958–59

Photographs leading writers, philosophers, and scientists who contribute articles for the long-running series "Adventures of the Mind" for *Saturday Evening Post*.

1959

Publishes *Philippe Halsman's Jump Book* (Simon & Schuster). More than 200 illustrious subjects from the period 1950–59 jump for him. In a cover story, *LIFE* devotes eight pages to the book (11/9/59).

Appears on the CBS-TV program *Person to Person.* Interview takes place at the Halsman studio and apartment on West Sixty-seventh Street.

1960

Sent to Russia by *LIFE* to photograph Russia's leading artists, writers, dancers, and politicians.

1961

Publishes *Philippe Halsman on the Creation of Photographic Ideas* (Ziff-Davis).

Photographs "New Frontier" story for *LOOK:* President John F. Kennedy and his entourage.

1962

Joins with Irving Penn, Richard Avedon, Alfred Eisenstaedt, and six others to form the Famous Photographers School.

Documents historic weeklong interview between Alfred Hitchcock and François Truffaut in Los Angeles.

1963

Major exhibit at Smithsonian Photography Gallery, Washington, D.C.

Receives the Newhouse Citation for journalistic achievement from Syracuse University School of Journalism.

1966

First of two extended photographic visits with Vladimir Nabokov in Montreux, Switzerland

Photograph of Albert Einstein used on United States postage stamp.

1968

Marriage of daughter Jane to Steve Bello

1969

Makes official portrait of President Richard M. Nixon.

1970

One hundredth *LIFE* cover: Johnny Carson (1/23/70). With a total of 101, PH has more *LIFE* covers to his credit than any other photographer.

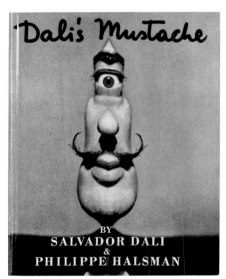

1954

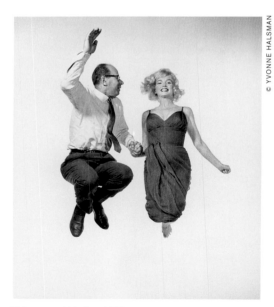

Halsman and Marilyn, 1959

© YVONNE HALSMAN

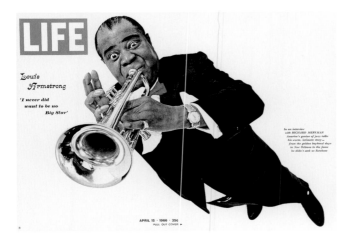 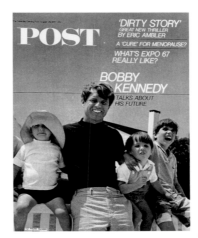 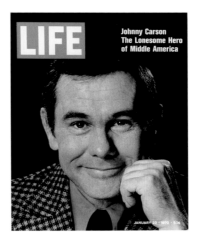

1971

Begins teaching "Psychological Portraiture" course at The New School, New York City. The class is held at West Sixty-seventh Street. PH continues to teach this course for the next five years.

1972

Publishes *Sight and Insight* (Doubleday).

Health begins to decline; sells ground-floor studio space and moves studio and darkroom upstairs into the family's apartment in the same building.

Birth of granddaughter Jennifer Sunshine Bello

LIFE ceases weekly publication after thirty-six years.

1973

Tokyo exhibit "Sight and Insight" organized and traveled throughout Japan by Orion Press.

1974

Photographs Alfred Hitchcock in Los Angeles: cover story for special issue of French *Vogue*.

1975

Recipient of the American Society of Magazine Photographers (ASMP) Life Achievement in Photography Award

Birth of granddaughter Sophie Claire Bello

Birth of grandson Oliver Halsman Rosenberg to Irène Halsman Rosenberg

1976

Health continues to fail. PH sells his collection to collector George Rinhart. (Halsman family reacquires the collection from Rinhart in 1987.)

1978

Makes last portrait of his old friend Salvador Dali.

Death of sister, Liouba

1979

At the invitation of Cornell Capa, founder of the International Center of Photography in New York, PH and Cornell curate and mount a comprehensive exhibition of his work, which then travels throughout the United States for the next eight years.

Philippe Halsman dies on June 25 in New York City.

PHILIPPE HALSMAN ARCHIVE

At present, the Philippe Halsman Archive continues to be administered by the Halsman family and remains at the original West Sixty-seventh Street location. It will eventually be housed at the Center for Creative Photography at the University of Arizona in Tucson.

Magnum Photos continues to distribute Halsman's work for reproduction in Europe and Japan.

PUBLICATIONS

The Frenchman (Simon & Schuster), 1949
Dali's Mustache (Simon & Schuster), 1954
 (Reissued by Flammarion/Abbeville, 1994)
Philippe Halsman's Jump Book (Simon & Schuster), 1959 (Reissued by Abrams, 1986)
Philippe Halsman on the Creation of Photographic Ideas (Ziff-Davis), 1961
Sight & Insight (Doubleday), 1972
Halsman Portraits (McGraw-Hill), 1982
Halsman at Work (Abrams), 1989
 (With Yvonne Halsman)

PERMANENT COLLECTIONS

Philippe Halsman's work is in the permanent collections of many museums and universities. Among them are:

Museum of Modern Art, New York
Metropolitan Museum of Art, New York
National Portrait Gallery, Washington, D.C.
Photographic History Collection,
 National Museum of American History,
 Washington, D.C.
Library of Congress, Washington, D.C.
George Eastman House, Rochester,
 New York
Royal Photographic Society, London
Bibliothèque Nationale, Paris
Metropolitan Museum of Photography, Tokyo
International Center of Photography,
 New York
San Francisco Museum of Modern Art
New York Public Library: Billy Rose Theatre
 Collection; Dance Collection
Brooklyn Museum, Brooklyn, NY
Denver Art Museum
Salvador Dali Museum, St. Petersburg,
 Florida
Worcester Art Museum, Worcester,
 Massachusetts
New Orleans Museum of Art
Polaroid Collection, Cambridge,
 Massachusetts
Yale University Art Gallery, New Haven,
 Connecticut
Museum of Fine Arts, Houston
Hallmark Photographic Collection,
 Kansas City, Missouri
Norton Simon Museum, Los Angeles
J. Paul Getty Museum, Los Angeles

Editors' Note

In 1995, we moved back to New York from California, took up residence in the Halsman studio, which housed the photographic files, and began to look after my father's archive. Since his death in 1979, it was my mother, Yvonne, who had been their steady, loyal custodian.

Working with the files from A to Z, day in and day out, we soon realized that our most important task would be to gather Philippe's life's work into a book, and with it to celebrate his unique contribution to twentieth-century photography. With a body of work of such range and depth, we knew our biggest problem would be selection. We could see that this time around there simply wouldn't be enough space for more than a few examples of his wonderful early work from Paris in the thirties, his fashion work from the forties, or his dance and theater photographs.

The project was launched one winter day when Robert Tracy, a dance historian, visited the Halsman studio on a research expedition. He responded with such excitement to Philippe's work that he brought over Carol Judy Leslie, publisher of Bulfinch Press, whose immediate enthusiasm for the book made it fly. We were then blessed to have Janet Swan Bush come on as our editor. The book flourished under her skillful guidance. And when J. Abbott Miller and Design/Writing/Research joined up, they brought their own provocative gifts to the layout and design.

Again we were lucky at the production phase, when Sandra Klimt, Martin Senn, and Danny Frank came on the project. Their wisdom and experience were indispensable in capturing and preserving the beauty of Philippe's vintage prints on the page. Thank you all.

Our warmest thanks also to Jeri and Phil Fox, Arline and Dan Kramer, Julie Galant and Martin Bondell, Jimmy Fox, Chris Boot, Liz Grogan, Phil Cowan, Ken Swezey, and Edna Weiner. We acknowledge with gratitude Peter Galassi, Susan Kismaric, Maryann Kornely, Beth Zarcone, and Graham Howe. Very special thanks to Richard Shapiro, Philip Livingston, and Ronald Blum for their care when we really needed it.

We send our thanks to Beverly Cox, Curator of Exhibitions at the National Portrait Gallery, for her dedication and foresight and appreciation of the work. And to Mary Panzer, Curator of Photographs, our gratitude and boundless admiration.

To Jen and Sophie, big hugs for their enthusiasm and encouragement amid the chaos, and for all the hard work on their grandfather's archive over many summer vacations.

Special thanks to Irène Halsman for her valuable contributions throughout. And to Yvonne Halsman, who gave Philippe her heart and soul, and kept it all together for him since the day they met.

Philippe would be ninety-two years old if he were alive today. We made this book to honor him.

JANE HALSMAN BELLO & STEVE BELLO
New York
March 1998

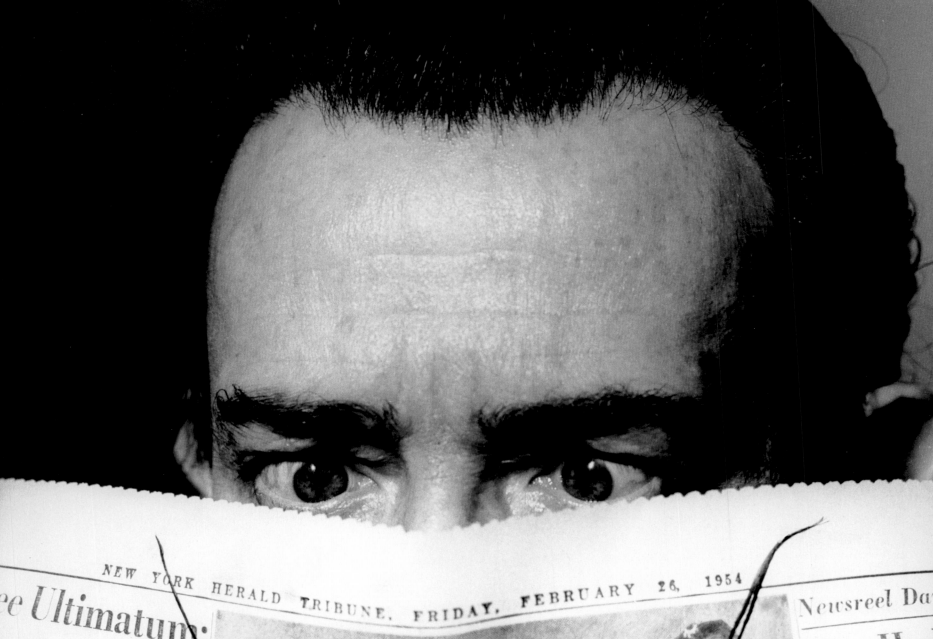

NEW YORK HERALD TRIBUNE, FRIDAY, FEBRUARY 26, 1954

ee Ultimatum;
, Says Letter

YoungSouthpaw
Asking $20,000;
Stengel Anxious

By Rud Rennie

ST. PETERSBURG, Fla., Feb.
25.—The Yankees today sent an
ultimatum to Eddie Ford, their
only unsigned pitcher. Roy
Hamey, assistant to George
Weiss, the general manager,
wrote him a stern letter telling
him the Yankees had made him
their final offer and that he had
better accept it and come to
camp and get in shape.

Ford, blond and cocky and as
tough in a salary confab as he
is on the mound, had a confer-
ence with Hamey here a couple
of days ago. He went back to
his cottage on the Gulf beach
without signing and no one has
heard from him since.

Unless Weiss grows angry
again as he did in the case of
Vic Raschi and suddenly decides
to unload the young lefthander
who won nine and lost one in
1950 and had a record of eight-
een and six last year, Ford is
in a strong position to hold out
until the Yankees give him what
he wants.

Asking for $20,000

Ford probably is asking for a
about $20,000. Last year the
was that Ford was r
be waits.

Giant Catching Staff—Ebba St. Claire (left), obtained from Milwaukee; Wes West-
rum (center) and Ray Katt, with the latter the man to beat, according to Durocher.

Herald Tribune—United Press

Rigneys Win Camp Game

Mueller Gets $18,000;

Newsreel Da

Cox Has
He'll B

By Harold R
VERO BEACH, F
Today was "N" (B
Day in Dodgertow
plan to attend
neighborhood mov
favorite Dodger t
Billy Cox, save you
did not get into an
while a dozen ca
out miles of footag
He was back in
parked in a whirlp
ing the first Broo
the 1954 campaig

Cox's trouble
back in the sacr
will probably be
three or four da
pick-up contest
hence will prob
without him. Ar
nothing new. Le
ried about a Cox
so did Burt She
Chuck Dressen.
Alston's turn, al
rent pilot is g
early in his stev

Pulls Muscle

Cox pulled a
practice Wedne
stiffened over
morning, after
Dr. Gene Zorn
cian and H

Team Standings
In N. B. A.

EASTERN DIVISION